THE
DEADLY
SHIPWRECKS
—— OF THE ——
POWHATTAN
& NEW ERA
ON THE JERSEY SHORE

CAPTAIN ROBERT F. BENNETT,
SUSAN LEIGH BENNETT &
COMMANDER TIMOTHY R. DRING

THE
History
PRESS

Published by The History Press
Charleston, SC 29403
www.historypress.net

Copyright © 2015 by Captain Robert F. Bennett, Susan Leigh Bennett and Commander
Timothy R. Dring
All rights reserved

First published 2015

Manufactured in the United States

ISBN 978.1.62619.977.4

Library of Congress Control Number: 2015931111

This book is dedicated in part to the memory of the 530 souls lost on the ships Powhattan *and* New Era. *It is also dedicated to the memory of the heroes of the United States Life-Saving Service, the original New Jersey surfmen and their descendants and the modern heroes of the United States Coast Guard.*

The authors also express their appreciation to Captain Bennett's family: his wife, Barbara, and daughters Lorri and Susan. In keeping with the tradition of dedications, this book is also dedicated to Barbara Ann Bennett, the lead author's wife, with the same inscription he wrote on January 18, 1977, for his first book:

I cannot express to you all the boundless appreciation that is in my heart for your encouragement, and forbearance, and confidence in the preparation of this book. All I can say is...I love you, 'til forever.

Finally, this book is dedicated to the lead author himself, Captain Robert Frank Bennett, USCG-Retired, who left this world on September 7, 2011.
For you, Daddy
Love, Susan Bennett

CONTENTS

FOREWORD

In 1848, Congress passed legislation requiring the government of the United States to establish a rescue response system to deal with the increasing number of fatal shipwrecks occurring near New York Harbor. This was not the first expression of federal concern about marine safety; one of the first federal statutes, passed in 1789, provided for the establishment and maintenance of lighthouses and other navigational aids and continued the system of marine pilotage that had been in existence at colonial ports. An increasing number of steamboat boiler explosions resulted in an 1838 law that sought to prevent such disasters. The United States Coast Survey was created to survey North America's coastal waters and to publish up-to-date nautical charts so that ships might safely navigate along its seaboard. United States Revenue Marine cutters were directed to cruise the areas of the coast where accidents frequently occurred so they could render assistance when needed. Finally, starting in 1849, the United States government established unmanned coastal rescue stations to respond to shipwrecks. These stations and the rescue equipment in them were intended to be utilized by volunteer rescuers, similar to a volunteer fire department. This system, however, had several shortcomings, which were tragically demonstrated in 1854.

That year, two horrendous shipwrecks took place on the New Jersey coast. Both involved American-registered sailing packet ships—the *New Era* and the *Powhattan*—that were carrying European immigrants to America. Both ships ran aground on offshore sandbars, coming to rest within one hundred to three hundred yards of the beach. The coastal area where this happened was between Sandy Hook and Little Egg Inlet, which was the same stretch

of beach that the federal government had selected in 1848 to build the new rescue stations. In the first few years of operation, starting in 1849 (when the first of eight initial stations was completed), the stations received plaudits for several spectacular rescues, the most famous of which occurred after the *Ayrshire* shipwreck of 1850. Volunteers using the federal rescue equipment saved all the ship's crew and 201 out of 202 British immigrant passengers. The 1854 *New Era* and *Powhattan* disasters and associated loss of life, however, resulted in a sobering realization that a proper rescue system required much more than simply placing equipment at eight locations along a sixty-mile coastline and trusting locally available volunteers with the responsibility for its maintenance and proper use, no matter how good the intentions of the volunteers might be.

The first of the two shipwrecks, the *Powhattan*, happened on April 16, 1854, on Long Beach Island near the present-day community of Surf City, New Jersey. All of those aboard (at least 326 persons) perished. The second shipwreck, that of the *New Era*, happened on November 13, 1854, near the north end of what is now Asbury Park, New Jersey. While nearly all of the ship's crew and some of the ship's passengers survived, the majority of the immigrant passengers (206 total) perished, even though this shipwreck occurred directly in front of a rescue boathouse on the beach. Aside from the ship's American crewmembers, the dead were mostly German passengers traveling to America in the hope of starting new lives for themselves. The immigrants' dreams of a new life in America ended fatally within yards of the sandy beaches of New Jersey.

Overall, at least 530 persons died in these two shipwrecks. To illustrate the magnitude of the human loss, if the present-day practice of erecting roadside memorials to honor the deaths of motorists were applied to honor the victims of just the *New Era* and *Powhattan* disasters, there would have been one memorial erected every two hundred yards along the sixty miles of beach between Sandy Hook and Little Egg Inlet.

In both the *Powhattan* and *New Era* shipwrecks, sinister clouds of suspicion arose regarding allegations of body looting and cowardice. Explicit in the sad results of these two cases, the vulnerabilities of the federal life-saving system had been revealed. Another aspect of these tragedies was the potential for prevention through better measures and requirements in maritime safety. Although Congress and the federal government believed that steamboat fires and explosions that killed American citizens on our inland waters could be prevented by the development and establishment of technical construction rules and by the licensure of ship personnel, sailing ships carrying European immigrants to our coasts were overlooked in these efforts and therefore at risk.

FOREWORD

The federally established coastal rescue system of stations and equipment (which was later expanded to include the coastline of Long Island and sections of New Jersey coastline farther south of the original eight stations, down to Cape May, New Jersey) of the 1840s and early '50s, while certainly important additions to coastline areas that previously had virtually no facilities for shipwreck rescue, did have serious shortcomings that resulted in a less-than-adequate system. None of these stations (actually boathouses) was manned by dedicated, trained, professional rescuers, and none was under the leadership and management of a full-time officer-in-charge, or keeper. The stations were located too far apart from one another to facilitate mutual support or a multi-station response. There was no program of maintenance of either the buildings or equipment, no system of inspections to verify station readiness and material condition and no regular appropriation of funds to pay for repairs or the replacement of worn-out or damaged equipment.

The wrecks of the *Powhattan* and *New Era*, however, finally prompted calls from the public and politicians to stop the carnage. This eventually led to new federal legislation that passed Congress in 1854, intended to institute improvements in the federal rescue station system. Even later, in the 1870s, this system was again changed to become the highly effective and successful United States Life-Saving Service. In 1915, it merged with the previously separate United States Revenue Marine to become what is today the United States Coast Guard.

This book is not intended to glorify or vilify any particular individuals, inventors or government officers. The persons involved at that time with overseeing, supporting, supplying and especially enabling the fledgling federal rescue system probably did their jobs the best they could and with some successful results.

Perhaps no better place exists in this book for the following reminder about a government's total reliance on response at the expense of prevention.

"The Ambulance in the Valley"
Joseph Malins (1895)
(Published 1913, Bulletin, North Carolina State Board of Health, Vol. 27, No. 10)

Twere a dangerous cliff, and it fair scared folks stiff,
But the view from the top was so pleasant,
That they swallered their fear, and there crashed down each year
Full many a squire and peasant.
"Something's got to be done." Said the people as one
But answers did not all tally.

Some said, "Put a fence 'round the edge of the cliff."
Some, "An ambulance in the valley."

Debate raged and stormed, and a study was formed,
And they might have been arguing yet,
But solution was found: "Let's pass the hat 'round,
And see how much money we get."
A collection was made to accumulate aid
And the dwellers in byway and alley,
Gave pounds, shillings and pence—not to furnish a fence
But an ambulance down in the alley.

"For the cliff is all right if you're careful," they said,
"and if folks ever slip an' dare dropping, it isn't the slipping that hurts
* them so much*
As the hock down below—when they're stopping."
So for years (you'll have heard), as the mishaps occurred
Quick forth would the rescuers sally.
To pick up the victims who fell from the cliff
With the ambulance down in the valley.

There said one finally, "It's a marvel to me,
That we give so much attention
To repairing results than to curing the cause;
We had much better aim at prevention
For the mischief, of course, should be stopped at its source,
Come, neighbors and friends let us rally.
'Tis far better sense to rely on a fence,
Than an ambulance down in the valley.

"He is wrong in his head," the majority said,
"He would end all our earnest endeavor.
He's a man who would shirk this responsible work
But we will support it forever.
Aren't we picking up all, just as fast as they fall,
And giving them care liberally?
It's plain that a fence is of no consequence,
If the ambulance works in the valley."

PREFACE

Inever had the privilege of meeting the author, Captain Robert Bennett, USCG-Retired, in person during his lifetime, although I certainly knew of him professionally. In my own historical research on the United States Life-Saving Service (USLSS) and United States Coast Guard (USCG), specializing in the technical design history of all of the service's rescue boats, I had read Captain Bennett's earlier published works (e.g., *Surfboats, Rockets, and Carronades* and *Sandpounders*) and encountered references to his years of research on the service's history. I certainly consider Captain Bennett to have been a colleague in these efforts, which was all the more reinforced by our memberships in the United States Life-Saving Service Heritage Association (the primary historical society engaged in the preservation and teaching of the history of the USLSS and early USCG).

It was with sadness, then, that I learned of Captain Bennett's passing in 2011. It was with happiness, however, that I accepted an opportunity, provided by both the heritage association and the United States Coast Guard Historian's Office, to contact the Bennett family and offer my services as a volunteer toward the preservation and cataloguing of Captain Bennett's extensive collection of photographs, drawings, documents and books related to the history of his beloved service. It was in conjunction with this effort that Susan Bennett made me aware of her father's unfinished and unpublished manuscript about the *Powhattan* and *New Era* shipwrecks. Sue and I agreed that this manuscript was an important part of the USCG's origins and history and that it should be published so that the story can be told. I am

honored, therefore, to be able to assist the Bennett family with this book, as well as with Captain Bennett's collection. While Sue and I have done some editing of the manuscript's original text, the story's theme, words and messages for us are all his.

TIMOTHY R. DRING
Commander, United States Naval Reserve-Retired
Member, United States Life-Saving Service Heritage Association
2014

1

A VOYAGE OF HOPE

While fictional, the following story about the disastrous stranding of the American passenger sailing ship *Powhattan*, laden with immigrants bound for New York, is based on the real event. This dramatic manner of describing the events and horrendous circumstances of that wreck was created in hopes that, by relating the story in a nonclinical and more human way, the reader might become more emotionally connected. Today's maritime rescuers who are exposed to high loss of life incidents typically experience such connections. The lead author was on scene at the twentieth-century *Andrea Doria* and *Hans Hedtoft* shipwrecks and, therefore, speaks from personal experience and observation.

Owing to the loss of almost all the ship's records, as well as the victims' names and hometowns, a fictitious Ulrich family has been created. They might have begun their journey from a real place, Wurttemberg, Germany. The names of the ship's officers and crew, however, are a matter of record, and they appear as they were in real life.

SINSHEIM, WURTTEMBERG, GERMANY

July 1853

Johannes Ulrich reread the letter from his Uncle Heinrich in Wisconsin. Then he passed it back to his father, Gustav, the letter's recipient.

"What do you think of this, Papa?"

"Well, it seems that brother Heinrich has done very well in America. You remember when he and Inga left Wurttemberg not ten years ago?" Johannes nodded. Gustav Ulrich continued, "Now he owns a larger piece of land that he could ever have dreamed of owning here."

"And, Uncle Heinrich says he and Inga now have twenty milk cows, at least thirty swine of various ages and more chickens than he can count. Can it be true?"

"I've never known Heinrich to lie. From all I've heard, America has become a dream come true for many of our countrymen. If I were younger, I might think about going there myself."

Smiling, Gustav directed his gaze directly into his son's eyes, "Johannes, you're the youngest of our three sons. You know that I'm not a rich man—comfortable perhaps, but I won't be able to leave you very much of an inheritance when I die. You really might want to think about joining Heinrich in—what does he call that place in America? Ah, yes, Wisconsin."

Taken aback, Johannes stammered, "But it would mean leaving you and Mama and my brothers, Erich and Manfred. And, of course, there's Marie and our children to consider. How would they take to leaving our home and family? What about the long voyage? And then, Marie's family, what would they think?"

"Well, Johannes, you must consider everything, but not only what is in the present, but what the future might hold for you and your family, and do what's best. I have been successful only because the baron trusted me to keep his books. He kindly provides us with some land and a nice cottage. Erich is the oldest of you boys and will take over my small but comfortable profession, in which he is excelling. The baron appointed Manfred as his forester, so I have no fears for his future. Ah, the baron has been generous to us Ulrichs. But he is aging, and his only child is a spinster. After he passes, she might have to sell off some of the family holdings. I have no assurances as to what will happen. If I were you, I believe I'd think very seriously about going to America, and you had better make sure Marie is agreeable, otherwise…"

Marie had spent most of her life in and around Wurttemberg. Her father served as a career army officer, and she both inherited and developed a strong sense of duty and decisiveness from him. Johannes carefully considered his father's advice. He explained to Marie what he was thinking of. Initially cool to the notion of leaving her homeland and family, Marie warmed to the potential for success her children might have in a new world unburdened with backward rules and an indecent caste system that would forever keep Johannes and his family in their place.

A VOYAGE OF HOPE

After his first conversation about emigrating back in July with Gustav, Johannes, or "Hans" as Marie called him, read everything he could find about America. He even devoured some books about learning to speak English. He also read as much as possible about sailing ships and, in particular, about packets in the Atlantic passenger trade.

Gustav had taught Hans something of bookkeeping despite the fact that Erich received schooling in that profession. For the most part, Johannes performed clerk duties at the local grocery and kept account of the store's general business. He and Marie rented three rooms over the store in which they made their home. Herr Schultz, the storeowner, accepted the departure of the Ulrich family with sadness but admired their courage.

Late in September, Johannes and Marie carefully counted out their financial assets and calculated that they would be able to purchase their passage by the end of January. They also counted the gold piece presented to them by the baron at their wedding. The couple, who had always huddled out of earshot of their two children, Rupert and Grete, when discussing their great adventure, agreed that the time had come to tell their children. If Johannes was willing to begin a new life, Marie was determined to be at his side—even in Wisconsin, their destination. She told him so. He embraced her; they kissed gently. Then, smiling, they broke the news to their children.

Johannes then explained all that he had learned about Wisconsin and of passenger packet ships, the kind of ship on which they would cross the Atlantic. He also explained the German emigration laws and the American immigration requirements. Rupert was eleven, and Grete would be eight in January.

"We're going to America!" both youngsters screamed with delight.

Paid in mid-February, the passage for all four members of the Ulrich family amounted to about sixty dollars in United States currency. At the last minute, Papa Gustav presented them with several gold coins, worth twenty United States dollars total, with his characteristic apologies that it could not be more. Marie's father, austere and solemn about seeing his youngest daughter depart for a distant place with the likelihood that he would never see her again, generously added more cash and tearfully gave her his blessing.

The Ulrichs would sail about March 1 from Le Havre, France, to New York on a fully rigged American packet ship named *Powhattan*. Uncle Heinrich in Wisconsin had sent tickets for their transportation from New York to Chicago, Illinois, and from Chicago to Madison, Wisconsin. Heinrich, Inga and their family would meet them there, and they would stay with Uncle Heinrich until they could raise their own house and barn.

As they packed all that they could bring with them, Marie carefully sewed her best jewelry and heirlooms and a small cache of gold coins into the hems of their clothing, careful to distribute their valuables so as not to be noticeable. Aunt Inga had written that was how she and Heinrich had protected their things during their Atlantic voyage. In fact, that had become common practice among most other working-class immigrants.

Le Havre, France

February 28, 1854

Johannes had read all he could about sailing ships and the management of passengers. He was fully prepared when he escorted Marie and the children to the Le Havre docks. Johannes' curiosity about the *Powhattan* led to his learning that the ship had only recently returned to Europe from a round-trip voyage between New York and Rotterdam, Holland. That voyage began on November 29, 1853. The immigrant passengers to New York then consisted mostly of Germans along with some from the Netherlands.

Johannes' brother, Manfred, unexpectedly accompanied them to Le Havre. They quickly located the *Powhattan*, moored at a wharf marked by a sign "The William Graham Company, Baltimore, Maryland." Sporting a fairly new coat of paint and recently tarred standing rigging, the ship exuded a strong sense of nautical capability. Along its side, Rupert spotted the telltale checkerboard design of imitation gun ports running from the front of the ship to its rear.

"Papa, look at the guns."

"No, Rup-chen, those are pretend gun ports and are only painted on to scare pirates away."

"Will we be attacked by pirates, Papa?"

"Very unlikely, but when we reach America, we might have to be especially careful about pirates on land who might try to deceive our ship captain into running aground so they can kill us and loot the *Powhattan*."

The Ulrich family watched from the dock as the ship's crew and stevedores hustled up and down the gangplank, bringing food and barrels of liquids on board the *Powhattan*. A water barge, moored out of sight on the other side of the ship, pumped fresh water into the ship's potable water tanks. Overhead, a yardarm had been transformed into a crane to load parcels through a

hatch to a stowage area deep in the ship. Johannes felt as if he could watch the hustle and bustle for hours, but Marie intervened.

"Come, Hans, let's get a good meal. The children are hungry. We'll have about forty days to watch sailors work once the ship sails."

After eating and with stomachs full, they returned to the inn where the baron had so graciously arranged for their lodging. There, they hired a cart, which Manfred and Johannes used to haul the baggage to the dock and up to the *Powhattan*'s gangway. At the gangway, they presented themselves to a mate who identified himself as Mr. Rogers. They watched carefully as he efficiently checked their names off on the passenger manifest. Rogers, a seemingly pleasant man, nodded to Manfred. He told Manfred that he was free to come aboard but must leave afterward. Rogers, perhaps intrigued by Marie, decided he would get to know these people better. He spoke to them in halting German and explained that they could follow him and bring their baggage below to the steerage deck.

The access down to the steerage deck led from the foc's'le (the common, phonetic pronunciation of the word *forecastle*) down two narrow, steep sets of stairs. Because of her sensitive nose, Marie immediately detected the recent efforts of a cleaning crew and of the residual stench of emesis, urine and feces. Another odor, which she could not identify, permeated the foul air on the steerage deck. Manfred looked at Hans and Marie and softly said, "Wood rot."

"What does that mean?"

"Hans, I think all old wooden ships have some wood rot. When they build them, they expect it, so they just build them stouter to account for what might happen."

About that time, Mr. Rogers motioned for them to follow him to the side of the ship. He pointed to a crib-like structure on the deck level that appeared to be a small compartment. A similar space had been constructed immediately above. In fact, both sides of the steerage space were lined with these small compartments, one on top of another. A long table and bench seats ran the length of the space in its center. Several lanterns provided dim light. The cargo hatch through which they watched cargo disappear added fresh air and daylight. Nevertheless, the prospect of having to spend six weeks in these stinking confines caused Marie to shudder. The children, however, saw an adventure.

"Papa! Mama!" Rupert shouted excitedly. "This will be like the week that Uncle Manfred took me on a camping trip and we lived in a tent."

"Mama, I don't like this place at all. I want to go home," Grete spoke with a frown, her eyes bulging with unspent tears.

"Children, we will be able to go up on the deck, won't we, Mr. Rogers?"

Marie's question tested Rogers's knowledge of German, but he caught the sense of it. "Aye, I mean, 'Ja.'"

Then, he added in English, "You can be sure that I'll see to anything I can do to make you comfortable."

Johannes picked up on Rogers's interest in his wife and asked, "Herr Rogers, this shiff ist how old?"

Surprised at Johannes' knowledge of English, Rogers quickly replied, "I think it was built in 1837."

"Ah, about seventeen years. But it has been kept in good repair?"

"Oh, yes. Mr. Graham makes sure of that."

Johannes and Manfred let their eyes wander over some additional details in the steerage space. Both settled upon a row of ringbolts fitted to the sides of the cribs. They looked at each other, and then, in a knowing way, Johannes asked, "Mr. Rogers, has this ship always been used for the Atlantic passenger trade?"

Rogers grimaced, "I think it may have been in the South American trade for a while."

With that, the mate excused himself and climbed back to the main deck. Returning to German, Johannes whispered to Manfred, "Yes, and I'll bet that this ship made Mr. Graham a great deal of money carrying so-called passengers from Africa to South American ports."

"No doubt America suffers from the same political garbage as Germany. My God, Hans, where did you learn all this?"

"As I've told you, I've been studying America. Working for the baron and living on his fiefdom, we're both well aware how much politics enters our daily lives, even in America. One good thing, if the *Powhattan* carried African slaves, Graham was deeply motivated in getting his cash cargo to their destination. So, if it was in good condition a couple years ago, it probably still is."

"Yes, provided it hadn't already reached the end of its life span when he changed back to Atlantic passenger trade. I don't like this at all. Hans, please change your mind and return with me to Sinsheim. Think of your lovely wife and children."

"Manfred, we have all our hopes set on making this voyage. Don't worry, we'll be fine."

"I hope so. My dear brother, I must be going."

The brothers shook hands and exchanged a hug. Marie noticed the farewells then in progress. She and the children stopped putting their belongings away in their assigned spaces and rushed over to say their

goodbyes. Manfred refused to let them accompany him up to the main deck. Tears had already burst forth in the corners of his eyes.

The creaking and groaning of the ladder announced the arrival of more passengers descending to the steerage deck. Marie caught apprehension in the eyes of two other women who were joining them.

AT SEA

March 4, 1854

The weather had cleared enough that Captain Myers decided that the passengers would be safe, provided they stayed in the waist of the ship, between the side bulwarks and the raised foc's'le forward and quarterdeck astern. Johannes had suffered from seasickness worse than young Rupert. Marie and Grete had suffered only from the stench of the confined steerage deck. After several hours on deck in the fresh air, Rupert had recovered enough that his natural curiosity caused him to begin asking questions of Johannes.

"Papa, why aren't all the sails on every mast working?"

Johannes, feeling better himself, gave the question some thought.

"I think it's because the wind is still blowing pretty hard. That's why the ship is leaning over and bouncing around so much. When that happens, the captain will limit the amount of sail area he lets the wind blow on. He has the fore topmast staysail and the inner jib set, along with the top sails, and the spanker is reefed as well." Johannes added, "When the wind dies down, he'll probably set the fore and mainsails."

Marie overheard the conversation, "Hans, how in the world did you learn all that?"

Nodding toward his son, he answered, "My dear wife, that is why it is so important to research and read books."

As the day wore on, the wind died, and just as Johannes had described, Captain Myers made more sail. Later in the afternoon, Myers clambered down the ladder that led from the quarterdeck to the waist, where he approached a small group of passengers. They immediately stepped back, showing great deference. In return, he announced, in reasonable German, "Good day. I am Captain Myers. I hope you are feeling more comfortable now that the wind has died down a bit."

They stared back, amazed that this man, the primary authority on the ship, would care about the comfort of mere steerage passengers.

The captain added, "If you need anything at all, please let one of my mates know and I'll be glad to see what I can do."

Gesturing toward the young man, who looked around twenty-five years old and had introduced himself as Mr. Rogers, he announced, "This is Mr. Rogers, my chief mate. And that fine young fellow over there is Mr. Harvon, my second mate. If you would like to know something, please ask."

With that, Rupert raised his hand, mortifying his father and mother. "Captain, may I ask you a question?"

"Surely, what is it?"

"The ship stays leaning over to one side. When will we lean to the other side?"

"Good question, lad." James Myers grinned, "We need to head to the west to get to New York, but the wind is blowing from that direction. Because this sailing ship cannot sail directly into the direction from which the wind is blowing—steamships can—we must sail off to the side of that direction. This is called 'tacking.' We are now on a port tack. This higher side over here is called the port side; that lower side over there, where we are leaning toward, that's the starboard side. Because the wind is blowing right at us, we have to tack…" Captain Myers paused, looking for the right word. "That means we have to tack first to one side of the direction we want to go, then tack to the other."

The boy understood. Myers continued, "In a couple hours, we'll turn to the left and bring the wind across the other side."

"Then we'll be on a starboard tack?"

"Correct, and the ship will then heel over to port."

The day ended much better than it had started.

In the days and weeks that followed, the ship tacked westward. Captain Myers and his crew carried out their shipboard routines. The weather followed the pattern typical for March and early April: the prevailing westerlies caused the ship to tack repeatedly, but the weather remained mostly moderate.

Marie and Johannes met a fellow passenger, a Lutheran minister, who they came to know as Pastor Immelmann. He was on his way to Minnesota to lead a congregation of German immigrants. He conducted Bible studies daily, with about ten or fifteen steerage passengers in attendance. Hans and Marie were counted among his most faithful. Immelmann also conducted services in the waist, weather permitting, every Sunday. He presented a sermon and led in the singing of hymns. Typically, a group of about fifty people joined in, but the number increased as the voyage wore on. Marie insisted that the children

also join them. Marie's faith had followed a more evangelical pattern, but she approved of the Lutheran doctrines as taught by Pastor Immelmann.

Young Rupert found every opportunity when he was allowed on deck to ask the sailors questions. He didn't seem to bother them at all. In the process, he learned the names of most of the lines leading from the pin rail aloft and their purposes. His daily discussions in broken but improving English with the sailors afforded the professionals amusement and a sense of accomplishment. Rupert discovered a host of nautical terms besides *port* and *starboard*; there was *leeward*, *weather* and *fore* and *aft*, *bow* and *stern*. At some risk for a scolding, he learned how to climb aloft on the weather ratlines that stretched between the shrouds. He learned that it was unsafe to try to climb up the leeward ratlines. Captain Myers noticed the interaction between his crew and the youngster and decided to allow it, so long as there was no risk to Rupert's safety.

Rupert reported daily to Johannes what he had learned. His father took notice.

"Rup-chen, you aren't thinking about becoming a sailor, are you?"

"No, Papa. Besides, I don't think there is any ocean in Wisconsin. But I read there is a very big lake called 'Lake Michigan.' But, Papa, I did learn from the sailors that if you climb aloft, you must go up in the windward side and hold fast to the shrouds, then you can put your feet on the ratlines. Just as you would climb a ladder on land."

"Rupert Ulrich! You haven't been climbing up those masts have you?" Marie asked with some aroused emotion.

"No, Mama, I've only learned in case some time I need to."

"Like when?"

"In case we are in a shipwreck."

"Rupert, don't even say such a thing!"

"Mama, shipwrecks happen. And Mr. Rogers told me that if we should ever strand on a shore, the safest place to be is up in the rigging."

At Sea

Friday, April 14, 1854: Good Friday

The air temperature had warmed into the sixty-eight-degrees-Fahrenheit range, matching the temperature of the Atlantic Ocean. Overnight, the color of the sea turned to an azure blue. The Ulrich family climbed to

the foc's'le for their routine morning airing. Hans insisted they do this every day when the weather decks were open to the passengers. Fresh air invigorated them as a respite from the stale, obnoxious stink that drenched the steerage deck. Some passengers lay still in their berths, barely active except to stagger to and from the sewage buckets and the center dining tables where they partook of ever-diminishing rations.

After finishing their noon meal on the steerage deck, the Ulrich family climbed the ladder to the main deck. What started out as a partly cloudy morning had, by early afternoon, gradually turned into yellowish-gray overcast sky. The wind had increased noticeably to a moderate breeze from the southeast, and the gentle waves marched row on row toward the ship's port quarter. A small group of passengers had formed on the forward port side of the waist. A smaller group had gathered aft near the ladder to the quarterdeck. The second group was kneeling and saying their rosaries. Johannes and Marie led the children toward the Protestant service that had apparently just begun. The pastor led them in several hymns and then began reading from the Bible, chapter twenty-two in the Book of Luke. The congregants then bowed their heads in prayer. Pastor Immelmann dismissed them at about 1:00 p.m.

By midmorning, James Myers was alarmed, although he dared not reveal it, even to Rogers and Harvon. By now, he'd become certain that the *Powhattan* was headed into a storm. By noon, the barometer had dropped five one hundredths of an inch since six o'clock that morning. The ship was passing across the western boundary of the Gulf Stream into the colder temperatures of the Labrador Current.

At around 2:30 p.m., Johannes noticed that the wind had picked up and was now crossing the ship's stern from the starboard quarter. The ship's sails began to strain ever so slightly, and the rigging groaned and creaked. Accompanying this, Johannes noticed that the waves had grown, some causing the ship to increase its up and down motion. He and his family still loitered on deck, joining several clusters of other passengers but clasping their arms to ward off the chill whenever they didn't need to hold on to the ship to steady themselves. They spoke about the few remaining days of their voyage.

From the quarterdeck, Rogers bellowed, "All hands to sail stations. Furl the topgallants. Furl the outer jib. On the mizzen, take a single reef on the spanker."

The crew obeyed the orders immediately, leaping to their tasks without a moment's hesitation.

"Hans, what does all that mean?"

"Marie, it means that the captain has ordered the ship to 'shorten sail.' That will reduce the amount of sail that the wind can blow on. We'll probably slow down a little bit, but the ship will ride easier."

The ominous weather change caused them to suspect that they might be headed into worsening stormy weather. That eventuality also meant that Captain Myers would necessarily deny access to the main deck to all passengers.

About 3:00 p.m., the ship heeled suddenly as a gust of cold wind ripped across the starboard quarter. The blast caused nearly everyone on board to experience a chill that might have been more related to their fears than to the ambient temperature. By 4:00 p.m., under a darkening sky, Harvon cleared all passengers off the foc's'le and from the quarterdeck. Thirty minutes later, he secured the waist's main deck to all but necessary crew. The air temperature had fallen to the point where even the stuffy and stinky warmth of the steerage deck was welcome.

The meal eaten below decks followed the customary storm routine that the passengers had gotten used to during previous periods of stormy seas. The food placed on the large tables slid about, and everyone had to hold their plates with one hand while shoveling food into their mouths with the other. By 5:00 p.m., the ship had taken on an abrupt pitching movement as it continued to run before the increasing wind.

By 6:00 p.m., the air temperature dropped beyond rawness and reached the point of bone-chilling coldness. In the ship's log, Harvon recorded that the wind velocity had already reached the "fresh breeze" category, and the waves had reached heights of eight to ten feet. Within an hour, heavy rain in squalls closed down visibility to a ship's length. Myers had expected that the storm would gradually cross the ship's track line from southwest to northeast. But instead of the wind backing in its direction, as it should on a vessel in this location east of the storm center, the ever-intensifying wind was veering. Also, the barometer continued to fall. He could only presume that the storm center was steering from the northeast to the southwest. The heightening seas buffeting the ship's stern caused the *Powhattan* to rise and plummet in the troughs between the waves, making any upright movement across the ship's decks tenuous at best.

The passengers attempted to gather themselves in their berths and to hold on as best they could, using their legs and elbows to keep their bodies from sliding about. At about midnight, Johannes heard some commotion coming from the hatch entrance to the lower hold. Aroused, he carefully moved

out of his berth where Marie cuddled next to him and, imitating the wide stance of the sailors, swaggered, knees bent, toward the source of the noise. He discovered Captain Myers's and Mr. Rogers's heads emerging on the steerage deck as they climbed up the ladder from the compartment below.

"I just don't like it, Captain. The seams are progressively leaking, and even with the pumps being worked every half hour, the water level is continuing to rise."

"I hear you, Mr. Mate, but this old ship has seen a lot worse than this."

"That may be, but I swear that I heard a sharp cracking sound when that heavy gust hit us about twenty minutes ago."

"Probably nothing, but let's assign some crew to man the pumps continuously even if they don't have to pump steadily. And keep me advised."

"Aye-aye, sir."

Aft in the cabin, Captain Myers and his mates discussed the weather situation. If the wind continued to intensify, which it likely would, Myers would have to change the ship's heading. Their first option was to continue toward New York on their westerly course with the expectation that the nor'easter would not linger and that they might cross behind the storm's path while it was hitting New England. But the crew also discussed the possibility that the storm had retrograded, meaning it had developed a track opposite to its customary path. In any event, Captain Myers would need to again shorten sail. He did, which slowed the ship's speed and reduced the pitching. Heightening seas coming from astern produced a distinct yawing effect as the distances between wave crests reduced the previous quickened slamming of the ship into the wave troughs. Below on the steerage deck, the passengers were able to hear the sailors on the main deck rush about hauling and releasing the running rigging necessary to furl the sails. In a short while, the ship had furled its topgallants and courses as well as its flying and outer jibs.

Near midnight, the wind velocity reached the "strong breeze," defined as Beaufort Force 6. With increasing wind, the ship's speed had increased to a good eight knots. But under reduced sail and running before the wind, the old *Powhattan* rode somewhat more comfortably, with only moderate pitching. As the wind backed more to the north and the seas heightened, the yawing actually decreased, but the ship continued to pitch and roll. The wave heights now approached twelve to fifteen feet.

Down below on the steerage deck, the passengers, for the most part, had settled down. If they had any fears, Captain Myers didn't know about them. Any English-speaking cabin passengers who overheard the hushed

conversations between Myers and the mates and the instructions given to the sailors would have learned that the ship was encountering worsening conditions at the same time as the leakage was requiring increased efforts to dewater the ship.

At about sunrise on Saturday, the fifteenth, Captain Myers wearily climbed the ladder next to his cabin up to the quarterdeck. Harvon reported to the captain that the pump teams had been operating the pumps without let up. Captain Myers replied that the amounts of seawater leaking on board during the present blow were not unusual for the old *Powhattan*.

The daytime sky above had taken on the color of tarnished pewter. Occasional low-flying scud clouds seemed to scratch their gray bottoms on the mast tops as the wind blew them from the northeast to the southwest. While no precipitation dampened Myers's clothing, sea spray had wet down the quarterdeck. The helmsman had taken the precaution of securing himself to the deck with a line tied around his waist so he wouldn't be thrown from his station.

As Saturday morning progressed, Myers scowled at the weather. The top sails and courses billowed, and the standing rigging creaked and groaned in an increasingly loud cacophony, straining under the wind. The wind began showing signs of reaching moderate gale force. The ship heeled to port as it surged before the wind-driven sea that was overtaking it from astern. Wave tops had begun to tower above the ship's square transom, sometimes over the helmsman's head.

Below deck, the steerage passengers attempted to find comfortable positions in their berths. A few were reliving the early days of the voyage when seasickness had reigned.

Johannes had begun to feel woozy. Marie noticed but said nothing. Their children had fallen in with some others and invented a game to see how far and fast a belaying pin might roll across the deck with each wave that lifted the ship.

Marie broke the silence. "Hans, I will certainly be happy when we get off this ship!"

"Me, too. Marie, how are the children?"

"Well, as you can very well see, they are playing with their friends."

"Let them continue. I don't want them to become afraid."

"Me either."

About midmorning, the *Powhattan* encountered rain and falling temperatures as the storm center pulled down cold arctic air from across the New England states. The seawater temperature dropped to the mid-forty-degrees-Fahrenheit range and remained there for the remainder of

the voyage. The wind velocity reached gale force, but before that happened, James Myers ordered all hands to sail stations. Three commands followed shortly thereafter.

"On the main- and mizzenmasts, furl the topsails."

"Run down the inner jib."

"Take a double reef in the spanker."

And a fourth order Myers gave in hushed tones, "Mr. Rogers, as soon as the men secure from sail stations, sound the bilges fore and aft."

"Aye-aye, sir."

By midafternoon, the ship began experiencing gale winds of Beaufort Force 7 or 8. The seas mounted even higher under the constant northeast wind. Anyone on the quarterdeck, especially the helmsman, had to keep a watchful eye astern in the event a steep wave swamped the ship. Rudder control was an absolute necessity—loss of control could cause the ship to broach and capsize.

By late afternoon, the old ship and its spars and fixed rigging had been receiving harsh punishment from the wind and seas for over twelve hours. The hull's structure flexed more in the roughening seas.

First Mate Rogers had completed his survey of the bilges. "Captain, I have to report that the hull has sprung several leaks. Mostly, it is the seams of the planking near the turn of the bilges. I've ordered these caulked as best we can from inside the hull and we have increased pumping to about twenty minutes per half hour on both pumps, but I don't think we can hold it much longer."

"Did you see any structural breaks?"

"I couldn't tell for sure, but the lower part of the frame just forward of the forward hold hatch, on the starboard side, might be fractured right in the bend."

Captain Myers's eyes widened. He muttered, "Oh, my God!"

Quietly, Myers turned to the first mate and uttered, "Mr. Rogers, please call upon the passengers for volunteers to man the pumps, but for heavens' sake, don't it do in a way that would scare the living hell out of them."

Passengers responded to the call for volunteers from among the able-bodied men. Johannes stepped forward immediately. Marie understood, but the circumstances now raised doubt in the minds of the passengers.

"Hans, please go help. Just be careful."

By nightfall, snow had begun. Even under reduced sail, the ship maintained a remarkable forward speed. Myers estimated that the ship had traveled perhaps 260 miles since his 6:00 a.m. position on the fourteenth. Over the course of the early evening, they might arrive over a shallower part

of the sea, where handheld lead line soundings would be possible. He had no real idea of his position except that he surmised by dead reckoning he was somewhere near the fortieth parallel of latitude.

At about 8:00 p.m., Captain Myers called for Harvon.

"Mr. Mate, I expect that we may be on soundings by now. What do you think about starting to heave the hand lead, say once an hour?"

"Yes, Captain, I agree. My latest dead reckoning shows us to be about due east of Squan Beach, New Jersey, and about sixty miles east of the beach. I have my charts ready, and we should begin finding the bottom in an hour or so. But it may be sooner. This damned wind has probably pushed us farther to the south and west."

"Keep me advised. Make sure you lash the leadsmen in the port chains. This will be a nasty and wet job. Relieve them as often as possible. Using the passengers at the pumps should save the sailors for better work."

At about midnight, the leadsman might have reported a sandy bottom at twenty-four fathoms, but shortly after midnight, the leadsman would report "by the deep—eighteen."

Myers then knew that he had only eighteen fathoms of water, which equated to a depth of 108 feet of water. As he and Harvon consulted the latest Coast Survey chart, they concluded that the ship was then about twenty-five miles off the New Jersey beach. But what beach? In the waxed concave portion of the hand lead, the leadsman reported black and yellow sand traces. Comparing that with the nautical chart caused them to believe the ship might be east of the Barnegat Lighthouse on Long Beach Island. Myers cautioned Harvon to alert the lookout to watch for Barnegat Lighthouse. It flashed a white light once every ten seconds.

As the night passed, the passengers from steerage who manned the pumps understood their peril. Johannes took the midnight shift at the pumps.

At Sea

16 April, 1854: Easter Sunday

Shortly after 2:00 a.m. on Easter Sunday, Marie whispered to her husband, whose gray shape staggered to the entrance to their berth, "Hans, I'm glad you're back. You look worn out. How long were you on the pump detail?"

Johannes replied in a tired voice, "We had four-man teams at each of the two pumps and two men on each team pumped for fifteen minutes straight.

Then another two men took our places. We did this for two hours, and then another eight men replaced our teams."

"Oh goodness, no wonder you look so worn out. Did you do any good?"

"A little, I think. At least the pumping removed a large amount of water. But even so, the water was higher when we changed teams than when we started."

"What will happen?"

"If the storm subsides, the pumps will start pumping out more water than comes in, and we will sail on to the Port of New York. If not…I don't want to think about what will happen."

Marie could not hide her fear, and her eyes filled with tears.

"Marie, please don't. We must be brave; if not for us, then for our little ones."

By Saturday evening, Captain Myers had come to the realization that he probably could not get the *Powhattan* to a safe port before it succumbed to the progressive leakage that was already allowing seawater through its hull. In a weakened state, the ship's old hull, spars and rigging would no longer continue to withstand the waves and the gale that threatened to rip its sails off its masts.

For the first three hours after midnight, the direction of the gale-force winds seemed to be backing toward the north–northeast. Myers asked himself if he should heave-to and alter course farther to the south. How soon would the leakage, which now required continuous hard pumping effort, totally overtake the capability of the pumps and thereby rapidly increase the influx of seawater? His mate's latest reports of water depths in the bilges were dismal; those levels were rising consistently despite the heroic pumping efforts. Myers reminded himself that, for a vessel offshore of the beaches of Long Beach Island, sailing down sea would probably place the wind across the ship's starboard quarter. Many ships opted to ride out storms in this manner and did so successfully. However, at least two circumstances weighed against this option: first, if such a maneuver would unreasonably delay the ship's arrival at the Port of New York, and second, if the vessel leaked progressively, meaning it was taking on water faster than could be pumped out, then foundering would occur before a safe resolution to the problem could be realized.

The *Powhattan* had no cargo of value. In fact, Myers wasn't even sure the old ship was still insured. Its loss would not arouse much notice among the marine insurance underwriters. The lives of the poor immigrant passengers also had no monetary value.

Captain Myers knew that as seawater added to the weight of the vessel, the hull would become increasingly ungainly and difficult to maneuver. The

advanced age of the standing rigging, combined with the heavy rolling and pounding, further added to the risk of dismasting. Should the vessel lose its masts at sea in a storm, it would face destruction.

Myers knew of the new United States federal system of life-saving stations that dotted the New Jersey and Long Island beaches. Successful rescues by local volunteers using these government facilities had received wide coverage in the New York newspapers. Myers spent little time pondering which would be worse, foundering at sea in a hull that had leaked beyond its capacity to float or taking a chance that rescue off a New Jersey beach might preserve at least a portion of the people on board. The responsibility for the lives of the persons on board never escaped James Myers's mind. Driving the *Powhattan* aground at high tide was the only decision he could make. He would do it.

At about 3:00 a.m., Myers ordered the spanker furled. The only sails remaining unfurled and set were the foretopsail and the fore topmast staysail. His reason for reducing sail to the maximum extent beyond what was necessary to maintain steerage was to slow the speed of the vessel as it approached the coastline and therefore minimize the damage it would sustain from going aground.

Myers researched his almanacs and calculated that predicted high tide would occur from about 9:00 a.m. to 9:30 a.m.. Knowing that storm tides generally exceeded the predicted tides, he would welcome any additional water depth clearance under his keel.

"Mr. Rogers, call Mr. Harvon and the cabin passengers, and the leading steerage passengers—say, the men who volunteered at the pumps—to report to my cabin as soon as they can."

A few minutes before 6:00 a.m., a dreary delegation assembled in the cabin. Captain Myers faced the group, "Thank you for coming so quickly. Our situation is desperate. The *Powhattan* will soon succumb to the seawater now flooding into its hull. If that happens before we can arrive in shallow water, the ship will sink and everyone on board will likely die."

Looks of shock appeared on every face. The mates, however, seemed to expect the news.

Myers continued, "We are off the New Jersey coast and will reach it in probably only an hour or so. Our latest soundings show only about eleven fathoms under our keel—that's sixty-six English feet or about twenty meters. The New Jersey coast has an outer bar that lies about two hundred yards off the beach and an inner bar that is about one hundred yards from the beach. I'm hoping to ride across the outer bar on high tide and make it to the inner bar by the time of high tide. With the new life-saving equipment the American

government has placed on that particular beach, we stand a good chance of getting everyone ashore safely. The shoremen who man that equipment did just that four years ago, not very far from where I believe we'll strike."

The group disbanded with Myers saying, "May God bless you and yours."

Shortly after 7:00 a.m., the lookout reported, "Surf ahead two points on the starboard bow. Distance about five hundred yards. I also see a large building near the beach."

Myers picked up his speaking megaphone and said, "All hands. Stand by to go aground. All hands aloft. Lay down to the main deck. Leadsman, come aboard. Mr. Rogers, alert the passengers to gather in their warm winter clothing and to hold tight to something solid. Abandon the pumps. I want everyone up from below decks as soon as we strike the bottom."

About a minute later, the ship's bottom grazed the top of the outer bar that lay offshore of the Mansion House on Long Beach Island, New Jersey. Just then, a large wave crested as it neared the bar and then lifted the old ship about eight feet before it passed beneath the *Powhattan*'s hull. The hull dropped with the loss of floatation afforded by the sea and slammed down on to the bar's hard sand bottom. With a sudden crash, the foremast unstepped from the keel and toppled forward to port. The heavy spar landed partly on the foc's'le, crushing the deck and breaking part of the starboard side bow planking off the hull structure. The fallen foremast dragged what seemed like miles of cordage with it, including all its standing rigging, creating an entanglement that remained attached to the hull. The successive seas floated the whole hulk past the outer bar and on into the deep swale about two ship lengths in width that separated the nearly parallel outer and inner bars. Once refloated with its starboard side toward the beach, the southerly current drifted the hulk and its debris to the south more or less parallel to the beach.

On board, bedlam ensued among the passengers emerging from the steerage deck onto the waist, which was now awash with seawater. Several sailors shouted, "Lay aloft!" to the passengers, who, despite a language barrier, understood the seamen's hand motions upward toward the shrouds and ratlines.

Waves easily rolled up the ship's port side and curled over the bulwarks. Seawater trapped on deck surged back and forth between the bulwarks, seeking release. The ship, buffeted by waves, rolled from side to side; however, as the level of seawater rose inside the ship's hull, the height of its keel above the sea bottom decreased, which further reduced the ship's freeboard, allowing even more waves to crash onto the ship's deck. The high tide, predicted at about 9:30 a.m., was affected by the storm, and it rose about four feet above the

predicted tidal range of four to five feet. This caused the higher waves to cross the barrier beach and, for awhile, this breach connected the Atlantic Ocean with Barnegat Bay.

The weight of added quantities of seawater rolling from side to side across the main deck between the bulwarks created tremendous pressure on the bulwarks, especially those that were secured to rotted vertical members. This resulted in sections of bulwark failing and opening the main deck in the waist to boarding waves. The ingress of seawater accelerated even more than before.

Young Rupert Ulrich, following his instincts, climbed the port mainmast ratlines that, at that time, seemed to be less exposed to the waves and wind. On reaching the deck, Johannes, Marie and Grete struggled to the starboard side of the hull and climbed up to the quarterdeck. There, they followed a cluster of passengers in climbing the starboard mizzenmast ratlines until they reached a space about halfway to the small platform called the mizzen top.

Johannes carefully helped Marie loop the ratlines about her arms and legs and then secured Grete to Marie using a long scarf fastened about Marie's waist. He kissed her and Grete and instructed them, "Hold on tight to each other and don't fall into the sea. Help will be coming soon from the people who live in that big house on the beach. I'll be right next to you."

Then, within an arm length of Marie and Grete, Johannes worked his own arms and legs in and about the starboard ratlines and shrouds until he felt that no wave would ever be able to wash him overboard. Mate Rogers made his way to Marie and Grete and personally checked their fastenings, making a minor adjustment. He nodded toward Johannes. Then, he smiled grimly at Marie and offered, "Everything will be all right, Frau Ulrich. Please stay exactly as you are."

Rogers scurried away, almost monkey-like on the standing rigging with which he was so familiar, to assist another group of passengers. Johannes noted that Mate Harvon was similarly engaged on the mainmast shrouds and ratlines.

On the foc's'le, Captain Myers assisted several sailors in cutting loose the reachable remnants of the foremast and its rigging.

From his position above the quarterdeck, Johannes saw Rupert waving to him from the mainmast rigging on the port side of the ship. He waved back. Rupert seemed to be as safe as possible. On shore, Johannes watched a man on the beach hustling about and giving some kind of directions to three other men. Those three started running in the direction opposite to that in which the *Powhattan* was drifting.

After drifting about one or two miles under a continuous barrage of gale winds and high seas, the hull continued to leak through its ineffective and

damaged hull planking, as well as from holes in the hull created by the floating, broken masts and spars. The ship had flooded to the point where seawater covered the steerage deck. Johannes noticed that the forward part of the ship's starboard side had seemingly snagged on to the bottom. Perhaps they had reached the inner bar that Captain Myers had declared to be his destination.

Myers continued to lead his seamen in trying to clear away the remnants of the floating debris and heavy spars that continued to drift apart from the ship's hull only to be hurled back by breaking waves. These large floating objects became battering rams, creating a tremendous crescendo of noise as the hull sustained a heavy pounding.

At about 10:00 a.m., the bow of the wreck had indeed grounded and become fastened to the seaward side of the inner bar. As the northeast wind and seas dashed the ship's starboard quarter, the ship, still partially afloat, gradually began to swing its stern clockwise, pivoting on the stranded bow. By 11:00 a.m., the ship was nearly broadside to the wind and waves. Moreover, the tide was then ebbing. About this time, Johannes watched as a set of three large waves, perhaps twelve feet high, passed over the outer bar where they crested and cascaded into white water only to reform and rise again. In succession, the waves lifted and fell, slamming the *Powhattan* onto the hard sand of the inner bar. As the third wave passed in its destined journey to the beach, Johannes felt the hull tremor and simultaneously heard a series of cracking sounds deep within the bowels of the ship.

Captain Myers and Mates Rogers and Harvon also heard the same sounds of destruction that they all expected.

Harvon was close enough to Rogers to yell, "There go the frames at the turn of the bilge! It won't be long before she settles on the bottom!"

"Yeah, but that might stabilize the hull and stop all this damned rolling!"

"Maybe. The good thing is that the tide is falling. Besides, we won't have far to sink."

As the cold penetrated the hands and feet of the souls clinging to the rigging, numbness and hypothermia set in. A few passengers, too weakened and unable to hang on, lost their grip and plummeted down from their positions aloft into the turbulent surf beneath. Their heads reappeared momentarily and then slipped below the surface where they drowned. A few who fell were able to swim for a few moments until the coldness of the seawater attacked their bodies. Their desperate motions to stay afloat, numbed by the cold, soon failed, and they, too, sunk beneath the waves and foam.

The ship pivoted to a point where the wind and seas were hitting it broad on the starboard beam. The ship, which had begun to settle on the sand on an

even keel, began to list slightly to starboard. Johannes realized that if the list continued, he would need to shift his position to the opposite inboard side of the starboard shrouds and ratlines, otherwise, he would find himself hanging upside down. He began to study his situation and plan his next move.

Shortly after 11:00 a.m., Grete looked up at her mother, tears streaming down her cheeks.

"I know, Gretchen, it's too cold, but we must do as father says. Hang on tightly."

"No, Mama, I can't. My leg hurts terribly."

Marie, sensing Grete may be suffering from a cramp, decided to try to help relieve the pain. "Where?" she asked, and Grete pointed toward the tops of her legs. To the best of her ability, Marie rubbed the child's legs with a free hand. But then the child let out a scream.

Marie tried to slide Grete around so that she could massage the cramp more easily. To do so, she felt she needed to loosen the scarf that bound them together. Using one arm and hand to secure her daughter, Marie began working the knot with the other hand. Just as she felt the knot go free, the *Powhattan* absorbed another sharp roll. Grete's young body slipped out from Marie's grasp and dropped cleanly into the ocean. Momentarily, the child's face popped out to the sea, her eyes and mouth agape. It was too much for Marie to bear. The scarf that bound Grete to Marie also held Marie in the rigging. Unable to let her helpless child suffer a frightening death alone, Marie quickly released the scarf's hold on her and deliberately dropped into the sea beside her daughter. Marie seized Grete in her arms and hugged her, and their eyes met.

Johannes turned in time to witness Marie fall feet first into tumult below. In horror, he yelled, "Marie, I'm coming!" He had entangled himself so securely that as he struggled to free himself, he briefly looked down to the place where Marie and Grete had been floating a moment before. Then, Marie's face emerged. Their eyes locked and she mouthed, "Ich liebe dich."

Johannes replied in kind, "I love you."

Mate Rogers had watched part of this scene unfold and scrambled to Johannes' side, restraining him as best he could. "Don't be a fool, man! You can do nothing for them and you have a boy to worry about. They're both now in God's hands."

Sobbing, Johannes re-entangled himself in the rigging.

At about 1:30 p.m., Grete's small body washed ashore two miles south of the wreck and was recovered. At about 2:00 p.m., searchers on the beach discovered Marie's remains a half mile farther to the south; she was taken to the same temporary collection place as Grete. The kind people of Long Beach Island and

Manahawkin donated grave clothes and buried Marie and Grete Ulrich among other *Powhattan* victims in a mass grave at the Manahawkin Baptist Church cemetery. Only God, in whose presence Marie and Grete now stood, realized their remains were arranged next to each other.

Shortly after Marie and Grete drowned, Rupert saw that they were missing. He could see the bowed head of his father still in his place in the starboard mizzen rigging. Above, the main topmast and the topgallant mast, which was affixed to the topmast, began to wobble. The shrouds and stays securing those spars in an upright position had successively started to fail. Suddenly, the two upper masts fell crashing into the waist accompanied by the clattering of blocks and tackle and the clumping of cordage.

Rupert apparently believed that his position in the port mainmast rigging was tenuous. He decided to use his agility to lower himself onto the main deck and to race to the quarterdeck and the sanctity of the mizzenmast. He would do this in between the waves that were sweeping across the main deck every ten seconds.

From the mizzen, Johannes had been watching over Rupert. Then, when Rupert inexplicitly began climbing down, Johannes reacted in horror. "No, no, Rupert. You must stay. Stay!"

But those words never reached the boy.

Rupert made it to the main deck just after the remnants of a wave disappeared over the port side. So far, his timing couldn't have been better. The boy ran leaping over wave-scattered debris and was about ten feet short of the steps leading to the quarterdeck when he stumbled and fell. Stunned, he rubbed his knees and rose slowly to his feet. It was too late. Another wave mounted the starboard side and swept toward Rupert, knocking him off his feet and carrying him through a place on the main deck where a bulwark had been a few hours before. Rupert landed in the sea to port. No one saw him alive again. His body floated upward only to be struck by a large section of a dislodged spar. The blow killed Rupert instantly, crushing his skull and mangling his left shoulder and his upper torso.

Rupert's body washed ashore at about 3:00 p.m., near a place called Peahala. His remains received the same sensitive care as had those of his mother and sister. He, too, was buried at Manahawkin, not ten feet from his mother and sister. He, too, stood in the presence of God.

Johannes Ulrich, sorrowed beyond belief, could do nothing but sob. Eyes closed, he fainted and fell into a deep sleep. Then Johannes experienced a sense of warmth and a presence he'd never felt before. A voice spoke, calling him by the Christian name with which he was baptized, "Johannes Karl

Ulrich, do not be afraid. Your wife and children have become united with your other children. They are all accepted and safe in the presence of the Lord."

The presence left him, and he awoke. His grief and fear immediately subsided and were replaced with solemn alertness. Focusing his vision toward the beach, Johannes could distinguish several persons on the sand. The tide had fallen, and the ship seemed to be resting a bit higher above the sea's surface. He noticed that the ship had pivoted more and, while not exactly parallel with the beach, had approached that position. The ship leaned over on its starboard side. Approaching seas nearly touched the extreme starboard end of the remaining main yard. The survivors like Johannes had shifted to the inboard of the shrouds. A few people still clung to the remnants of the mizzen shrouds and ratlines connected to the mizzen top. The mizzen topmast had long since gone by the board. Johannes exchanged weak pleasantries with nearby survivors, who included Chief Mate Rogers.

By midafternoon, Johannes noticed the same man who had been active on the beach wade out toward the ship. Captain Myers climbed the inclined main deck to where the port rail in the waist had once been and, using his speaking trumpet, hailed the man on the beach. Johannes estimated that about seventy meters separated them. He could not hear the words that passed between them. Captain Myers seemed very agitated as he carefully made his way back across the deck to starboard.

An hour or more passed. The wind and storm seemed to be moderating but the seas continued to blast the sand in a rolling fury. The tide turned, and the freeboard of the wreck gradually diminished as the sea level rose. At about 5:00 p.m., Johannes and the other survivors watched helplessly as a set of very high waves approached the outer bar. There, the first wave crested and broke but re-formed as it sped toward the inner bar. Again, it crested into a horrible hollow. The wave top engulfed the end of the main yard. Moments later, the wave crashed over the wreck of the *Powhattan*, submerging the hulk from bow to stern in a foaming mass of seawater.

The force of one thousand tons of water thrust down on the weakened deck and broken hull structure and totally disintegrated the *Powhattan*. The survivors shrieked in almost a single voice and became immersed in the wave. The wave tore Johannes free of his secure wrappings in the ratlines. He was driven head over heels, tumbling to the sea bottom. A piece of the hull structure smashed him in the back of his head. He felt a pang of pain and then saw only blackness as he lost consciousness.

Suddenly, the blackness turned to an intensely brilliant light. From within the light, a hand beckoned him to follow. He did, and he was unafraid.

Johannes Ulrich's body was never found.

2

THE PACKET SAILING SHIP AND THE EMIGRANT TRADE

EMIGRANT VOYAGES TO THE NEW WORLD

By the early 1800s, the United States offered nearly unlimited hope to anyone who was willing to relocate and work hard for his or her own advancement. The laws and economic conditions of the United States at that time encouraged many from Europe to immigrate to this country and start a new life as Americans. These immigrants abandoned families, hometowns and cities, friends and their European culture and traditions to travel by ship to the Americas. If these immigrants understood what risks they would potentially face on a sea voyage of over forty days and three thousand miles, they were possibly comforted by the success of thousands of previous shipboard immigrations. They also accepted the discomforts of their steerage-class accommodations with the possibility that these discomforts might be extreme.

Following the end of the War of 1812, the Port of New York had surpassed all other American East Coast ports (such as Boston, Philadelphia, Baltimore and Charleston) as the preferred destination for immigrants coming to the United States. New York also offered advantages as a destination for imported cargo and freight. The reasons for this are complex but were due mainly to the larger size and capacity of New York Harbor combined with the more favorable methods of transportation inland from New York City into the interior regions—e.g., by means of canals, roadways and (starting in the 1830s) railroads.

The Packet Sailing Ship and the Emigrant Trade

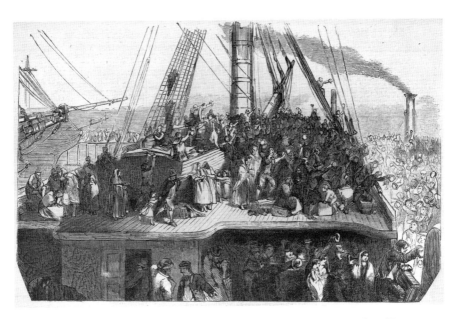

Illustration entitled *The Departure* depicting German immigrants departing from Europe, bound for the United States aboard a sailing vessel. *From* Frank Leslie's Illustrated Newspaper, *January 12, 1856.*

Immigrant arrivals steadily increased during the early 1800s. For example, between 1830 and 1860, it is estimated that as many as 2 million Irish immigrants and 1.5 million German immigrants traveled to the United States to start new lives. One challenge in accurately measuring the number of immigrants arriving in the United States in the early 1800s is that, until the federal census of 1850, the country of origin of a United States resident was not requested or recorded in official censuses. In addition, the federal government did not have a centralized process for recording immigrant arrivals and archiving their documentation. The best available estimates indicate that from 1850 to 1860, there was a total of 1,894,095 new immigrant arrivals (of which 1,775,195 were from European nations), and from 1860 to 1870, there was a total of 1,428,532 new immigrant arrivals (of which 1,133,987 were from European nations). This is despite the negative impacts of the American Civil War (1861 to 1865) on the volume of merchant ships traveling to and from the Port of New York.[1]

This increase in immigration was facilitated by the development of more reliable, less expensive and more regularly scheduled voyages between Europe and the United States, brought about by the introduction of the sailing packet ship and its trade operations.

Design, Construction and Operation of the Sailing Packet Ship[2]

The 1820s witnessed the introduction of so-called packet sailing ships in the transatlantic trade. These merchant ships derived their "packet" name from the fact that their typical cargo consisted of individual packages of freight. In today's maritime parlance, such vessels would be called "break bulk" merchant cargo ships. American and British shipping interests introduced the packet concept of operating a class of fully rigged ships on transatlantic voyages in accordance with a set voyage schedule that satisfied mercantile demands for a predictable transit time between America and Europe. With the introduction of packet ships, most overseas parcels of cargo departed and arrived according to predetermined departure and arrival dates in accordance with a published schedule.

These sail-propelled packet ships also engaged in transporting passengers from Europe to the United States and Canada. On westbound packet ships, this passenger trade consisted primarily of immigrants who were accommodated in the ship's upper cargo hold, although some minimal amount of cargo was typically stowed in the lower hold along with the passengers' baggage. On eastbound voyages, these packet ships frequently carried dry cargo from the Americas (quite often agricultural products) in both their deep holds as well as in their upper holds. The tremendous increase in the numbers of persons seeking to immigrate to North America, combined with a general shortage of sailing vessels in the passenger trade, led to a massive ship construction program of new passenger packet sailing ships in the 1850s. Older, more worn-down packet sailing ships also got pulled into the passenger trade and away from cargo-only trade.

With predictable schedules came the requirement for packet ships and their crews to abide by a sailing schedule. One result was a natural desire of successful packet shipmasters to take risks in operating the ship so as to ensure an on-time arrival at the destination port.

Packet ships had to meet robust design standards because, as fully loaded vessels, they were intended to be driven hard in service. Masts and rigging were built to withstand Atlantic gales but also to sail as fast as possible. However, packet ships were primarily cargo carriers and not luxury yachts; as such, they were designed for carrying profitably large numbers of people, westbound, and sufficiently large amounts of cargo, eastbound.

Packet ship passengers fell into two general categories: cabin-grade passengers and steerage passengers. Cabin-grade passengers paid higher fees for their passages, and their accommodations (usually located along the

NEW YORK AND LIVERPOOL PACKETS

To sail from NEW YORK on the 26th, and from LIVERPOOL on the 11th of every month, viz:

	FROM NEW YORK	FROM LIVERPOOL
Ship GARRICK	November 26....................	January 11
Capt. T. Walker	March 26..........................	May 11
	July 26.............................	September 11
Ship SHERIDAN	December 26.....................	February 11
Capt. J.W. Porter	April 26............................	January 11
	August 26.........................	October 11
Ship SIDDONS	January 26........................	March 11
Capt. L.J. Briggs	May 26..............................	July 11
	September 26....................	November 11
Ship ROSCIUS	February 26......................	April 11
Capt. D. Maloney	June 26............................	August 11
	October 26........................	December 11

These ships are of the first class, built in the city of New York, and commanded by men of experience and ability. Their accommodations are equal to any ships in the trade, and every exertion will be made to promote the comfort of passengers and convenience of shippers.

Neither the Captains or owners of these ships will be responsible for any letters, parcels, or packages, unless regular bills of lading are signed therefor.

For freight or passage apply to
JOHN COLLINS, *Agent*, 106 Wall St., New York,
Or to RICHARD S. ELY, *Agent*, Liverpool

Example of a typical period advertisement for packet ship sailings, illustrating the regular schedule of departures and arrivals. *From Basil Lubbock's* The Western Ocean Packets.

upper decks of the ship) were far more commodious and elegant than steerage accommodations. Cabin-grade passengers typically shared their food and water supplies with the ship's officers and, on occasion, had entertainment provided. The crew generally allowed cabin-grade passengers to be up on the ship's quarterdeck as long as the weather conditions were suitable.

Steerage passengers paid much lower fees compared to cabin-grade passengers. The quality of their accommodations was much lower, and their crowded and common areas on board ship were confined to the upper cargo hold (i.e., below the ship's main deck). The total space allotted to steerage passengers varied from ship to ship, but numerous crib-like berths were usually constructed along the ship's sides in a large single compartment. An entire family was expected to occupy a single crib berth, and the passengers were required to provide their own bedding and storage of personal luggage. Tables, some lanterns and some bench seating typified the remaining

accommodations. Steerage passengers ascended and descended to and from the main deck only by means of steep ladders. In good weather, steerage passengers were usually allowed access to the main deck in the ship's waist but rarely to the fo'c'sle deck. In bad weather, the main deck would be closed off, confining the steerage passengers to their below-deck area.[3]

While packet ship interior arrangements varied somewhat from ship to ship, the typical packet ship had a deckhouse called the "galley" aft of the fo'c'sle in which food was prepared. Cabin-grade passengers and ships' officers' meals were cooked and served by stewards. In contrast, steerage passengers typically had to cook for themselves using the ship's stoves, providing that the seas and weather permitted it. A shipmaster had the responsibility of providing certain minimum amounts of food and water for the steerage passengers, purchasing these bulk supplies at an open market at the port of departure. The sources and quality of the food and water supplies for the ship's crew and wealthier cabin-grade passengers was frequently better than the food and water for the steerage passengers. As a result, this difference increased the risk of food- or waterborne disease among the steerage passengers compared to the risk among the ship's crew or cabin-grade passengers.

Packets typically had a length-to-beam ratio of about four to one, making them more blunt in the bow and wider in beam than they might have been had they been designed solely for speed. By comparison, the well-known fast-sailing clipper ships had length-to-beam ratios on the order of six to one, increased in later models to seven or eight to one. Clipper ships were built for long-distance speed runs carrying high-value cargoes to and from Asia. A comparison of the two vessel types shows that the hull shape of a clipper ship was finer lined than the bulkier packet ship. Even though the faster clipper ships first appeared on the scene on the 1850s, packets continued to dominate in the transatlantic passenger trade until replaced by transatlantic steamships later in the nineteenth century.

A typical packet ship was designed to handle rugged sea conditions with a wide hull, thereby sacrificing speed but gaining some additional stability with a higher length-to-beam ratio. Also, for the most part, packet ships seemed to forego the more elaborate sailing rigs of the clipper ship, being outfitted instead with a fairly basic sailing rig arrangement.

The displacement of packet ships gradually increased over the four decades of their operation (i.e., from 1820 to 1860), from slightly less than three hundred gross tons to almost two thousand gross tons in later model packet ships. Measurement tonnage had nothing to do with a vessel's actual

THE PACKET SAILING SHIP AND THE EMIGRANT TRADE

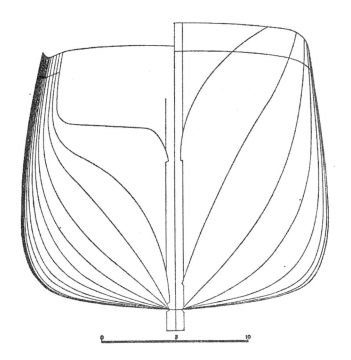

The stern/bow (left/right) hull profile of a typical sailing packet ship (in this case, the former *Guy Mannering*), showing the fullness of this ship type's hull in order to maximize the amount of cargo that could be carried on a voyage. *From Henry Hall's* Report of the Ship-Building Industry of the United States.

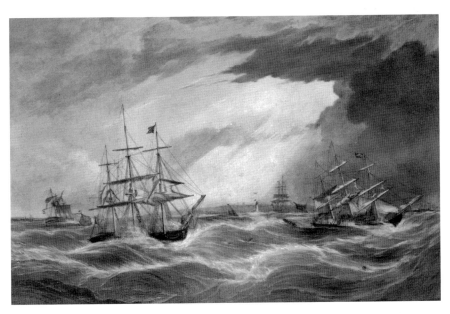

A painting depicting the loss of the sailing packet ships *Pennsylvania* and *Lockwoods* in 1839 off the coast of England. *Courtesy of the Library of Congress.*

weight or displacement but served as a means of comparing the overall sizes and carrying capacities of merchant vessels.

The hull of a packet ship was built of planks fastened over frames, made preferably of wood from live oak trees, with frames spaced transversely along a heavy oak keel. The shape of the hull above the keel initially flowed upward in a shallow *V* shape and then rounded up in a general vertical direction. Looking down on the ship, the overall appearance along most of its length was of nearly parallel sides, gradually forming a point at the bow of the ship and slightly turning in at the stern of the ship with a generally flat transom. Hull planking was fastened to the frames horizontally from the keel upward in strakes. The strake nearest the keel was the garboard strake, and the highest continuous strake at the main deck level was the sheer strake. Soft, rot-resistant cedar was a typical hull planking material.

A vertical curved structure called the "stem," attached to the forward end of the keel, created the bow's cutwater. It also provided support for the bowsprit, which stuck out from the bow on a fore and aft line. Fixed rope rigging called "stays" ran upward from the bowsprit to provide a source of vertical support for the foremast.

Within the hull, a lower deck extending across the vessel ran from the ship's stem to its stern supported by floors. This lower deck provided the cargo space on both the western and eastern packet voyages. Above this lower deck ran another interior deck sometimes called the "'tween deck." It was this deck that was fitted with cubicles for the berthing of the steerage passengers. Each cubicle was about five feet high and allowed enough space for a mattress and personal items. On the eastward voyage, this 'tween deck was used to stow cargo. Above the 'tween deck there was a main deck, which was the uppermost continuous deck and partially exposed to the elements.

Typical with the wooden ship design standards of the day was the fact that neither the steerage passenger deck nor the cargo holds were segregated by any watertight bulkheads with watertight doors (i.e., these areas were completely open), and the decks were not sealed off from one another by means of watertight hatches or doors. This arrangement, unfortunately, meant that flooding of one compartment would readily spread to other areas of the ship and could not be sealed off.

Weather decks are those decks that are exposed to the elements and form part of the uppermost watertight envelope of a vessel. At the forward end of the ship, a short deck that was raised above the main deck ran forward to the base of the bowsprit. This exposed deck was termed the forecastle or fo'c'sle, with the space under it creating a shelter leading to

the hatch where the crew's berthing space and necessary ship's stores were located. The fo'c'sle deck itself provided access to the fore rigging, the jib sails and the ship's anchor. Depending on its length, it might also have been used to stow any ship's boats.

At the after end of the main deck, another deck rose up and extended to the stern, sometimes referred to as the "poop deck." This exposed area was the location of the ship's steering wheel, which was manned by the helmsman and the officer on watch. Below this deck was an area subdivided by simple partitions into cabins for the wealthier passengers as well as the ship's officers. Hatches called companionways, which had ladders, enabled vertical access between decks. Larger hatches in the main deck allowed access to the upper hold/steerage deck and to the lower cargo hold deck below. The exposed portion of the main deck was typically referred to as the ship's "waist" and, depending on the ship's layout, might also be a location of the stowage of the ship's small boats. The waist was also typically the location of the ship's main cargo hatch.

The main deck, including the waist, typically included along the sides pin rails on which belaying pins held and secured coils of ropes that composed the ship's running rigging for the sails. This running rigging would usually be deployed over the main deck whenever the ship had to change course or its sail configurations.

Packet ships usually carried ships' boats, but the number and type was quite varied. It is important to note that, at this point in the 1800s, the primary purpose of these boats was to provide routine transportation on

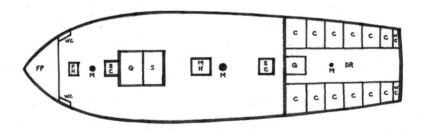

An overhead view of the main deck of a typical sailing packet ship. From left (bow) to right (stern), the letters represent the following: FP=forepeak, WC=water closet/head, FH=forward hatch, M=mast, SC=steerage passenger deck companionway/stairway, G=galley, S=storeroom, MH=main hatch, C=passenger cabins and DR=dining room. *Redrawn from diagram in the American Colonization Society's Annual Report.*

and off the ship for the crew and officers (e.g., between the ship at anchor and other ships or to the shore) or for small items of cargo. Although, under emergency circumstances, these boats might also serve to evacuate a stricken vessel, they were not usually designed or built as true lifeboats or surfboats that could be used to transport survivors to shore through surf, especially during a storm. The ship's crew was not typically trained to operate these boats in this manner. In addition, packet ships were not equipped with life rafts, lifejackets or life preservers; this was the case despite the fact that, during the 1800s, it was not common for people (even professional seafarers) to know how to swim well or have basic in-water survival skills.

Packet ships, like clipper ships, typically had a ship type of sailing rig. This meant that they carried square sails on three masts: a foremast, mainmast and mizzenmast. The number of square sails carried on each mast could vary by individual ship and in response to the prevailing weather conditions but, in general, were as many as could be safely carried to provide the highest speed when the ship was fully loaded. Natural-fiber (e.g., manila) ropes referred to as "standing" rigging supported each mast. Each sail hung from its yard or yardarm on a mast and was supported and controlled by ropes referred to as "running" rigging. Appendix A includes a more detailed description of a typical ship-type sailing rig.

Sails needed to be set and furled by sailors working from the yardarms to which the sails were secured. At the same time, cordage related to the deployment of the sails needed to be handled by seamen working on the weather decks. When going aloft, the ship's crew ascended each individual mast using ratlines secured horizontally between fixed rigging called "shrouds" with sailors going aloft on the windward side of the ship because the ship naturally heeled to leeward, making their climb easier and safer.

The primary purpose of shrouds was to hold masts in a vertical position by fastening the top of the mast to the sides of the ship. Fixed rigging called "stays" secured the masts from the centerline of the weather decks, and stays on the foremast typically carried triangular sails. After climbing up the ratlines to the point where the shrouds fastened to the mast, a sailor would then crawl onto a platform called the "top," enabling him to step out on footropes suspended beneath the sail's yard. Successive shrouds extended from the lower top to the next mast, providing more ratlines to ascend to higher yards. On occasion, sailors would descend the mast by coming down the backstays.

Setting and furling sails involved nearly every seaman on the ship's crew. During emergencies, such as the sudden onset of wind gusts, the quickness with which sails could be doused or taken in impacted the survival of the ship because sudden gusts of higher-speed wind could not only shred sails and break running and standing rigging but also cause ships to be blown over and potentially capsized.

PACKET MASTERS AND CREW[4]

Packet ship crews considered themselves a special breed accustomed to hard hours and difficult, round-the-clock work, including their dangerous work aloft in the ship's masts and yards to change sail while underway. The shipmasters were typically a hard-driving breed of men. They usually lived well and enjoyed privileges far in excess of the range enjoyed by other ship's officers, let alone the non-officer ship's crew. Moreover, keeping the ship to its sailing and arrival schedule no matter what the conditions were was their stock in trade. To meet packet ship schedules, shipmasters needed their ships to sail at maximum speed, and increased speed meant taking risks with higher levels of fatigue among the ship's crew as well as increased risks to sailors performing their difficult work aloft in the ship's sail rigging at night. It could also increase the risk of collisions with other vessels and allisions with floating objects and icebergs. It also took its toll on the ship's structural integrity and the sail rig.

The British government had created rules that were intended to ensure that basic living conditions on passenger ships met minimal standards of safety and health. The rules included requirements for certain minimal amounts of food, drinking water and other supplies on a per-person basis. Too often, however, shipmasters found ways to circumvent these rules, and a shipmaster tended to bend any rule that might restrict the income a master and crew would receive from a voyage.

In the days before the packet ship, with its rigid sailing schedule, it was customary for merchant vessels to take in the sails to some degree at night to reduce the risk of damage while sailing, and the officers and crew could relax. If the weather turned bad, the crew would respond appropriately to further reduce sail and minimize the risk to the ship and cargo, even though this would mean a drop in the ship's speed along its voyage. The packet ship's rigid sailing schedule, however, tended to

create a transatlantic race against time to ensure on-schedule arrival and cargo delivery to the glory and financial gain of the captain and with the willing participation of its crew, even if it meant placing the ship and its cargo at risk of damage en route.

Packet Ship Owners[5]

A packet ship owner was primarily interested in achieving the maximum revenue return on his ship's passenger- or cargo-carrying voyages while investing the minimum amount in ship upkeep and repairs. This practice drove many ship owners to use their packet ship on as many voyages as possible until the ship either broke apart or was otherwise damaged to a degree that prevented further use. The practical lifespan of a clipper ship in the tea trade to and from Asia was typically estimated to be about five years. Ten to twelve years was a reasonable life expectancy for the average wooden sailing ship (with an unsheathed hull), such as many of the packet ships built for the Europe to New York immigrant passenger trade.

Ship owners, on the one hand, had to comply with the minimal demands made by governments and/or marine insurance underwriters, including the need for maintenance and repairs, while on the other hand, they needed to operate and sail their ship in as efficient a manner and at the least cost possible in order to make a profit. This dilemma influenced a ship owner's decision to take whatever risks necessary to enable packet ships to complete as many profitable voyages as possible despite the risks, provided that the marine insurance underwriters were not aware of what was happening.

Installing copper sheets or sheathing on the bottom of wooden ships improved the ship's resistance to worms and other wood-boring parasites, which could literally eat away the hull planking and frames. This sheathing, however, did nothing to prevent wood rot. Wood rot is a fungus growth that attacks and breaks down any wood that is exposed to water. Improved ventilation and the use of preservative coatings on the wood help to reduce this risk, but these techniques were not available in the 1800s. Most wood will rot, although some species of wood (such as cedar) are more resistant to rot than other species; oak, for example, is not rot-resistant. The impact of this risk is that, while a ship's exterior hull planking of cedar might appear sound, the underlying oak frames, oak keel or other critical wooden hull structures could become seriously rotted to the point of hull failure.

Marine boring organisms (such as ship worms) can also attack wooden hulls and destroy a new wood hull in a relatively short time. For example, a new United States Revenue Marine cutter assigned to the Gulf of Mexico in the 1800s was destroyed within six years of its construction due to the actions of marine wood-boring organisms. If the hull of a wood vessel is coppered, meaning that its bottom is sheathed with non-ferrous metals, its lifetime can be extended.

A packet ship's hard use in stormy seas and strong winds could also shorten the ship's lifespan even if damage from marine borers or wood rot was not a factor. While rot could weaken the hull's interior structure, and worms could eat away at the planking, continuous pounding of a ship's hull by stormy seas could loosen the fastenings that held the hull planking to the hull frames, and as the hull worked or flexed, its planking would further loosen from its supportive structure, causing leaks and allowing seawater to enter the hull. Moreover, iron hull fastenings (screws, nails or bolts) corroded when exposed to salt water (one reason that copper or other non-ferrous fasteners were usually preferred, but they cost more). Corroded iron fasteners, therefore, could also contribute to the weakening of a ship's hull and loss of its watertightness, especially during storms or in the event of the ship running aground. The risk of this type of failure was also proportionate to the age of the ship and its hull. A ship's owner might opt to have his ship refastened, re-coppered and structurally upgraded, but it cost so much that the owner might delay this repair work as long as possible.

Years of hard use at sea could also take its toll on a ship's standing rigging. While standing rigging was customarily tarred to seal and protect the rope cordage from the elements, the unexposed parts of standing rigging usually lost tensile strength over many years of service. Like hull fastenings, standing rigging required replacement on some sort of a routine schedule to ensure that it would not fail under the stress of use.

Other Risks[6]

Besides the obvious risks of hull failure, grounding and shipwreck, passenger ships also had to contend with the threat of disease outbreaks while underway on a voyage. On average, cholera outbreaks from contaminated food and/or water occurred on one out of every four packet ships voyages in the mid-1850s. Ships occasionally had to return to port after sustaining

numerous deaths, especially if among the members of the crew. Disease outbreaks prior to a ship's arrival at its destination port could lead to delays in the ship being allowed to disembark passengers, with the ship, crew and passengers being quarantined for sufficient time to allow the disease to run its course. This would result in the delay of the ship's arrival time, and the resultant loss of revenue to the ship's owner and crew.

It was also not uncommon for accidents to occur among the passengers while the ship was underway. There was always the risk of being swept overboard in bad weather or injured or killed by blows from broken ship's rigging, pieces of the hull or loose cargo. In contrast to today's cruise liners and safety precautions, a voyage on a sailing packet ship of the nineteenth century was an inherently hazardous undertaking, with the risk of injury or death to the passengers and/or crew either during the voyage or in the final approach to the destination.

3

MARITIME SAFETY

THE EARLY YEARS

SHIP DESIGN AND CONSTRUCTION[7]

Over the many centuries of shipbuilding and operation, four principles associated with the seaworthiness of any oceangoing vessel were developed. A ship must be:

- designed and constructed for the service and route intended, so that it may be expected to survive the prevailing sea and wind conditions
- maintained to proper material standards
- manned by an adequate number of qualified seamen and officers to manage, maneuver and navigate the ship
- properly equipped for its intended voyage

With respect to a ship's design and construction, several objectives are typically sought: the hull and rigging must be strong enough to survive the prevailing weather and sea conditions of the route and watertight, the vessel must be stable and not top heavy (increasing the risk of capsizing) and the vessel's means of propulsion must be reliable.

In the first half of the nineteenth century, the use of steam to propel vessels was just emerging; however, wind and sails still powered most of the vessels engaged in transoceanic trade. By the mid-1850s, ocean-sailing vessels were still being constructed of wood using traditional methods of shipbuilding. The prevailing thinking in ship design and construction

seems to have been to improve an already existing model but make it larger and faster. These designs, however, still did not yet include the below-deck watertight compartmentation that is a standard feature of modern ships. In terms of a ship's sail arrangement, if the overall number of square sails in a ship's rig could be reduced, the number of crewmen required to man them could also be reduced. Vessels in transoceanic trade that could sail before predictable winds, however, needed as many square sails as possible to make the best speed; thus, the total number of sails and the size of each sail increased.

In designing ships, as a vessel's length increased, so also must its amidships strength be increased. The importance of this additional strength is highlighted by stresses on a ship's hull from either hogging (where the middle of the ship raises well above the normal horizontal position) or sagging (where the middle of the ship droops well below the normal horizontal position) in response to ocean waves. As a vessel hangs momentarily on passing waves, it hogs, then as the bow and stern are lifted by succeeding waves, the amidships portion of the hull sags. While this continual bending is normal in small magnitudes and isn't usually very apparent, over time it loosens the hull fasteners of wooden-hulled ships.

As clipper ships made their appearance for use in transporting high value but low volume and weight cargos across vast expanses of ocean, their designers sought to decrease the ships' scantlings (hull structural supports) to make them lighter and faster. Vessels are influenced by a speed to length ratio, meaning that every standard hull (at least what are known as "displacement hulls," which constituted virtually all large ship vessels designed in the nineteenth century) has a maximum speed potential based on its length of immersed hull. By reducing the ship's breadth or beam width, the designed maximum speed can be increased, but in doing so, it might have the effect of reducing the ship's hull strength and stability.

Buoyancy and watertightness are obvious requirements for a vessel. A vessel will not float unless the vessel's out-of-water weight is less that the weight of the water it displaces. Adding weight, such as cargo, to a floating vessel increases the amount of water displaced as the vessel settles deeper into the water. The degree of vessel submergence depends, then, on the difference between the pre-loaded and post-loaded weights. If the actual weight to be added to a vessel is known, then the weight of the volume of water that will be displaced can be calculated. This allows a ship owner to know how much cargo weight can be added. When calculated on a pounds- or tons-per-inch immersion basis, this enables the ship to be safely loaded yet maintain a safe amount of freeboard (height of the hull sides above the ship's waterline) to protect the ship from storm waves sweeping over the ship's sides and flooding the deck hatches.

Watertightness incorporates more than just the outer envelope of a ship's hull and must be kept intact to keep the water out. The vessel's deck and hatch openings must also be watertight to prevent the accidental ingress of waves and water leakage. If water is taken on board by waves breaking across the deck, that water must be provided a clear means of escape off the ship and back into the sea. The vessel will otherwise incur stability problems from the added weight of any seawater entrapped atop its main deck.

There is the matter of the ship's stability, and the need to maintain it when underway at sea. This stability is assessed both lengthwise and across the beam of the ship. It is possible to calculate the stability of a vessel by determining the vessel's center of gravity and center of floatation under various load conditions and angles of inclination. Nineteenth-century shipbuilders, however, had little knowledge of or access to detailed calculations of these types. Instead, they knew from experience that wider ships were more stable and that, if a vessel was made too wide, it would become unmanageable in heavy seas. They experimented by adding a little length here and subtracting a little beam there and measuring the results in speed gain versus loss of stability, sometimes referred to as a ship's "tenderness." If the result increased the ship's speed without sacrificing stability, they were satisfied. A tender vessel rolls in a seaway very slowly and, when heeled (leaned) over beyond its stable limits, will capsize.

A proper ship maintenance program requires that a vessel undergoes periodic drydocking so that its entire hull can be inspected and so that the fastenings holding the hull planks to the internal frame structure can be examined to ensure they are intact and tight. The interior portion of the hull must also be inspected to be sure that any cracked or rotted frames or other interior structural hull members are properly repaired. Masts and standing rigging must also be inspected for wear and decomposition. Some types of maintenance were ongoing matters, including sloshing standing rigging with tar and pitch to prevent deterioration, applying oakum and pitch to keep decks watertight, painting topside areas and replacing ratlines and chafing gear.

The number of crew members had to be sufficient to provide an adequate watch rotation of deck watch officers, helmsmen, lookouts and a deck force capable of handling the routine repositioning of sails. In addition, the crew would include a cook, a boatswain (bosun), a carpenter, maybe a steward for the officers' mess and sometimes a sailmaker.

A sailing vessel's equipment included its ground tackle, which meant all its anchoring equipment (anchor, plus the anchor chains, ropes/lines and associated equipment), small boats, spare sails and spars, charts, barometers,

compass and navigational equipment. Navigation-related items such as nautical almanacs, published sailing directions, sextants and timepieces were usually the personal property of the ship's officers rather than ship's property. As such, each ship's officer was responsible for ensuring that he had reliable and up-to-date navigational instruments and publications. Hand leads for depth sounding, signal flags and flares, chip logs and other similar items fell into the category of ship's equipment. Rope and stores of pitch, oakum, paint, etc. and tools for their use were also treated as necessary ship's supplies. Finally, there would need to be a supply of safely preserved food and clean water.

TONNAGE MEASUREMENTS AND TERMS[8]

The weight of the water that a vessel displaces when it is afloat is measured in standard tons. This is referred to as "displacement tons." Displacement tons is a term typically used to describe the sizes of non-commercial military vessels, where the ship's draft varies not by the amount of cargo being carried but instead by the weight of the ammunition, fuel, stores and personnel carried by the ship.

When describing a merchant vessel, where consideration of the amount of cargo that can be carried is a factor, the cargo weight is expressed in standard tons called "dead weight tonnage" (DWT). To determine a ship's DWT, the vessel's displacement in tons at its lightest draft necessary for the vessel to float (but without including the weight of any cargo carried) must first be determined and then the displacement in tons fully loaded with cargo to the deepest draft allowed by law and safe practices is determined, with the difference between the two measurements constituting the ship's DWT.

DWT measurements are determined customarily for cargo vessels carrying liquid and/or dry bulk products. This is where the calculation of tons-per-inch immersion comes into play. A vessel's DWT can change if the ship owner desires the ship to have more freeboard; in this case, the ship's DWT value decreases. If the ship owner chooses to ignore freeboard safety restrictions and load more cargo than normal, then the DWT value increases.

Net tonnage is a vessel's gross tonnage, less the amount of ship's volume deducted for certain compartments related to machinery, crew use, etc. Gross tonnage is a good measurement of the enclosed volume of a vessel. For sailing packet ships, their tonnages, because of their generally standard length-to-beam ratio, are proportionate to the packet ship's length, with a longer packet ship generally having a greater tonnage value.

SHIP SAFETY EQUIPMENT[9]

Until the very late 1800s and early 1900s, merchant ships generally were not well outfitted with safety and rescue equipment. For example, lifeboats, life rafts, life preservers, life jackets, emergency lighting, portable pumps and firefighting equipment were not typically carried by merchant vessels and were not required by any maritime laws or regulations. A typical ship of that time might have had one or two hand-driven pumps used to bail water leaking into the below-deck areas or holds and perhaps a few fire buckets and axes but was otherwise not equipped to deal with major flooding of the hull or outbreaks of fire. While most ships carried some small boats for use when the ship was at anchor, these boats were not designed or equipped as true lifeboats and were not available in numbers sufficient to accommodate the entire compliment of a ship's crew and passengers.

Tragically, it was not until after several horrific ship fires, floodings and wrecks occurred that national governments finally enacted laws mandating that larger commercial vessels be equipped with a basic outfit of safety and rescue equipment. Until that time, oceangoing ships were, in many ways, deathtraps for the crew and passengers in the event of a major fire, flooding or grounding.

MARINE INSURANCE INDUSTRY AND MARITIME INSPECTIONS[10]

From as long ago as 1688, starting in Edward Lloyd's coffeehouse in London, England (the birthplace of the famous insurance firm Lloyd's of London), there has been a recognized need for insurance coverage of ships and cargo against damage or loss from the hazards of a sea voyage. This started out as a simple process of obtaining, by means of a contract and up-front payment of a fee, the insurance coverage for a particular ship, a particular cargo load or a particular voyage. It did not involve, however, any oversight by the firm providing the insurance coverage of the ship or its operations.

Over time, the firms providing marine insurance realized that closer scrutiny of the ships, their owners and their crews and operating practices was warranted in order to deter fraudulent insurance claims for payment. The representative of the marine insurance firm given the role of investigator was the underwriter, who was supposed to determine the seaworthiness of the ships, the value of the cargo and the riskiness of the voyage in order to

calculate the fee required to provide the coverage requested by the ship's owner. In this way, the first form of maritime safety inspection was developed. Inspections by an insurance firm, however, did not have the authority and enforceability of an inspection by a governmental agency.

To avoid the scrutiny of a marine insurance underwriter's inspection, some ship owners chose to forgo any insurance coverage at all for a ship, its cargo or voyage, with all of the attendant risks of financial loss if there was damage to or destruction of the ship or cargo. Other owners might try to deceive the underwriter by doing barely enough with a ship to make it appear to be seaworthy. Other owners might try to underwrite the cost of insurance coverage themselves, even if it meant the risk of bankruptcy in the event of ship and/or cargo loss.

To the credit of the marine insurance industry, however, it was the pressures that it put on national governments that brought about reforms in maritime law, the implementation of regulations and processes intended to improve the safety of ships, the proper protection of a ship's cargo and the manner in which ships were operated at sea in the nineteenth and twentieth centuries.

Disastrous shipwrecks involving American river steamboats formed the impetus for the Steamboat Act of 1852. As early as 1838, the federal government had been concerned by deaths resulting from explosions of steamboat propulsion boilers. Although the steamboat industry objected to federal involvement, public outcry for preventive measures and regulations overcame industry objections, and in 1838, the United States enacted its first steamboat accident prevention law. These regulations only applied to river steamboats because boilers of that time were still using wood for fuel, which woud have required an impractically large amount of fuel for ocean voyages. It was not until boiler fuel was changed to coal, allowing longer voyages, that ocean steamships fell under these regulations.[11]

Although the 1838 steamboat laws were a start, steamboat disasters continued to occur. The 1852 law established a comprehensive prevention scheme of engineering construction standards for boilers and safety valves, lifesaving and firefighting equipment, periodic government inspections, accident investigations, the creation of an agency within the Treasury Department to oversee the program and inspections and the licensure of both steamboat engineers and captains. In addition, inspected steamboats were required to carry one floatation device for every person on the vessel, including passengers and crew members. Cork-filled life jackets had been developed in England in 1851 by Captain John Ross Ward of the Royal National Lifeboat Institution but were generally not in use in the United

States until about 1861. Float boards made of balsa or other lightweight woods were used instead. These were manufactured with handholds that enabled a person in the water to grab hold of the floatation device.

The steamboat inspection initiative resulted in the creation of a new agency in the Treasury Department, known at the Steamboat Inspection Service. It later became one of two cornerstone agencies of the Department of Commerce when that cabinet-level department was formed in 1903, and in 1942, it became a part of the United States Coast Guard. With that transfer, the Coast Guard absorbed the authority for conducting marine casualty investigations that affected all United States–flagged vessels as well as casualties involving foreign flag vessels on ocean and coastal areas subject to United States jurisdiction. This authority supplemented the investigation authority assigned to the Revenue Marine bureau by a Congressional Act on June 20, 1874. That legislation required merchant vessels to submit reports of any incidents of grounding, foundering, fires, explosions, capsizing and similar accidents occurring on United States and foreign vessels within waters under United States jurisdiction. It applied to all vessels, regardless of means of propulsion. Officers of the Revenue Marine conducted investigations whenever deaths occurred to determine if any person employed by the United States government contributed to or caused the accident. Up until 1874, shipmasters were not required to report any accidents at sea unless the ship involved was a steamship and therefore subject to the 1852-issued regulations for steamships.

Unfortunately, in 1854, the concern for loss of life on American ships did not extend to sailing passenger ships, possibly because Congress didn't wish to forcibly regulate the big and politically powerful shipping firms or because the majority of persons dying in sailing packet shipwrecks were foreign nationals. The result was a lack of any requirements that sailing shipmasters be tested and licensed, that accident investigations be conducted or that life-saving equipment be carried on American sailing ships for passengers and crew. It was not until the 1880s that certain classes of American sailing vessels over seven hundred gross tons displacement became subject to vessel inspection and certification. By that time, most of the American sailing vessels that were involved in wrecks consisted of coastal schooners of typically less than seven hundred gross tons. During these years, therefore, while American steamers all carried life preservers and were crewed by licensed officers, many sailing schooners were manned by men who were ignorant of basic navigation methods and lacked any life-saving equipment.

Early Nineteenth-Century Aids to Navigation in the United States[12]

Despite their near uselessness during times of low visibility (e.g., under foggy conditions), lighthouses are important references in helping vessels transit coastal waters as well as to help identify a ship's position and its approach to port entrances. Lighthouses are typically placed near key navigational points and enable vessels to stay within the confines of channels. Lighthouses are always clearly marked and identified on navigation charts, enabling a navigator to establish the position of the ship against a fixed geographical reference point.

Lighthouse structures are typically painted in a unique and visibly differentiating manner, using different colors and markings to facilitate daytime identification. For nighttime identification, lighthouses were designed to display different light characteristics. Lights were usually white, with some having a characteristic flash and dark period, usually based on the time required for the light beam itself to rotate. Colored panels of glass were used to give the light beam a distinctive color other than white, such as green or red. At night, the observer could consult the local nautical chart or light list and, by discerning the characteristic of the light being observed, identify the light and thereby determine the ship's position.

In 1789, Congress passed one of its first laws that required the federal government to assume the responsibility for the establishment and management of lighthouses, beacons and other related aids to navigation. Part of that same legislation also provided for continuing the state-managed system of maritime pilotage then in place and mandated that the state pilotage system should continue until superseded by federal requirements. The maintenance and expansion of a national system of lighthouses and other aids to navigation required annual appropriations, which even today vary significantly from year to year based on the availability of funds.

The system of aids to navigation (i.e., lighthouses, light vessels, fixed-position landmarks and floating buoys) existing in the coastal areas and harbor entrances of the United States in the early 1800s was very limited. Prior to the development of electronic navigational beacons and equipment in the mid-1900s, all nearshore navigation had to be performed with the use of visual aids ashore or in the water. Although a federal lighthouse service (the so-called United States Lighthouse Establishment) had been created early on as part of the Treasury Department, the administration and management of the system up until the 1850s was very deficient and poorly funded, and the resultant overall quality of American aids to navigation was considered poor at best by most professional navigators and mariners.

Although the first installation in the United States of the powerful French-designed Fresnel glass-prism type of lighthouse lens (which significantly concentrates a light beam's intensity and, therefore, extends the visible range of the beam) occurred in 1841 at the Navesink Lighthouse on the Atlantic Highlands of New Jersey (south of the New York Harbor entrance), it was not until the late 1850s that a regular program of Fresnel lens installation was undertaken for all major American seacoast lighthouses. For example, by 1853, only five lighthouses in the United States were equipped with Fresnel lenses. Up until then, most lighthouses used an earlier, very unsatisfactory lighting system of multiple oil lamps with simple curved mirror reflectors, which produced weak and short-ranged light signals.

It was in 1851 that the first significant reforms and improvements in the system were taken in the formation of the United States Lighthouse Board, consisting of qualified technical supervisors, engineers and naval officers given the authority and resources to properly administer and equip the system, employing the best available, state-of-the-art technology. Improvements were gradual, however, because they were dependent on the budget provided by Congress for this purpose. The Civil War also delayed improvements. It was not until the late 1800s that effective improvements were achieved nationwide.

In terms of floating markers such as buoys, until the introduction in the very late 1850s of iron-hulled buoys of standardized shapes, colors and markings, most of the floating channel markers used in American ports were a hodgepodge of hollow wooden barrels, casks or solid wooden spars that might be of any variety of shapes and/or colors and which may or may not have been placed in the proper

A typical non-standardized wooden cask or barrel buoy.
Drawn by T. Dring.

position to mark a channel or obstruction. There was no national standard of buoy shapes, colors or markings until Congress passed in September of 1850 legislation to mandate nationwide buoy standardization.

Until the Lighthouse Board began to acquire or build new vessels to serve as lighthouse and buoy tenders, there was no provision for a nationwide program of regular buoy maintenance or verification of positioning of these floating markers, with most of this work being done by private firms under contract to the federal government or local port authorities. As a result, the buoyage system in American ports was in poor material condition and very difficult to use for safe navigation as reported by many ship captains. It was not until the 1870s that buoys having an audible signal (typically a bell with clapper activated by passing waves) were introduced, and it was not until 1888 that some experimental buoys were introduced with any type of lighting apparatus.

EARLY NINETEENTH-CENTURY CHARTS, INSTRUMENTS, METHODS AND PUBLICATION OF SHIP NAVIGATION[13]

By the 1800s, shipmasters could readily purchase nautical charts for use on coastal waters over which they would be navigating. Nautical charts were, and still are, based on detailed surveys by surveyors or topographic engineers and accurately display aids to navigation (e.g., lighthouses, light vessels and buoys), basic shoreline topographical information, water depths and characteristics of the sea bottom. A compass rose is also depicted to aid in measuring the bearing to an object or to lay out a course for the ship to steer. Information about the effects of local magnetic fields (magnetic variation) on magnetic compasses is also provided. Distance scales in both statute and nautical miles are also depicted.

Until the mid-1800s, the only nautical charts available for navigation of the coastal areas and harbors of the United States were those produced by foreign agencies or surveyors during the colonial era rather than by the United States government. The primary entrance chart for the Port of New York for the first few decades of the 1800s was one originally surveyed and published by the British government in the mid-1700s, prior to the Revolutionary War. Although a coastal surveying agency was established by the United States federal government as early as 1807, it was not until the 1830s that this agency, the United States Coast Survey, was finally given the personnel, equipment and financial resources to properly survey the entire

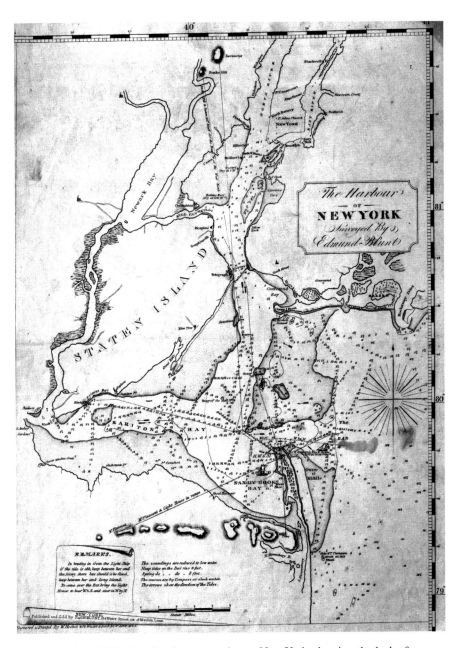

A portion of an 1827 chart for the approaches to New York, showing the lack of detail in channels and the inadequate aids to navigation. *Courtesy of National Oceanic and Atmospheric Administration.*

Following pages: First edition (1845) of the U.S. Coast Survey chart for the approaches to New York, showing the improved depiction of water depths, channels and aids to navigation. *Courtesy of National Oceanic and Atmospheric Administration.*

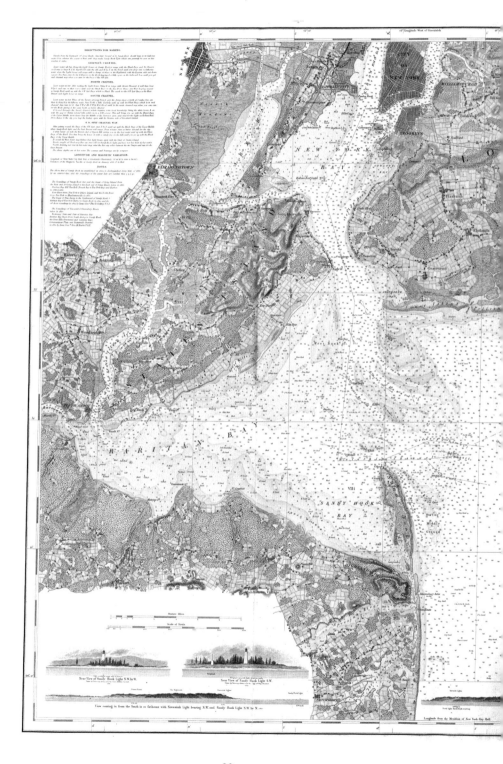

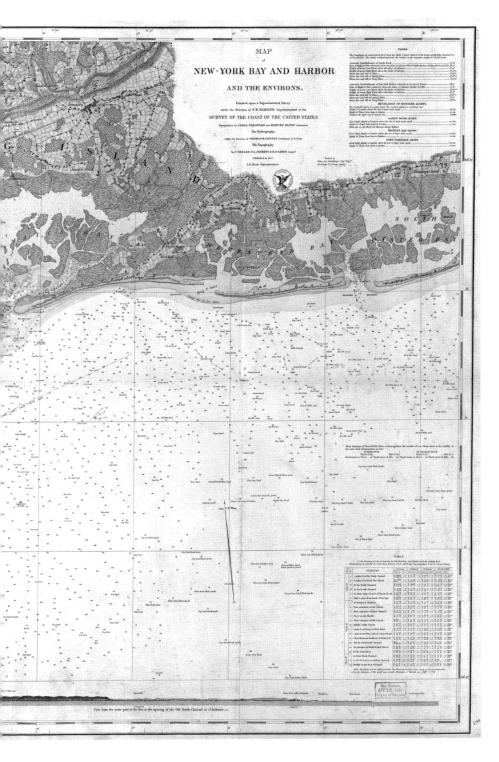

United States coastline and to produce up-to-date and detailed nautical charts for use by mariners. The agency's first chart for the approaches and channels of New York Harbor, based on such a thorough survey, was not published until 1845.

Coastal charts typically display lines connecting points with equal water depth soundings, known as "curves." For example, the five-fathom (thirty feet) depth curve defines a border on the sea bottom where on one side of the curve, the water depth is five or less fathoms and on the other side of the curve, the water depth is more than five fathoms. The five-fathom curve could also be considered the limit to which a deeper-draft ship could approach a coast without running the risk of grounding. The problem a shipmaster typically faced was relating an observed lead-line measurement of water depth to the water depths depicted on the local nautical chart as a means of estimating his vessel's location, particularly if few other cues were available to help determine the ship's position.

Along with new surveys and nautical charts, the United States Coast Survey was responsible for the publication of guidebooks for each geographic section and harbor of the United States, referred to as "sailing directions" or "coast pilot." The first such publication by the Coast Survey for the Port of New York was not issued until 1878. Until that time, the coast pilot publications for American coastal areas were issued by private contractor Edmund Blunt of Boston, Massachusetts. Coast pilot publications for the coastlines of the United States were also available from foreign sources.

Until the late nineteenth century, much of the practice of navigation, especially celestial navigation, was more an art than a well-defined science without the availability of today's formal schools, training courses or easily understandable reference texts and manuals. One important improvement in this regard resulted from the efforts of a prominent New England mathematician and ship navigator named Nathaniel Bowditch, who published, in 1802, his now-famous navigation reference book *American Practical Navigator*, in which he described in easily understandable terms the proper methods of coastwise and celestial navigation at sea, including a simplified method for determining longitude by lunar measurement (the so-called lunar distance method).[14]

For celestial observations of the sun, moon, stars and planets, an octant or sextant was used. This handheld optical instrument was used to measure the angle between the celestial body and the visible horizon, and through a series of trigonometric computations, this measurement could be used to determine a ship's latitude and, if the time of measurement was known precisely from a chronometer, a ship's longitude. For the computational steps,

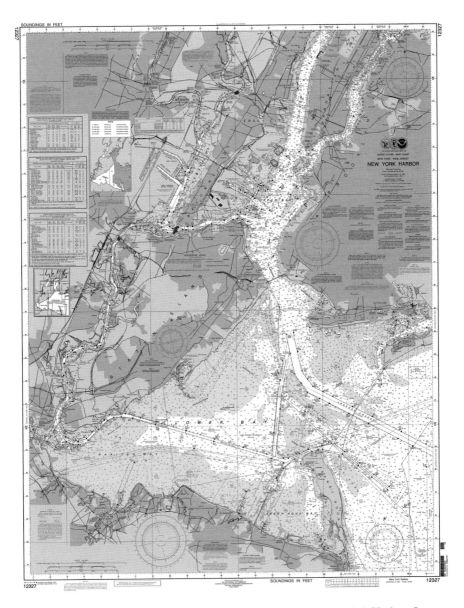

A modern U.S. National Ocean Survey chart for the entrance to New York Harbor. *Courtesy of National Oceanic and Atmospheric Administration.*

a compilation of celestial body information termed a nautical almanac was used (which also tabulated the times of sunrise and sunset for future dates), along with certain trigonometric tables. For example, a nighttime angular measurement of the altitude of the North Star, Polaris, could provide

the ship's latitude, which could also be determined by a daytime angular measurement of the sun taken at the local time for noon. Using *Nautical Almanac* data, a ship's navigator could measure lunar distances between the moon and other bodies (stars or planets), which could provide a somewhat accurate determination of a ship's longitude.

For precise measurements of longitude, however, ships needed to possess a highly accurate timepiece referred to as a "chronometer." It could provide the exact time of the celestial observation of stars. Although invented much earlier in the 1750s, chronometers, by the 1850s, were still very expensive pieces of nautical equipment, and not all sailing ships could afford to have even a single chronometer on board. Without a chronometer, a ship's navigator had to rely on much more basic and potentially less accurate methods of determining a ship's position at sea, all of which were highly dependent on the visibility of celestial bodies, coastal landmarks or floating aids to navigation near shore. As such, if visibility was poor due to stormy weather or fog, a ship's position at sea was determined more by estimation than by precise measurements.

A properly maintained magnetic compass was also critical for safe navigation, both as a means of steering and maintaining a specific course and as an instrument to observe the compass bearing of a landmark or navigational aid to determine the ship's position. If the compass was not functioning properly, either because of magnetic interference from any nearby iron-containing objects or because of poor maintenance, the compass might possibly provide erroneous readings of direction or bearing, leading to the ship either heading in the wrong direction or incorrectly determining its bearing from a critical landmark.

A chip log and a timepiece (or hourglass) were important tools for measuring the speed of the ship through the water. The chip log included a spool of rope or line knotted at specific intervals of length with a flat piece of wood tied off at the end, which acted as a drogue. The line and drogue would be tossed into the water while holding onto the spool, allowing the line to freely uncoil from the spool while someone observed the length of line (number of knots) paid out over a measured period of time. By this means, a ship's speed could be measured (hence, the velocity term of knots of speed) in nautical miles per hour.

Before the availability of weather predictions broadcast by radio, a ship's crew at sea had to determine what the prevailing weather conditions were and what changes could be expected. An instrument critical for this purpose was the barometer, used to measure changes in local atmospheric pressure. In particular, a rapid rise or fall in atmospheric pressure was usually an

indicator of changing weather, with a falling or decreasing pressure reading indicative of an approaching storm and a rising or increasing pressure reading indicative of fair weather and moderating seas.

In coastal navigation, besides the magnetic compass and the chip log, another critical navigational tool was the hand lead for measuring the water depth around the ship. When ships navigated over shallower coastal waters, they were said to be on soundings, meaning operating in ocean areas over which the depth of water could be measured by hand lead lines. Hand lead lines have been in use since biblical days. Lead lines are ropes or lines tied off to a lead weight of seven to ten pounds, with the line demarcated in fathoms (one fathom being equal to six feet). A ship's crewmember, called a "leadsman," heaves the lead line into the water alongside and just in front of the ship while holding onto its end. The technique involves heaving and paying out the lead line ahead of the vessel's path so that by the time the lead sinks to the bottom, the vessel will be nearly above the lead with the line kept as taut as possible, meaning vertical to the ocean bottom. At the same time, he observes the lead line, measuring the depth at the water's edge by observing and reading the markings on the line.

The intermediate whole fathoms of depth (i.e., those not marked on the line) are called "deeps," while depths that correspond to a particular marking were called a "mark." In reporting depth, it was therefore customary to use, for example, "by the mark five" or "by the deep six." The only fractions of a fathom usually reported are halves and quarters, the customary expressions being "and a half eight" or "less a quarter four." The famous American author Samuel Clemmons was a licensed river steamboat pilot and created his pen name "Mark Twain" from reference to the leadman's traditional callout for two fathoms or twelve feet.

The lead weight also had a concave recess that could be filled with wax to collect residue from the bottom, as a means of indicating whether the bottom consisted of mud, sand or clay. Navigation charts showed not only the depths of water but also the composition of the sea bottom in coastal waters, so a skilled navigator might gain important navigational data from such bottom information.

In order to determine the required frequency of casting the hand lead line to measure water depth, the master needed to be cognizant of the local information and conditions concerning the way a particular coastline shallowed as the distance from the ocean to the beach and its sandbars decreased. He also needed to know his vessel's speed as a means of ensuring that there would be sufficient time to safely react should the depth decrease

to dangerous levels. For example, if the ship was proceeding at eight knots on a westerly course toward the New Jersey coastline, the ship would travel two nautical miles every fifteen minutes. If local conditions were such that the bottom at the ten fathom curve began to rise or shallow more abruptly, then a wise shipmaster who had obtained soundings of twelve fathoms would immediately order the hand lead cast more frequently than when the ship was in deeper water. In that manner, there would be sufficient time at a speed of eight knots for the ship to react and either stop or change course before running aground.

If repeated soundings from a vessel revealed that the water was becoming increasingly shallow (or shoaling), the vessel's master had cause for alarm unless navigating in a channel of known depth or the master knew by navigational bearings that his vessel was moving through water of sufficient depth. Other than these exceptions, a prudent master must then consider that the ship was heading into danger; i.e., his depth clearance may decrease to zero, with the ship running aground. In these circumstances, the only options were to stop, anchor the vessel or to change the heading of the vessel to take it back out into water of sufficient depth.

PERILS OF THE PORT OF NEW YORK

New York City and its large harbor had, by the early 1800s, surpassed the early Colonial-age harbors of Boston, Philadelphia and Charleston as the primary maritime entryway to the United States. The harbor's entrance and channels were limited, however, to existing natural channels and inlets. The dredged shipping channels of today did not yet exist and would not exist until the early 1900s.[15] Until the advent of a reliable mechanical means of propulsion (e.g., steam engines coupled to paddle wheels or propellers), most commercial vessels continued to rely solely on wind power and sailing rigs for propulsion and were therefore dependent on prevailing local wind patterns and any changes in wind speed or direction when approaching and entering New York Harbor.

As clearly shown on a nautical chart of the coastal areas around New York, the approaches take the form of a funnel, with the coastline of Long Island on one side and the coastline of New Jersey on the other side. Both of these coastlines are similar in that they consist of long barrier beaches in front of large, shallow bays with inlets. They also have a series of extensive shallow sandbars running parallel to the beach at distances of anywhere from several yards up to hundreds of yards off the beach. The position of

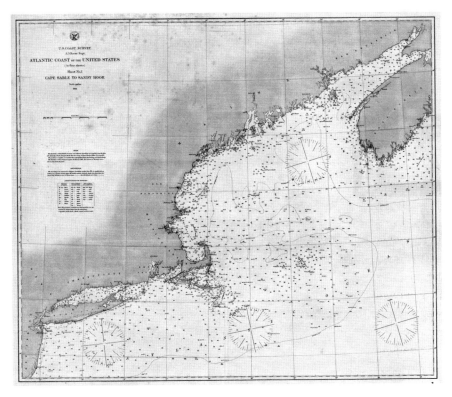

1864 U.S. Coast Survey chart of the approaches to New York Harbor (at lower left), illustrating the funnel-like area between the Long Island coastline (at top) and the New Jersey coastline (at far left, lower edge). *Courtesy of the Office of Coast Survey, NOAA.*

these sandbars is also variable, depending on local ocean currents, nearby river and stream runoff of sediment and the actions of storms.

The effect of a funnel-like approach to New York Harbor to the sailing ships of that period was that any ships that were either following an erroneous course due to poor navigation or were blown off course by storm winds risked running aground. Until well into the late 1800s, these coastline barrier beaches were essentially uninhabited, with only a few small villages of local fishermen along the coast and without any roads or bridges to facilitate travel onto or along the barrier island.

Neither of these coastlines was well marked in the early 1800s by seacoast lighthouses of sufficient visibility or by other easily discernible landmarks that could serve as a warning to approaching ships. The state of the aids to navigation system for the approaches to New York Harbor in the 1850s was poor, with significant gaps in coverage and lighthouses that were not

equipped with state-of-the-art optics and light signals. A ship approaching the New York Harbor entrance from seaward had to be fairly close to shore to be able to visually acquire the lighthouses then in service and properly identify them, particularly under poor conditions of visibility.

Around the entrance to New York Harbor were Sandy Hook Lighthouse and the Navesink Twin Lighthouses (at the Highlands just south of Sandy Hook). The Long Island shoreline was marked only by the lighthouses at Montauk Point and on Fire Island, while the New Jersey shoreline below the Navesink Twin Lighthouses was marked only by the lighthouses at Barnegat Inlet and Cape May. Of these, only the Navesink Twin Lighthouses had the state-of-the-art Fresnel lenses, while the other lighthouses were still equipped with much less effective oil lamps and reflecting mirrors. The lighthouses at Barnegat and Fire Island were also not sufficiently tall enough at that time and had been reported as being very difficult to acquire visually from sea, even in clear weather.

The final approach to New York Harbor was a risky maneuver. To make a proper approach to the then primary deep-draft channel (i.e., Sandy Hook Channel), over the shoals and into the harbor entrance, a ship was required to closely approach Sandy Hook to a point just off the beach in order to access the natural channel and then make a critical right turn to align the ship in the relatively narrow channel and avoid running aground on Sandy Hook. Even if a harbor pilot was brought aboard to guide the ship in this maneuver, any problems associated with poor weather or sea conditions while under sail could easily result in a disastrous grounding. It was not until 1914 that the now commonly used deep draft Ambrose Channel was dredged and marked with navigational aids.

The buoyage in place for the entrance channels at that time was of horrible quality, judging from the contemporary comments of experienced mariners. For example, John Maginn, then president of the New York Pilot Association, in a letter to the United States Coast Survey in response to its request for information, detailed the buoyage problems in New York Harbor to include confusing buoy coloration as well as misplacement of the channel buoys.[16]

While pilotage is today required by law, this was not the case back in the early 1800s when ship captains were not forced to take a pilot on board to guide them into a harbor. The area around New York Harbor is the location of the oldest harbor pilot organization in the United States, the Sandy Hook Pilots, which established its services starting in 1694 and continues today to provide pilots to guide ships into and out of New York Harbor. Until

1895, there were actually a number of different companies and individuals competing to offer pilotage services to inbound ships entering New York Harbor. Pilots competed to meet an inbound ship as far out to sea as possible, hailing the shipmaster to solicit interest in the employment of that pilot before competitor pilots could do the same. The meeting place for this transaction was and still is today the area off of the harbor entrance termed "pilot grounds" or the "pilot station." Today, there is a single organization of state-licensed New York Harbor entrance pilots, the Sandy Hook Pilots, which functions in this role in addition to a group of federally licensed harbor pilots.[17]

RESPONDING TO SHIPWRECKS

INTRODUCTION

Prior to the Civil War, American merchant marine vessels carried a preponderance of the American cargoes being transported by sea. American marine insurance firms and underwriters also provided the overwhelming majority of the insurance coverage for these vessels during their voyages. With the outbreak of the Civil War, however, American ship owners (most of whom had their businesses in the Union) changed the registry of their vessels from the United States to foreign countries so as to avoid attacks and seizures by Confederate warships. As a result of this change, marine insurance coverage was also changed to foreign firms and underwriters. Following the war's end, most vessel registries and insurers were not changed back by the owners to their prewar American status. The result was a reduction in the role that American marine insurance underwriters had in promoting and influencing improvements in vessel safety, passenger and cargo protection and rescue response in the event of a shipwreck.

If a vessel had the misfortune to run aground on one of the area beaches or sandbars along Long Island or New Jersey, the vessel was in imminent danger of breaking up from the continuous pounding of surf on the vessel's wooden hull, with the loss of passengers, crew and cargo unless the prevailing weather and sea conditions were benign or immediate help was available

from seaward or the shore. From the very early days of civilization, it has been customary human nature to go to the aid of people in distress, and there is a long-standing maritime tradition of a vessel and its crew going to the aid of another vessel in distress. In the case of a vessel's grounding under stormy conditions, however, the risk of death or injury to the rescuers can be as great as that to the victims unless the rescuers are well-trained, well-equipped and immediately available to attempt the rescue. The majority of the United States coastline was still overwhelmingly rural in the early 1800s and lacking in local rescue resources until the advent of an organized and properly equipped coastal rescue system later in the 1870s. Until then, the availability of rescue resources at the site of a shipwreck or vessel grounding were more a matter of chance than design.

Local legend also played a role in the fears associated with shipwreck on a remote beach. Accusations of piracy and looting by local citizens exacerbated the fears of shipwreck along the New Jersey coast. There were many stories of its coastal inhabitants behaving criminally by looting the bodies of shipwreck victims and stealing property from any doomed vessels. Moreover, print media of the time fostered tantalizing accusations alluding to the deliberate luring of vessels ashore for these criminal purposes. They even postulated that this was a common lifestyle among the residents of the New Jersey beaches.

For example, a particularly disastrous storm hit the New Jersey coast on February 15, 1846, causing a total of nine vessels to run aground along its coastline. Of the 101 persons on the nine shipwrecked vessels, a total of 48 survivors and 53 deaths were reported. Contemporary news accounts described many instances of treachery and the looting of the bodies of the dead by local citizens living in the area of the shipwrecks. In response, the New Jersey state legislature appointed a special investigative commission to examine the charges. In carrying out its investigation, the commission interviewed witnesses and took testimony. Eyewitness testimony was provided by local surfman John Maxon and others who were present at the scene of the shipwrecks and volunteered as rescuers. The rescue operations by Maxon and his volunteers involved significant risk on their part, wading into high surf to try to save victims who usually could not do much under extremely cold ocean temperatures to help themselves.

These men provided the commission with facts and details of the incident. Despite shortcomings in the resources available for shipwreck rescue, criminal acts against the cargo and survivors were not determined to be a factor. Owing to the outspoken nature of these men of the local coastal

boatman culture, they were not reluctant to make their observations and opinions known.

As a result of the investigation, the New Jersey state government judged the media reports of treachery and looting to be without basis and, instead, discovered that quite the opposite had occurred. Responding citizens had shown valor and bravery when trying to save as many victims as possible. Moreover, the circumstances of the few documented cases of looting that did occur typically indicated that the violators were surviving ship's crew members or were persons who were not local to the coastal area. Nevertheless, this negative stigma stuck in popular lore, and the New Jersey coastal areas continued to be feared as areas that harbored local looters and murderers of shipwreck victims (e.g., tales of notorious Barnegat pirates).[18]

Adding to the fear of piracy and looting was the fear that some of the ship owners and captains were either incompetent or uncaring. It is likely that there were some ship owners who knowingly used unsafe ships with rotted hulls in the transatlantic passenger trade, and there were some captains who were negligent and failed to take basic precautions at sea. Popular press accounts of that day related storied of shipwrecks when witnesses on shore watched helplessly as vessels quickly disintegrated upon impact with the beach's outer sandbar, suggesting that the ship's hull was weak to begin with and/or that the ship's captain took no measures to avoid running aground.

First Local Attempts

The Humane Society of the Commonwealth of Massachusetts[19]

Besides the coastlines of Long Island and New Jersey, another area of the American coastline that experienced the horrible effects of tragic shipwrecks with heavy loss of life was New England, specifically the shores of Massachusetts. The areas around Cape Cod and the natural channel entrances to Boston Harbor had been well known, since colonial times, to be infested with rock shoals and extensive sandbars that caused the destruction of many vessels and the deaths of many crew members and passengers. In response, a group of prominent citizens of Boston formed, in 1786, the Humane Society of the Commonwealth of Massachusetts (abbreviated henceforth as the Massachusetts Humane Society or MHS) based on a similar humanitarian organization in Great Britain called the Royal Humane Society. Among other

goals, its stated purpose was the promotion of attempts "to recover persons from apparent death, especially in cases of suffocation and drowning," as well as the "preservation of human life."

The MHS took its first significant steps toward a coastal shipwreck assistance network in 1787 with the construction of three houses of refuge located at important sites where shipwrecks were known to commonly occur but locally available resources for food and shelter were minimal or nonexistent. The houses of refuge were small huts that contained food, water and fire-building supplies sufficient to last until assistance could be obtained from the nearest town. The locations of these facilities were reported to mariners in a number of navigational publications and were also identified on coastal navigation charts. Ultimately, seventeen houses of refuge were constructed by 1806.

The next important step was the construction, in 1807, of the very first coastal rescue boathouse at Cohasset, Massachusetts, followed by the construction of others over subsequent years. By 1869, there were a total of forty-one fully equipped boathouses located along the Massachusetts coastline (plus a total of eleven houses of refuge and ten mortar stations) from the border with New Hampshire down to the border with Rhode Island. Each boathouse was equipped with at least one pulling surfboat and other rescue apparatus. Local volunteer crews that were trained in the safe

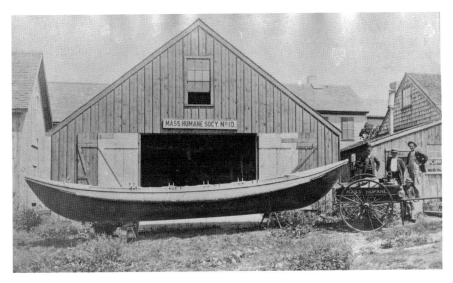

The Massachusetts Humane Society rescue boathouse located in Marblehead, Massachusetts, with pulling surfboat in front. *Photograph courtesy of Richard Boonisar.*

and proper use of the boat and equipment manned the boathouses. It is most noteworthy that the MHS continued to maintain these stations and their volunteer crews well into the United States Life-Saving Service era of the 1870s and even into the early years of the United States Coast Guard. The last operational facility finally closed down in 1918.

Although local private contributions and state-level funding financially supported the majority of the MHS's effort, some support was derived from federal sources. An 1847 amendment to the annual Lighthouse Bill authorized the expenditure of $5,000 to furnish lighthouses with the means to render assistance to shipwrecked mariners. That money was later granted to the MHS by the secretary of the treasury but only after the passage of the Newell Act on August 14, 1848. Up to that time, no federal money had ever been appropriated to either the MHS or any other organization or locale for the purpose of rescuing shipwrecked mariners from the shore.

STATE-SPONSORED WRECKMASTER SYSTEM

American marine insurance underwriters of the early nineteenth century became deeply concerned by the loss of life and cargo that resulted from shipwrecks. These businessmen had been sincerely distressed by these losses with the result that the underwriters sponsored efforts by local or state governments to reduce the loss of life and cargo from shipwrecks and to mitigate the suffering of shipwrecked people. As mentioned above, in some cases, humane societies and benevolent associations were established for those purposes (with their greatest supporters being the marine underwriters and commercial maritime interests of the ports), and in other instances, municipal and/or state governments established a system of local, officially appointed wreckmasters who were paid to respond to shipwrecks and secure any salvageable cargo or property from pilferage as well as to assist any survivors.

As far as the situation in New Jersey, on May 31, 1799, the state government enacted legislation that contained the following provision:[20]

> *Be it enacted…that no violence, wrong, or injury shall be offered to the persons or goods on board any vessel, which shall be stranded or wrecked upon the coast or territory of this state; but that such persons shall be harboured and relieved…*

Responding to Shipwrecks

That it shall be the duty of the sheriff of every county bordering on the sea, to give all possible and immediate assistance and relief to any vessel stranded or in danger of being stranded, or in distress, and to the people on board the same; to use his utmost endeavors to save such vessel and people, and to secure and preserve, for the purposes aforesaid, the cargo and goods; and to that end, the said sheriff is hereby authorized and required to employ such and so many fit persons, as he shall think requisite or proper.

The sheriffs would appoint commissioners of wrecks (or wreckmasters) assigned a geographical area of responsibility (delineated as a district with a listing number), the boundaries of which typically coincided with the contiguous beach areas within a certain county or adjacent counties. In some instances, wreckmasters were political appointees. Local politicians could appoint wreckmasters from among the ranks of well-known and seasoned surfmen, many of whom held or had held positions of responsibility as marine insurance underwriter agents themselves. The selection of wreckmasters, however, seems to have been based less on proven skills and more on local political affiliations, plus perhaps the ability to read and write. A similar system of wreckmasters and assigned districts was also established along the Long Island, New York coastline.

The wreckmasters were reliable men who understood the business of salvage and marine insurance. The wreckmasters, in turn, relied on local boatmen (mostly fishermen and so-called wreckers) to assist them in responding to a shipwreck, including the manning and operation as surfmen of a locally designated wreck boat, such as a surfboat. It is important to note that, in this context, the term "wrecker" did not mean a person who criminally caused a ship to wreck; rather, he was a person who derived honest income, paid for by marine insurers, from the recovery of as much of the ship's property and cargo as possible in the aftermath of a wreck. Sometimes, these wreckers could assist in refloating the stranded vessel. More often, they removed valuable cargo and vessel equipment and rigging to a place of safety ashore and gathered up the remnants of shipwrecks for salvage purposes. The wreckmaster took charge of and secured all cargo and goods that were landed by his crew of volunteers.

Wreckmasters bore the responsibility for assembling crews of skilled volunteer rescuers and salvors. In practice, skilled volunteers typically responded without summons once they became aware of a wreck in their respective locale. Rallying their partners, they would haul, either by

LISTING OF APPOINTED WRECKMASTERS FOR THE COASTLINE OF NEW JERSEY, 1846

DISTRICT NUMBER	WRECKMASTERS*	AREA COVERED	AVAILABILITY OF DEDICATED SURFBOAT
1	Henry Wardell and James Green	Northern Monmouth County, from Sandy Hook south to Long Branch	Yes; kept in the vicinity of Seabright, NJ
2	John Remsen and Edwin Dennis	Central Monmouth County from Long Branch south to Manasquan Inlet	Yes; kept in the vicinity just north of Deal Beach, NJ
3	Hugh Johnson	Southern Monmouth County and northern Ocean County from Manasquan Inlet south to the now-extinct Cranberry Inlet in the vicinity of Seaside Park	Yes; two surfboats, one kept just south of Manasquan Inlet and the other kept in the vicinity of Seaside Heights, NJ
4	Joseph Lawrence	Ocean County from Cranberry Inlet south to Barnegat Inlet	Yes; location unknown from available archives
5	Unknown from available archives	Barnegat Inlet south to Cape May	Yes; kept in the vicinity of Atlantic City, NJ

*Reportedly, Samuel A. Forman, John S. Forman and David Newberry were among the ranks of wreckmasters retired by the 1840s.

RESPONDING TO SHIPWRECKS

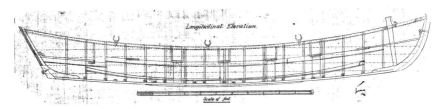

A Jersey type pulling surfboat of the type used by the U.S. Life-Saving Service in the 1870s and 1880s. The wreck boats used along the New Jersey coast were similar in size and design to the Jersey model. *Courtesy of the National Archives.*

themselves or by the use of any available horses, a surfboat to the location on the beach opposite that of the wrecked ship. Once at the scene, if the prevailing surf conditions permitted, these volunteer surfmen launched their boats and set about rescuing the people on board as well as any valuable cargo. When the seas calmed down, they then salvaged the wreck to the maximum extent possible.

A wreckmaster or one of his crewmembers typically owned large surfboats that they dedicated solely to salvage work. These surfboats were usually larger and more seaworthy than the coastal fishing skiffs then in use and were usually twenty-two to thirty feet in length and built of cedar planking fastened in an overlapping manner (the so-called clinker or lapstrake technique of boat hull construction) over oak frames. In overall shape and design, they were similar to the Sea Bright Skiff model of surfboat that is used even today by beach lifeguards (although today's boats are built of fiberglass).

The owners of these surfboats kept their boats serviceable and readily available to be deployed to the scene of a wreck, and they usually erected small storage sheds near the beach to hold the necessary salvage equipment. As it was, shipwrecks occurred frequently enough back then for the wreckers and salvors to regularly maintain their boats and equipment in good condition. These seaworthy boats served as capable platforms during post-storm salvage operations. Despite their comparatively large size, they could not usually be safely launched into storm surf in gale-force winds. Under these conditions, the wreckmaster and his volunteer crew would attempt to wade out into the surf and physically take hold of any survivors washed toward them by the high surf, often endangering their own lives.

The courts charged New Jersey wreckmasters with protecting and administering the disposition of any cargo or goods salvaged at a shipwreck as well as the disposition of human remains and their personal possessions. If a wrecked vessel had no marine insurance coverage or if the marine insurance underwriters could not be identified and contacted, the law allowed salvaged goods to be sold at auction. The proceeds from the auction were then to be

divided between groups specified in the law. The wreckmaster's salvage crew received an appropriate share to compensate them for their efforts, with the balance used to fund the public schools in the state. For insured vessels, however, the value of the salvaged cargo or goods was assigned to the marine insurance underwriter who then essentially owned the wreck. In these cases, the agents for the marine insurance underwriters contracted with the salvage crew for their services, and the wreckmasters supplied the salvors. Marine insurance, therefore, heavily influenced salvage and rescue efforts during these early years.

In order to provide some incentive for shipwreck rescue volunteers, the State of New Jersey determined that those surfmen who engaged in rescuing the lives of the shipwrecked would be awarded the first opportunity to provide contract salvage services for which they would be compensated; thus, the wreckers became contract salvors. The results of this policy created regional cadres of volunteer surfmen who willingly responded to the call of the wreckmasters. This somewhat paralleled the concept of a volunteer fire company, except that volunteer firemen are not often compensated for their efforts.

Even though a ship's hull might have been destroyed in a shipwreck and declared a total loss, remnants of its sails, rigging, spars, cordage, cargo and other portions usually could be recovered to some extent. Agents for the marine insurance underwriters worked closely with the wreckmasters to effect the recovery and salvage of such items. Together, they took control of every shipwreck, ensuring that the salvage operations were handled properly. Typically, these agents originated from the same class of people as the wreckmasters, sometimes actually being relatives of wreckmasters and wreckers alike, and were often former wreckers themselves earlier in life. Local and knowledgeable, these agents secured the trust of the wrecker-salvors, which helped to ensure that their volunteer efforts would be fairly compensated. An important motivation in all this was derived from the fact that New Jersey state law entitled the state government to a lawful portion of the value of the salvaged goods landed on its shores.

While the efforts by local wreckmasters and crews addressed to some extent the absolute need for locally available resources to respond to a shipwreck, these efforts were limited only to those areas covered by the state-organized networks of New Jersey—and to a lesser extent, New York along the Long Island coastline—and did not include the other United States coastal areas, except for Massachusetts and its local humane society. However, shipwrecks continued to occur with significant loss of life due to the lack of available rescue resources. This situation changed though, as will be described in the next chapter, with the passage of new legislation by Congress in August 1848.

THE FIRST FEDERAL EFFORTS

NEWELL ACT OF 1848

On August 5, 1848, Congressman William A. Newell of the Second Congressional District of New Jersey (which, in 1848, included the shoreline areas of Monmouth County and a stretch of beach south of Barnegat Inlet identified as "Long Beach Island"), introduced in the House of Representatives an amendment to a lighthouse appropriation bill sponsored by Congressman Joseph Grinnell of Massachusetts. The text of the amendment was as follows:[21]

> *For providing surfboats, rockets and carronades, and other necessary apparatus for the better preservation of life and property from shipwreck on the coast of New Jersey, between Sandy Hook and Little Egg Harbor, ten thousand dollars; the same to be expended under the supervision of such officers of the Revenue Marine Corps as may be detached for duty by the Secretary of the Treasury.*

The amendment further stipulated the expenditure of a total of $10,000 for the purchase of rescue equipment and the construction of unmanned boathouses where the equipment was to be stored, located at selected points along the sixty-mile stretch of New Jersey coastline

between Sandy Hook and Little Egg. The intention of the legislation was that these resources would be used by whatever volunteers were available at the scene of a shipwreck. The bill, including Newell's amendment, unanimously passed the House of Representatives on August 9, 1848, and became law a few days later as the Act of August 14, 1848.

Newell's motivation for creating this amendment was based on a tragic shipwreck that he had witnessed on Long Beach Island in New Jersey some years before, when all of the ship's crew members and passengers were killed in plain sight of the local citizens gathered on the beach, even though the wreck itself was located only a short distance offshore. As a physician, he had felt a personal sense of humanitarian responsibility to respond to such tragedies, and these feelings compelled him, once elected to Congress, to pursue the creation of some sort of a federal government–sponsored system for rescuing the victims of shipwrecks.

Dr. Newell recognized the need for shore-based rescue equipment that supplemented whatever limited resources were then available (e.g., the state system of wreckmasters). It was left to the United States Treasury Department, with the assistance of the United States Revenue Marine, to

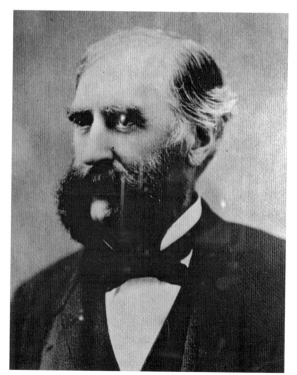

execute the provisions of the Act of August 14, 1848, within the scope envisioned by Newell and the legislation.

On August 22, 1848, Stephen Pleasanton of the United States Treasury Department's Fifth Auditor's Office (the federal office charged with the administration of lighthouses) addressed then secretary of treasury Robert J. Walker about the funds provided by Dr. Newell's amendment:[22]

Congressman William A. Newell, MD. *Courtesy of the USCG Historian's Office.*

The First Federal Efforts

*In the lighthouse law passed on the last day of the late session of Congress,
is an appropriation of a very unusual kind.*

Unusual kind indeed! Appropriating federal funds today to support a
life-saving system along the United States coastline, especially a coastline
known for its disastrous shipwrecks, would be routine. This was not the case
back in 1848. The appropriateness of the federal government getting into
the business of establishing and equipping rescue stations created some
Constitutional questions. A somewhat related precedent of the United States
Army Corps of Engineers clearing inland waterways of snags and dangerous
shoals on behalf of the general public had already been set. As another
precedent, the crew and vessels of the United States Revenue Marine had
previously been directed to rescue people from vessels in distress and to patrol
dangerous waters. Congress fortunately agreed that the establishment of
coastal shipwreck rescue facilities by the federal government was consistent
with these precedents under the general welfare proviso of public law.

Federal Construction of Rescue Boathouses

The points along the sixty-mile stretch of New Jersey coastline between
Sandy Hook and Little Egg selected for the construction of rescue equipment
boathouses were chosen on the basis that they would cover what would typically
be the southern or lee shore approaches to New York Harbor, particularly
during the well-known wintertime storms referred to as nor'easters. That
construction of these boathouses was initially limited to the coastline of New
Jersey was based on the belief that most of the tragic shipwrecks had occurred
along that shoreline compared to the shoreline of Long Island to the north,
but it was also dictated by the limits of what a mere $10,000 could cover
in terms of equipment purchases and boathouse construction. Through the
1850s, however, this initially small network of boathouses was expanded to
include the entire shoreline of both New Jersey and Long Island (a total of
fifty-four boathouses), as well as the stationing of additional Francis metallic
pulling surfboats at select points on the Great Lakes and the Gulf of Mexico
(usually without the provision for a protective boathouse).

Dr. Newell's legislation provided that the construction of the federal
rescue boathouses should be under the direction of an officer of the United

The Deadly Shipwrecks of the *Powhattan* and *New Era* on the Jersey Shore

Captain Douglas Ottinger, U.S. Revenue Marine.
Courtesy of the USCG Historian's Office.

States Revenue Marine, who would provide the appropriate technical oversight of the project. Appointed to this task on October 18, 1848, was Captain Douglas Ottinger, who was at that time one of the service's most experienced senior officers. In selecting the sites for boathouse construction, though, Captain Ottinger also called on the local expertise of the New Jersey state wreckmasters, as well as the nearby New York Committee of the Board of Underwriters, which was one of the leading sources of marine insurance for vessels and cargo and which would have had a vested interest in the establishment of the new system. Robert B. Forbes, an experienced ship captain and one of the principals of the MHS (MHS), was also consulted. Edward Watts of the United States

List of the First Eight Rescue Boathouses Established in New Jersey Pursuant to the Act of August 14, 1848

Boathouse Number	Site Name
1	Sandy Hook (Spermaceti Cove)
2	Long Branch
3	Deal
4	Wreck Pond (Spring Lake)
5	Squan Beach
6	Six Mile Beach (Chadwicks; today Island Beach)
7	Barnegat
8	Long Beach Island/Bonds

The First Federal Efforts

Treasury Department was appointed to assist Captain Ottinger in arranging the details.

With local assistance, Captain Ottinger selected the sites for the first eight stations, including the arrangement for the property leases or land deeds needed for the construction of the boathouses. The first of these original eight boathouses (Boathouse No. 1, then called "Sandy Hook," later referred to as "Spermaceti Cove") was completed in early 1849, with the other seven being completed by May 1849.[23]

Each of the original eight boathouses was about twenty-eight feet long and sixteen feet wide and occupied a block of land about one hundred square feet in size. Instead of having a conventional foundation, each boathouse rested on wooden piles sunk five feet into the ground. The white oak sills of the houses were locked to the piles with treenails. Each structure had a pine plank floor. Oak or pine posts formed the uprights of the sides of the boathouse. Interspaced between these posts were uprights with braces at the corners of the buildings. Rafters rested on a plate on top of the posts.

The boathouses were divided into two stories. Access to the loft-like upper story was gained by a ladder opening in one corner of the ceiling. Two large

Post-construction architectural plans for the first eight rescue boathouses established by the U.S. Congressional Act of August 14, 1848. *Courtesy of the National Park Service.*

windows provided light in the lower story, while two windows served the loft. Shutters protected each window. At one end of the building were barn-like twin doors for the removal of the apparatus housed inside; on the opposite end was a single door. The buildings were enclosed with cedar shingles nailed to lathing. The shingles were usually painted with two coats of white lead-based paint, with the roof being covered with tar and red ochre. All the boathouses were painted white or whitewashed at one time or another.

The boathouses were sited and aligned so that the twin main doors faced to leeward in a storm (i.e., toward the southwest), such that a nor'easter gale would not impede the deployment of the equipment out the main doors.

Selection of Rescue Equipment

In equipping these boathouses, it was critical that the items selected be simple, functional and easily useable by volunteers who might not be professional boatmen or mariners. This was particularly critical when a rescue would be attempted when the prevailing seas and surf were severe. As such, Ottinger was faced with the need to assess what methods were already available or which ones could be easily and inexpensively developed along the lines of the rockets and carronades suggested in the Congressional legislation.

The following table lists the critical rescue equipment that was purchased and stored for use for each of the completed boathouses. (Appendix B has

1849 Rescue Boathouse Critical Equipment List

Item	Number Supplied
26-foot Francis metallic (corrugated galvanized iron) pulling surfboat	1
16-foot oars	14
Surfboat wagon with iron wheels	1
Francis metallic (corrugated galvanized iron) lifecar	1
Manby mortar	1
24-pound iron mortar shot with fastening wires	10 shot
4½-inch manila hawser	1 720-foot length
2½-inch manila line	2 720-foot lengths
Flax shotline	3 900-foot lengths
Spiral wire (for mortar shot)	12 wires

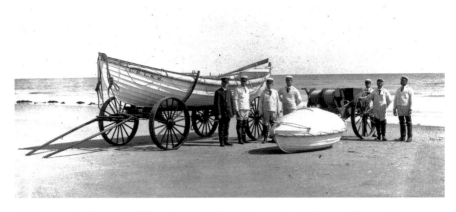

A photograph of a typical life-saving station's equipment, including a pulling surfboat on its boat wagon, the lifecar and the cart used to transport the equipment needed to rig the rescue apparatus from the beach to a shipwreck. Although this photograph was taken in the late 1890s and shows later-generation U.S. Life-Saving Service rescue equipment, it is illustrative of the types of equipment that were provided in the rescue boathouses constructed pursuant to the 1848 Newell Act. *Courtesy of Richard Boonisar.*

a complete list of boathouse equipment.) The custodial responsibilities for each boathouse, as well as the duties of a rescue response leader when using the equipment, were given to the most reliable person Ottinger could find in the area around each boathouse. While ideally this role would have been assigned to someone with expertise in performing coastal rescues (particularly in a boat launched from shore during severe weather), in some cases the individual selected turned out to be only a respectable local citizen, to whom the keys to the boathouse were given.

In selecting the boat and equipment that would be supplied to each boathouse, Ottinger consulted with various persons who were able to make appropriate recommendations. This included the aforementioned Robert Forbes of the MHS as well as a local New York City entrepreneur named Joseph Francis, who had developed a method of constructing small boats made of corrugated sheets of iron or copper metal (shaped so by means of a hydraulic press) riveted together. Using this technology, a design for a twenty-six- to twenty-seven-foot-long surfboat had been developed, in addition to a tube- or egg-shaped enclosed vessel referred to as a lifecar, into which shipwreck survivors could be placed lying down and then pulled ashore from the wreck using ropes or hawsers.

While rockets might have had the necessary range to reach out to a wreck two or three hundred yards off the beach and possessed acceleration slow enough to permit the carriage of attached lines, the trajectories of the rockets

Joseph Francis. *From William C. Bryant's* Francis' Metallic Life-Boat Company.

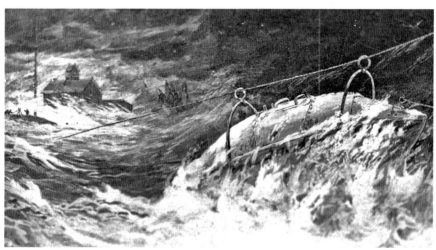

A nineteenth-century depiction of a typical shipwreck rescue during a storm using a lifecar, showing the typical means of beach-to-ship rigging. *Courtesy of the U.S. Coast Guard.*

then available were erratic and lacked the necessary accuracy. Smaller cannon (e.g., carronades or small howitzer cannon) offered accuracy but also had projectile muzzle velocities that could part the line attached to the projectile. Robert Forbes of the MHS provided great assistance in reporting to Ottinger that in Great Britain there had been successful experiments with line-throwing rockets, and that Captain Manby of the British Royal Artillery had done some experimentation with a small mortar, including its use to fire small lines out to shipwrecks. Ottinger conducted his own tests of various kinds of small artillery pieces that could be used to fire a small rope or line to the shipwreck from the shore, eventually deciding on the use of the so-called Manby mortar to shoot a modified shot or cannonball to which the line was attached.

Manby's mortar (an eprouvette mortar) offered real promise as a means of establishing a linkage between the shore and a shipwreck. If a mortar shot could carry a light line across to a wrecked ship, then stronger cordage could then be attached to the light line and, in turn, be hauled out by the crew on board the wreck. The mortar shot was a four-and-a-half-inch diameter, twenty-five-pound ball that could be aimed to fire across the rigging of a wreck. Attaching a spiral wire, like a spring, to an eye screwed into the ball, the other end of the spring was tied to a leather lanyard and then the lanyard tied off to a shotline.

A larger hawser was then sent out to the shipwreck via the shotline, from which was suspended the lifecar, along with the required heaving lines or ropes that would be used alternatively by either the shipwreck crew or the volunteers on the beach to haul the suspended lifecar back and forth between the wreck and the shore to evacuate the survivors. The number of survivors who could be brought ashore on each trip inside the lifecar varied from four to six, depending on their height and weight.[24]

If weather and sea/surf conditions permitted, the supplied Francis metallic surfboat (erroneously referred to in many previously published works as a lifeboat) could be used. Surfboats are smaller boats designed to be launched and recovered from a beach through surf waves. The specifics of its design tended to depend on the prevailing local characteristics of the beach gradient and its typical surf. Beaches having a gradual gradient usually have surf that is different in character from the surf associated with beaches having a steeper gradient. In practical terms, what this difference usually translated into was a surfboat design that was either double-ended (where the shape and form of the bow had the same pointiness as that for the boat's stern) or single-ended (where the stern is typically squared off

in shape, with a wide and sloped transom). Most surfboats used along the coastline of New Jersey in the mid to late 1800s were of the single-ended design, while those used in other areas, such as New England, were usually double-ended in design.[25]

Appendix B provides images and drawings of the Manby mortar, the lifecar, and the metallic surfboat.

Nearly all double- and single-ended surfboats of this period were built of overlapping planks of cedar over oak frames (i.e., of clinker or lapstrake hull construction), which resulted in a boat that had a lighter weight yet very rugged hull. One difficulty, however, with cedar-hulled boats is that they need to be wetted or floated frequently to prevent dry rot and to keep the wooden hull members swollen together tightly to prevent leaks between the planking. When wooden planking dries out, the wood shrinks and separates, creating leaks when the boat is launched. Storing a wooden-hulled surfboat unattended for extended periods in a boathouse without periodic use was not considered an acceptable practice.

It was this problem that led Ottinger to select as an alternative (albeit much heavier alternative) the corrugated iron–hulled surfboats manufactured by Joseph Francis. These surfboats, along with the corrugated iron lifecar, were actually built under contract to Francis by the Novelty Ironworks facility in Brooklyn, New York (the site of construction of the famous Civil War Union Navy ironclad USS *Monitor*). The first model of metallic surfboat that Joseph Francis developed and provided to Ottinger in 1849 was twenty-six feet in length and of the single-ended variety, having sides of corrugated iron and a bottom and transom of wood. In actual use, however, this design had some of the same problems with shrinkage as a surfboat built entirely of wood. Francis very quickly changed to a twenty-seven-foot-long, double-ended design, having a hull made entirely of riveted sheets of corrugated iron, with iron-sided end air cases at bow and stern (to provide added buoyancy) and with only the boat's thwarts (seats) and oars being constructed of wood.

In order to be deployed at a wreck scene, these heavy surfboats had to be hauled from the boathouse to the beach location of the shipwreck. For this purpose, a four-wheeled, two-axle boat wagon was provided (but no horses were provided by the government). Although a team of horses was used whenever available, it was more common for the volunteer crew to haul the boat on its wagon themselves to wherever the wreck was located. Due to the lack of hard surface coastal roads at that time, it was typical that the boat and wagon had to be pulled across sand dunes and along the beach to get to

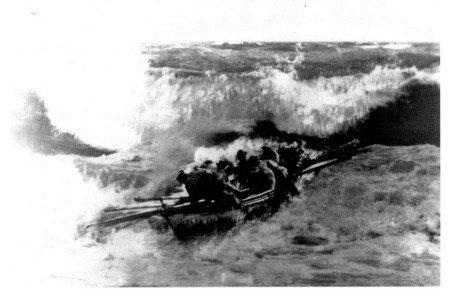

A late 1800s photograph of a typical surfboat launch through surf, taken at the later-established U.S. Life-Saving Service station located on Plum Island, Massachusetts. *Courtesy of U.S. Coast Guard.*

the wreck, typically hampered by severe wind; rain, snow or sleet; and beach washouts that might prevent travel along the beach near the edge of the sea.

Using a surfboat under storm conditions requires a well-trained crew and coxswain. The methods for launching surfboats evolved through generations of coastal fishermen who earned their livelihood from using such boats launched from an open beach. It is typically the case that the most dangerous tasks associated with surfboat use are its safe launching into and through the surf and then its return to the beach through the surf. In both instances, timing and teamwork by the coxswain and crew is critical to ensure a safe and effective launch and retrieval.

The general technique for a launch started with identifying a "hole" along the beach, near the shipwreck, where the boat could be launched. A hole is a natural channel cut through the inner bar where ocean water that had been washed over the bar by waves headed toward the beach flows back to sea. Inhabitants of the New Jersey coast call the current passing seaward through the hole a "sea puss" (in modern parlance, it's a rip current). The swift outbound current of the sea puss somewhat slows and flattens the incoming waves, while providing a surfboat with an

The Deadly Shipwrecks of the *Powhattan* and *New Era* on the Jersey Shore

A photograph showing the preparations for launching a surfboat from its boat wagon. *Courtesy of Richard Boonisar.*

A photograph showing the surfboat crew waiting for the opportune moment for launching into the surf. They are waiting for the brief period of a "slatch" when the size and frequency of surf waves was temporarily lower to allow the surfboat to safely launch and transit through beach surf. *Courtesy of Richard Boonisar.*

THE FIRST FEDERAL EFFORTS

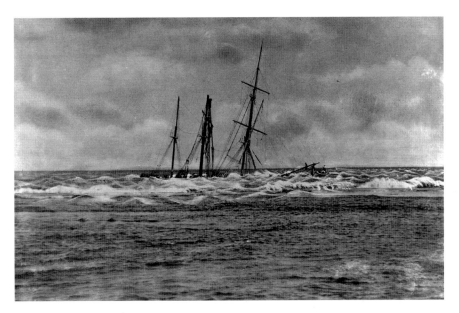

A photograph of a rescue surfboat and crew rowing through surf to go alongside a grounded sailing vessel. This particular rescue occurred off of Cape Henry, Virginia, in 1916. *Courtesy of the U.S. Coast Guard.*

added push from astern by the out-flowing current. Local fishermen and surfmen would typically keep track of the locations of such holes along their particular stretches of beach. While holes can meander in exact location over time, they are generally predictable and discernible to the trained eye.

Sea surf generally follows patterns, with sets of waves arriving on the bar and beach in a somewhat predictable sequence, with breaks in between (referred to as "slatches"). A break in the wave sequence is usually the appropriate time for the coxswain and crew to quickly launch the surfboat into the seas and row offshore as fast as possible before the next wave sequence begins and peaks. Much of the quickness of the crew in performing this depends on their ability to coordinate the pushing of the surfboat out, climbing into the boat to take up their oar to row and then rowing together to get past the most dangerous area of surf, all the while maintaining sufficient forward momentum.

Once past the breaker line, the surfboat's coxswain would choose his approach to the wrecked vessel. When approaching a vessel stranded on a sandbar, a surfboat's crew was frequently able to make use of the lee created by the wreck itself, with the safest side to approach being the leeward side. If the wreck was broadside to the beach and waves were sweeping over the

wreck, the surfboat might instead have to remove survivors from either the bow or stern of the wreck to avoid any floating debris that lay to leeward between the wreck and the beach, as well as to avoid the wash coming off the deck that might fill the surfboat.

In returning to shore, timing of the surfboat's travel through the surf in conjunction with a sequence break was absolutely critical but somewhat hindered in that the view of surf conditions from a surfboat looking shoreward was less effective than looking to seaward. The important point was for the surfboat not to be placed on the front side of a curling wave (especially with the side of the surfboat facing the wave) but rather riding the back of the wave all the way into the beach.

If all else failed, the only other means of rescue might be for the volunteer rescuers to wade out into the surf to retrieve a line from the ship or survivors in the water. They would then physically haul the immersed survivors to shore. The choice of any of these rescue methods, however, was limited by the capabilities of the available equipment and the willingness of the responding volunteers to risk their own safety to carry out the rescue attempt.

Administration System

The intention of the 1848 Congressional legislation was that the rescue equipment would be used by whatever volunteers were available at the scene of a shipwreck, with no intention of providing any sort of full-time, professional, trained personnel to staff the boathouses and to assist in a rescue response (somewhat similar in concept to the operations of the Massachusetts Humane Society's boathouses and volunteer crews). Moreover, there was no provision in the legislation for any type of upkeep or maintenance of the boathouses and equipment. As such, although these boathouses were often referred to as "stations," in actual practice they were nothing more than simple storage facilities for equipment.

For each equipped boathouse, Captain Ottinger arranged for a local citizen to have custody of the boathouse keys. In most cases, Captain Ottinger was able to present the keys to a local boatman or surfman who was usually well known by the local marine insurance underwriter agent as well as the local state wreckmaster. Captain Ottinger also provided this custodian rudimentary training in the proper use of the mortar, beach apparatus and other equipment. For each section of coastline intended to

be served by a particular boathouse, it was left to the custodian to organize and lead a crew of nearby volunteers to perform the rescue, provided that he could find volunteers who were willing and able. In addition, each custodian was expected to coordinate his role with the local agent for the marine underwriters.

As Captain Ottinger pointed out in a letter dated May 1849, keeping the equipment in good order required constant attention. To this end, the Board of Underwriters correspondence also reveals it had taken serious interest in the proper maintenance of the boathouse and equipment.

For example, on Long Beach Island one of the persons entrusted with a boathouse key understood this challenge and attempted to correspond with authorities about his needs. While there is no record of exactly what he requested, the archives do include a reply to his request. On August 1, 1851, secretary of treasury Thomas Corwin directed a letter to Samuel Perrine of Long Beach.[26]

Sir,

Your letter of the 29th ultimo with account for keeping surf-boat No. 7 is received, and in reply I have to say that as this is the first account of the kind that has been presented to the Department, you will please state by whom you were employed and on what terms.

Very respectfully,
Thos. Corwin, Secretary

Walter R. Jones, president of the New York Life Saving and Benevolent Association, sent a letter on January 21, 1853 to Captain John M. Brown at Squan Beach, New Jersey. Captain Brown enjoyed a fine reputation among coastal surfmen and represented the New York Board of Underwriters for many years. The text of Jones's letter is very simple:[27]

Sir: Please inform me what articles are short in the different boat-houses [sic] on Jersey shore, within a reasonable distance of your residence, so I can take measures to have all deficiencies supplied.

No record of Captain Brown's reply exists; however, there was no doubt in Jones's mind regarding the responsibility of his organization in trying to keep the boathouses properly supplied.

The Deadly Shipwrecks of the *Powhattan* and *New Era* on the Jersey Shore

It was in a report dated October 7, 1854, by Samuel C. Dunham, the newly appointed superintendent of the New Jersey Life-Saving District, that has found a more complete description of some of the problems that existed by that time with most of the boathouses and equipment.[28] In this report, Dunham detailed numerous instances of damaged, missing or defective equipment across all of the existing stations, along with many boathouses badly in need of basic repairs or maintenance. It was not until the establishment of the fully staffed and equipped United States Life-Saving Service in 1878 and its stations that this problem was fully rectified.

Early Successes

During the first years that these boathouses were in operation, the equipment was new and functional, with the result that this volunteer rescue system met with notable successes. While part of this was due to the newness of the system, much of it was also due to the fact that the shipwrecks in question were located near enough to the closest boathouse so that the volunteer rescuers and the equipment could be quickly and successfully deployed. Some examples of these successes include the following:[29]

- On January 12, 1850, the bark *Ayrshire* wrecked on Squan Beach during a nor'easter. The ensuing rescue efforts using the nearby government boathouse and equipment, led by John Maxon, an experienced surfman, resulted in the rescue of 201 survivors out of 202 on board, all of them rescued by means of the Francis lifecar over a period of two days. The wreck occurred within visual distance of Maxon's Sportsman's Inn, a popular hunting lodge, and the new Station (Boathouse) No. 5. While the number of local surfmen in the area was limited, Maxon was likely successful in obtaining a crew of volunteer rescuers that included his family members and some of the hunting lodge visitors.
- On December 3, 1852, the ship *Georgia* wrecked near Bonds on Long Beach Island, and locally available volunteers using the nearby government boathouse's lifecar rescued 296 survivors out of 296 on board. In this effort, the local hotelkeeper Thomas Bond obtained the assistance of hotel employees and probably some of its guests.

- On January 13, 1853, locally available volunteers using the Squan Beach government boathouse and lifecar rescued all 234 persons on board the wreck of the ship *Cornelius Grinnell*, which had run aground near Manasquan, a well-populated community.
- On October 22, 1853, volunteer rescuers using the government lifecar saved all seven hundred persons on board the ship *Western World* near Spring Lake, a few miles north of Manasquan Inlet. As in the case above, there were sufficient local citizens available and willing to help.
- On January 12, 1854, all one hundred persons on board the ship *Chauncey Jerome Jr.* were rescued at Long Branch, with seventy rescued by using the government surfboat and thirty rescued by using the government lifecar. As with Manasquan, the Long Branch area was then a well-populated community.
- On April 17, 1854, the ship *Underwriter* wrecked near Mantoloking on Squan Beach, and volunteers brought about 500 persons of the about 640 passengers on board ashore by lifecar (all of the others on board also survived). This site was about three miles north of Maxon's on the peninsula then known as "Squan Beach."

Similar successes occurred along the coast of Long Island. Local volunteer crews used the boathouses and rescue equipment that had been established there in the 1850s.

Assuming that all of the estimated numbers of people were accurate, along just the New Jersey coast, the new rescue system and equipment helped in the saving of 2,032 persons from what otherwise would have been almost certain death by drowning or exposure. But what would happen if a ship wrecked on an isolated beach, miles from a government station and during weather conditions that prohibited beach travel? On April 16, 1854, the answer to this question was tragically realized.

6

TWO PACKETS OF HOPE

INTRODUCTION

Sailing packet ships were actively engaged in the European immigrant passenger trade in the 1840s and 1850s. These European immigrants were typically of middle-class origins—tradesmen, shopkeepers, artisans, farmers, etc. As with other immigrants, some had sewed their valuables into their clothing, a standard practice to prevent theft by other passengers or sailors. By the early 1800s, New York had become the primary destination port for immigration to America.[30]

This book focuses on two particular immigrant packet sailing ships, the *Powhattan* and the *New Era*, which experienced tragic ends to their voyages, shipwrecked on the beaches of New Jersey. For these immigrants, their voyages of hope became voyages of horror. The loss of life from these two shipwrecks (altogether 532 deaths, of which 326 were from the *Powhattan* and 206 from the *New Era*) represents two of the deadliest wrecks ever to occur on the New Jersey coast.

The first disaster involved the American-registered sailing packet ship *Powhattan*, which grounded on a sandbar off Long Beach Island, New Jersey, on April 16, 1854. The exact number of people who died is not known because all the ship's records were lost when the ship disintegrated on the sandbar, and there were no survivors. The media-published accounts of

the *Powhattan* wreck went unchallenged by the federal and New Jersey state governments. No one reportedly employed rescue equipment, nor is there evidence that any person on the shore made an attempt to rescue survivors in the surf. If there was a coroner's inquest, no record of it exists.

The second disaster involved the sailing packet ship *New Era*, which ran aground on Deal Beach, New Jersey, on November 13, 1854, from which there were some survivors. Some deaths had occurred earlier in the voyage before the ship stranded (possibly as many as forty-nine persons), either the result of being swept overboard by seas or from an outbreak of cholera on board the ship. Other than these, all the other deaths occurred as a result of the wreck, and many of these deaths might have been a result of negligence on the parts of the vessel's master, its officers and its crew.

The combination of a storm at sea, gale winds, a nearly invisible beach having unmarked offshore shallow sand bars and a wooden sailing ship of questionable structural integrity are components that greatly increase the risk of a sailing ship running aground and wrecking on a sandbar or beach. Whenever a wooden-hulled sailing vessel grounded on a shoal area (especially a sandbar), a number of disastrous events usually occurred. The force of striking the shoal would cause the wooden hull planking and structure to collapse, which caused seawater to flood the ship and resulted in the loss of floatation. The force of striking the shoal would topple one or more of the vessel's masts, destroying the sailing rigging and reducing or eliminating the vessel's means of propulsion and maneuverability. A grounded ship's hull loses stability and can roll over on its side or capsize. While a grounded ship's hull is still partially floating with part of its hull touching bottom, passing storm waves lift and drop the hull onto the shoal, causing additional damage and weakening of the ship's hull structure or, ultimately, the complete destruction of the hull.

Survivors on board a stranded wreck could escape from the ship by boat or some sort of life-saving apparatus, if the ship was so equipped, or be rescued by persons ashore using rescue equipment deployed from the beach. If the survivors were forced to jump overboard or were swept overboard by storm waves, their prospects for survival dramatically decreased. They would immediately be at risk of death by drowning, hypothermia (e.g., exposure to very cold seawater, with the typical time until unconsciousness being about fifteen minutes and death within forty-five minutes) or from severe injuries if struck by debris from the shipwreck or entangled in ship's rigging that had fallen overboard. Because sailing vessels at that time were not required by law to carry lifeboats, life rafts or life preservers, there was rarely any means for wreck survivors in the water to help keep themselves afloat.

THE WRECK OF THE *POWHATTAN*

The following are the known particulars of the *Powhattan*:[31]

Vessel name: *Powhattan*

Registry and homeport: American; Baltimore, Maryland

Rig type and hull layout: Ship type (i.e., three masts, square sails on each) packet, hull of two decks, with square stern

Date/place built: February 1837; Baltimore, Maryland

Measured tonnage: 598 gross tons

Length: 132'10"

Beam: 31'7"

Depth: 15'9.5"

Vessel master: James Myers (or Meyers) of Baltimore, Maryland

Owners: William Graham, David Griffith and George Brown of Baltimore, Maryland; John A. Brown of Philadelphia, Pennsylvania; and James Brown of New York, New York

No images of the *Powhattan* are known to exist. Its appearance, however, can be estimated based on the characteristics of well-documented sailing packet ships of its size and generation. Because of its identification as a ship, it would have been a three-masted, square-rigged sailing vessel, although the particulars of its rigging and sails are not known. The specifics of its hull construction and deck layout are also unknown but can be estimated based on common features of packet ship layout. Packet ships typically had blunt bows and slab sides. The *Powhattan*, with a registered length of about 133 feet and a registered breadth of 32 feet, yields a length/breadth ratio of four to one. Therefore, it seems to have been a typical sailing packet ship of the late 1830s in design and form.

Based on the documented size of the *Powhattan*'s crew (fifteen crew members) compared with the crew sizes of other contemporary packet ships, it seems reasonable to assume that the *Powhattan* did not carry an extensive set of different sail types and probably had a fairly basic sail/mast arrangement. It probably would have carried a total of twelve sails, with eight of them being square sails (three square sails each on the foremast and mainmast and two on the mizzenmast plus the so-called spanker sail) and the remainder being triangular-shaped jib sails. Square sails as well as the spanker sail could be reefed or shortened (reduced in overall size) for sailing under severe weather conditions.

The packet ships of the nineteenth century were not fine lined, and their waterline form did not vary all that much with their form at their highest

watertight deck. Their sterns were square-shaped and their bows were blunt in shape. A ship having a blunt bow form might have a block coefficient of 0.88 to 0.90, while that for a ship having a sharp or fine-lined hull would be between 0.50 to less than 0.70. It is estimated that the *Powhattan's* block coefficient was about 0.80 to 0.90. From this rough computation, therefore, it can be reasonably stated that this ship was not fine lined.[32]

The draft of the *Powhattan* when it arrived off Long Beach Island on April 16, 1854, is unknown from the available records. With a hull depth of about 15.8 feet, a beam of 31.6 feet and a length of 132.3 feet, the *Powhattan's* measurement volume would have been 66,055.0 cubic feet, less the volume of the hull deducted for its bow and stern shapes. By applying a coefficient of 0.9 to this number of cubic feet, the vessel would therefore have measured about 595 gross tons (it actually measured about 599 gross tons). If an assumption is made that the main deck level was probably 6.0 to 7.0 feet above the waterline, by subtracting that from the vessel measurement depth, it can then be assumed that the *Powhattan* probably had a draft of between 10.0 to 12.0 feet.

The reason these estimates become useful is that they provide an approximation of how far offshore of Long Beach Island the ship would have stranded, with reference to the cartographic information at that time on water depths over both the inner and outer bars at both high and low tide, as well as the distance offshore from the beach that the sandbars were located. The distance offshore that the *Powhattan* stranded might shed some light on why this shipwreck was so catastrophic in terms of loss of life and lack of effective rescue.

The ship was placed into service by 1837. Its owners appear to have registered it with United States Customs for the purposes of foreign trade (e.g., immigrant passenger service), and it appears to have remained in that service until 1838. Afterward, though, its record of voyages is missing until 1846. While this was possibly because the ship had been enrolled in coastwise trade (a vessel licensed to engage in carrying cargo interstate from one United States port to another, which is exempt from United States Customs tariffs), it is also possible that the ship was engaged in carrying slaves from Africa to the Americas, since the seagoing transportation of slaves was prohibited by that time.

Even though American-registered vessels were prohibited by United States federal law in the early 1800s from engaging in the slave trade, until 1850, only the United Kingdom and its Royal Navy was actively enforcing the antislavery provisions on the high seas. The British were reluctant,

however, to intercept American-registered merchant ships. During the 1840s and early 1850s, a United States flagged vessel had carte blanche to trade in slaves provided it didn't try to land them in a United States port. Instead, American ship owners redirected their slave-carrying vessels to land in South America or on a Caribbean island, with the final voyage segment into southern United States ports accomplished using vessels registered with nations not having slave trade prohibitions.

Between 1846 and 1848, the *Powhattan* was apparently reregistered to carry passengers on several voyages from Europe that entered the United States ports of Baltimore, New Orleans and New York. It also entered New York in 1852 when the ship was engaged in foreign passenger trade between Le Havre and New York and once more in 1853 when it sailed between Rotterdam and New York.[33]

The April 17, 1854 edition of the *New York Times* reported that in Boston, on Saturday, April 15, about four inches of snow had fallen since 2:00 a.m., followed by a change to rain. Philadelphia was experiencing an all-day severe snowstorm.[34] The April 18 edition told how in Philadelphia, on April 17, the snow had continued all night but then turned to rain. It also reported that trains from the west had been detained because of the snow. Additionally, it reported that in Baltimore, on the seventeenth, the snowstorm continued and had been one of the severest experienced that winter. Even though the snow melted quickly, the air temperature was still very cold.

Although meteorologists could provide a modern explanation for this strange storm, which began in New England and then progressed toward the southwest, it is clear that a severe winter storm with gale-force winds was occurring from the northeast. It is likely, therefore, that the *Powhattan* encountered these conditions during its approach to the Port of New York between Friday, April 14, and Easter Sunday, April 16, 1854.

The master of a sailing ship had several options when encountering a severe storm at sea. His safest course of action was to direct his vessel to run down-sea—i.e., run with the wind and seas rather than against them—and under reduced sail. In an Atlantic Coast nor'easter, this meant heading the ship toward the southwest. For a vessel off Long Beach Island, sailing south would have had the wind coming across its port quarter and wind-driven seas likewise coming toward the ship from the port quarter. Many sailing ships would typically opt to ride out storms in this manner. Another option would be to try to alter the ship's heading to come about, bringing the ship's bow to starboard and through the wind before hauling off on a port reach to the southeast.[35]

At least two circumstances, however, weighed against these options for the *Powhattan*. First, the ship would be delayed in its arrival at New York because it would be heading away from its destination. Second, if the ship's hull was leaking faster than it could be pumped, it would eventually sink and the master might intentionally take the ship onto the beach, hoping that survivors could land safely rather than have the ship founder offshore where survivors would be at greater risk of death.

If stormy seas caused a vessel's wooden hull fastenings to loosen too much, opening its seams, the hull would leak and become flooded with seawater. As the flooding seawater added to the weight of the vessel, the ship would become increasingly ungainly and difficult to maneuver. If a sailing ship's rigging was old and weakened, heavy rolling and pounding of the ship in the storm might result in the ship being dismasted, losing its means of propulsion and maneuverability. The master of such a threatened sailing ship might, therefore, make the decision to intentionally approach the beach as a last, desperate effort to save the people on board.

A potential factor in the *Powhattan*'s wreck, the material condition of its hull, remains a mystery. Corroded structural fastenings, wood rot and marine borers shortened the life span of many nineteenth-century wooden sailing vessels. The *Powhattan* would have been a little more than seventeen years old by 1854, which categorized it as an old vessel by the standards of that time. The normal lifespan of a wooden merchant ship was typically between ten and fifteen years, depending on its history of overhauls and refittings and whether or not the vessel's hull had been sheathed with metal plates to protect against marine borers. A ten-year lifespan for a wooden ship's hull was not uncommon, although some wooden ship hulls wore out in as little as five years.

In the case of the *Powhattan*, there is no evidence regarding whether the ship had been properly maintained over its seventeen years of service. Based on contemporary standards, by 1854, it had outlived the customary lifespan of a wooden-hull packet ship. Its owners had probably paid off by that time whatever loans might have been taken for financing its construction. If this were the case, the *Powhattan* might not have been insured by that point, particularly since there are no reports of the involvement of any marine insurance underwriters or agents after its wreck.

THE DEADLY SHIPWRECKS OF THE *POWHATTAN* AND *NEW ERA* ON THE JERSEY SHORE

THE VOYAGE AND TRAGEDY

According to a passenger manifest transcribed by today's Immigrant Ship Transcribers Guild (ISTG), in September 1853, the ship *Powhatan* (of different spelling but having the same gross tonnage as the *Powhattan* and, therefore, likely the same ship) boarded 219 passengers in Rotterdam, Holland, for a forty-seven-day voyage to New York that concluded on November 28, 1853. This earlier voyage is consistent with a later report from the 1880s by a former passenger on the *Powhattan* who had arrived at New York five months before the disaster.[36]

Some evidence suggests that for its last voyage, the *Powhattan* first boarded passengers in Bremen, Germany, before arriving in Le Havre, France, its final European port of departure to start the three-thousand-mile voyage to the United States. It departed from Le Havre on about March 1, 1854, with a total number of passengers and crew between 326 and 354 persons, including 311 to 339 passengers and 15 crew members. The exact number and identities of the passengers were never confirmed. If the *Powhattan*'s previous voyage experience was any indication, it is likely that several of the passengers died en route as a result of illness before the shipwreck. Typically, persons who came aboard infected with serious disease would have died in the first week or so of the voyage.

The names of some of the *Powhattan*'s passengers were reportedly derived later through genealogical research, but the validity of this information is not known nor were the sources of this information reported. A book recovered in the wreckage contained the names of several passengers along with their dates of births. From what little is known of the passenger list, they were mostly German, with a few from Holland. When the ship finally cast off its mooring lines, the scene must have been one of joyous expectations. To these future Americans, the *Powhattan* had become their ship of hope.

The *Powhattan* sailed from Le Havre, France, on March 1, 1854, with an estimated voyage duration of forty-seven days. As a point of reference, the usual voyage transit time under sail alone from Europe to New York in 1854 was about forty-two days, based on typical sailing packet ship schedules. A voyage duration of forty-seven days suggests that the *Powhattan* was not a fast-sailing vessel.

The distance between Le Havre, France, and the Port of New York is about 3,030 nautical miles, based on two so-called great circle tracks.[37] Over a twenty-four-hour period under sail, a westbound sailing vessel using this route would likely travel 72 nautical miles per day at a speed of about three knots. A slower-sailing packet ship with all its sails set would

likely be capable of making about seven to eight knots, with winds at a steady sea breeze intensity of about nineteen to twenty-four knots (a so-called fresh breeze) from astern.

Because sailing vessels cannot sail directly into the wind, sailing ships heading into the prevailing westerly winds have to follow a zigzag-like track line, tacking alternately toward the north and then to the south so as to have an overall heading toward the west. In some wind and sea conditions, a westbound sailing ship would make no overall westerly progress, even while tacking back and forth at eight knots. At other times, with a favorable wind coming directly from astern, a sailing ship could maximize its progress and gain up to two hundred miles a day, even more if the wind was strong and full sail was used.

The specific details of the *Powhattan's* final voyage, however, are unknown because the ship's logbook, documents and papers were lost when the ship wrecked on April 16, 1854. Knowledge of the prevailing weather that existed in the ship's vicinity two or three days preceding the wreck allows for an estimation of what transpired during the last few days and hours leading up to the shipwreck. By estimating the *Powhattan's* most probable speeds of advance under southeasterly winds that backed to the east then later to the northeast and increased in intensity (from a strong breeze to a moderate gale), it is possible to backtrack for the last three days of its approach to Long Beach Island, where it grounded in the early morning hours (estimated at 6:00 a.m.). Although one account states that the ship grounded on Barnegat Shoals the night before, this is doubtful, since the prevailing weather conditions included nearly zero visibility, and the beaches at that time of the year would have been essentially deserted.

The *Powhattan* would likely have been capable of its best speed using its full suite of sails, with the wind coming from either directly astern or from across either quarter of the ship. While the ship might make good speed through the water, more important was its actual speed and distance of advance along the ship's intended route over a twenty-four-hour period (the so-called speed made good and distance made good), which would have been recorded in the ship's logbook on each day of its voyage. Under full sail, the *Powhattan's* speed would likely have been between four to ten knots, depending on the prevailing wind speed/direction and sea conditions. Under reduced storm sails, that speed would have changed to about six to eight knots, again depending on wind speed/direction and sea conditions.

April 14, 1854, was the forty-fourth day of the *Powhattan's* voyage. As mentioned above, there was a snowstorm in Boston on April 15 beginning in

the early morning, and Philadelphia had a snowstorm from the morning of the fifteenth through the night of the sixteenth, which later turned to rain on the morning of the seventeenth. Baltimore also had a snowstorm that continued on the seventeenth. This weather activity suggests a somewhat atypical nor'easter storm. Nor'easter storms usually develop off the southeastern Atlantic coast and then proceed up into New England, with gale-force winds and high seas. These wintertime and early spring cyclonic storms can travel along at various speeds but can also linger in an area. This storm seems to have stalled or, possibly, retrograded. While not a common occurrence in April, this nor'easter also included precipitation in the form of snow.

The presence of the nor'easter storm would have caused the sky at sunrise on April 14 to have been red, which would have likely caused alarm among the ship's crew (based on the old seafaring adage "red in the morning, sailors take warning"). During the period of twilight before dawn, however, the sky and horizon might have been clear enough to allow celestial navigation observations to fix the ship's position. As the morning progressed, the sky would likely have become increasingly overcast with the result that subsequent celestial observations would have been impossible, and the ship's position would have been estimated. Sunrise that day would have occurred at about 5:15 a.m. At this point in the voyage, based on the estimated location of the storm, the wind was probably blowing a gentle breeze from the southeast, with the ship making good about four to five knots in speed, and its heading being roughly northwest, easing the ship along.

An estimated position for the *Powhattan* at 6:00 a.m. on the fourteenth can be achieved by considering the most probable wind velocities and directions preceding a northeast storm at the most likely latitude position of the ship (at 39.5° latitude north) and then estimating the ship's speed and distance of advance in a due westerly direction along that parallel of latitude toward the coast for the forty-eight hours following 6:00 a.m. on the fourteenth. This position would, therefore, have placed the ship about 342 nautical miles due east of Barnegat Lighthouse on Long Beach Island, New Jersey (i.e., near 39°40' latitude north, 66°40' longitude west).

It is also likely that the *Powhattan* was still experiencing the effects of the Gulf Stream. Under these circumstances, the seawater would have been warmer in temperature (about sixty-eight to seventy degrees Fahrenheit at that time of the year) than the sea temperature outside of the Gulf Stream. These conditions would have also warmed the air somewhat.

After dawn, an increasing number of "mares' tails" clouds would have been observed, followed by an overcast sky by noontime. The mares' tails clouds

would have been replaced by "mackerel sky" clouds by late Thursday afternoon. In addition, the ship's barometer would have indicated a steady decrease in atmospheric pressure. A decrease of 0.10 inches or more in a twenty-four-hour period is usually an indicator of an approaching storm, but if the period was only three to six hours, it meant that a major storm was approaching.

By about 11:00 a.m., the sky would likely have been completely clouded over, totally obscuring the sun and preventing any further celestial navigation observations. Navigation would then depend entirely on estimations of the ship's position referred to as "dead reckoning." The ship would also have passed through the Gulf Stream's strongest currents by that time. Captain Myers would have continued to maintain a westerly course and would likely have begun checking the ship's speed at least hourly to assess progress. Based on the ship's last known position at daybreak, he probably figured that the *Powhattan* had about another 240 miles to go before it reached shallower water that would require frequent depth measurements, which, together with the nautical chart for the area, would have provided a better indication of the ship's position.

By noon, it's possible that the wind had increased to a moderate breeze and had backed a point or two toward the east, with the barometer showing a continuing drop in atmospheric pressure. Captain Myers would have likely discussed the deteriorating weather with his officers, and they would have been familiar with nor'easter storms. If a nor'easter was headed toward them, they would begin to face winds of increasing velocity from the east, backing to the northeast. The winds would create sea waves increasing in height commensurate with the wind velocity. Heavy rain would occur, and while it was officially over three weeks into the spring season, snow and sleet still remained a possibility, depending on the air temperature.

By noon, the seawater and air temperatures would have begun to decrease. The increasing wind, still coming from astern across the port quarter, would have caused the ship to heel slightly to starboard, and the seas would likely have increased to four to six feet. The barometer would have fallen another 0.03 inches since noon. By evening, the wind velocity would have reached the fresh breeze category, and the waves would have further increased to six to eight feet, with the ship beginning to pitch and roll, as well as having an increased angle of heel under sail. Myers would likely have directed that the bilges be sounded at least hourly to detect any leakage and, if so, that pumping commence.

Captain Myers and his officers probably realized that a storm lay ahead of them and might have estimated that the storm's center would pass to

their west in a northeasterly direction. If the wind continued to intensify, they would have two options—continue toward New York on the westerly course the ship was on (if it was expected that the nor'easter would not linger) or have the ship heave to or stop, placing the ship on a starboard reach while keeping the wind coming across the starboard quarter. This second option represented the safest course of action for a ship in Atlantic waters when it became necessary to ride out a storm, but it was tempered by the caution that proximity to nearby land and shoals might increase the risk of running aground.

Captain Myers probably chose the first option in the belief that, if it proved incorrect, the ship could still be stopped. He probably expected that the wind would gradually tack to the northeast, eventually causing the ship to shift its yards from port to starboard while bringing the wind across the starboard quarter, which would essentially be the heave-to position. If the ship was stopped before it became necessary, however, the ship could drift toward the southwest and farther away from New York. With increasing storm seas, Captain Myers probably directed that passengers be kept below decks or in their cabins, particularly since the ship would have begun to dramatically yaw and pitch, and that lifelines be set up along the exposed deck areas.

Captain Myers most likely increased the soundings taken of the ship's below deck areas, holds and bilges, to assess any water leakage and the need for pumping. All wooden-hull vessels experience some minor leakage through hull planking seams, but in the case of the *Powhattan* and its aged hull, this amount was probably more than usual. With the hull beginning to be affected by heavier wave action, the seams would open up excessively, resulting in greater amounts of seawater flooding the hull below deck. Most ships of the size and layout of a packet had two manually operated pumps, one forward and one aft, with pump suction heads located as close to the centerline and as low to the keel as possible. The vertical trunk containing the pump and suction head was known as the "well," and the depth of water in the well roughly indicated the amount of seawater leakage. A crew member would measure the water level in the wells, and the level would indicate the need for pumping. Captain Myers likely expected that the frequency of pumping would increase. If necessary, he had the authority to order passengers to operate the pumps.

Captain Myers might also, at this point, have considered the amount of sail the ship was using, with concern over whether the sails needed to be taken in. With the wind gradually increasing to a moderate gale, he likely knew that the time would come soon when he would need to shorten sail.

By sundown on Friday, April 14, however, it was likely that the *Powhattan* was still under full sail in order to arrive at New York on schedule.

At about midnight, the wind may have reached the strong breeze category of Beaufort Force 6, backing to a near easterly heading.[38] A capable shipmaster would have altered the ship's heading to the left to a southwesterly course. With increasing wind velocities resulting from the approaching storm, the ship's speed had likely increased to about eight knots. By running before the wind, the *Powhattan* could continue to ride comfortably, with some moderate pitching. As the wind backed more to the north and the seas continued to increase in height, the ship's yawing might actually have decreased.

By daybreak on April 15, the sky above would have taken on the color of lead, created by the solid overcast of thickening clouds. The seas would also have become rougher and steeper, causing an increase in the ship's pitching and rolling. As a result, anyone needing to be up on deck, such as the ship's helmsman, had to be secured by ropes around his body to some part of the ship's structure to prevent being thrown overboard.

As morning progressed, the increase in wind speed and force would have fully filled all the sails and would have begun to strain the ship's rigging. By this point, the weather conditions in general would have further deteriorated to a moderate gale. This would have produced wave tops that would likely have towered above the ship's transom at the stern and sometimes higher than the helmsman's head, adding to any fears or concerns on the part of the passengers and crew.

By about midmorning on the fifteenth, it is reasonable to assume that the *Powhattan* had encountered rain and falling temperatures. No longer in the vicinity of the Gulf Stream, the seawater temperature would have dropped to the mid-40 degrees Fahrenheit range. By this time, the wind would have registered gale force, and Captain Myers would have had no choice but to shorten sail. Doctrine called for dousing the highest sails first, since any additional speed that might be gained by those sails would have been offset by the risk of the ship being blown over. Even a minimum number of sails in use would still provide sufficient speed to maintain steerage and control of the ship's movement. The first square sails to be furled would have been the highest ones on each mast (the topgallant sails). Furling sails while standing on a footrope suspended beneath a yardarm was tough work, and when coupled with a screeching wind and a pitching ship, it was dangerous. The spanker sail was probably reefed as well as the mainsail and foresails.

By midafternoon on the fifteenth, the ship most likely would have been experiencing gale-force winds of Beaufort Force 7 or 8, and the seas

would have mounted even higher than before. Anyone standing watch on the quarterdeck, especially the helmsman, had to keep a watchful eye astern in case a steep wave was overtaking the ship and swept across the quarterdeck, flooding or pooping the ship. Constant rudder control was an absolute necessity, for loss of control could cause the ship to broach and possibly capsize.

The *Powhattan*, its aged spars and fixed rigging receiving harsh punishment from wind and seas for over twelve hours, would have been at severe risk of damage. Pumping would have increased to near continuous operation. At this point, the passengers would have been put to work in this effort. The urgency of the situation would have easily prompted the passengers' concerns for the ship's well-being as well as their own survival.

The *Powhattan*'s sails might have been further reduced to only the foremast and mainmast topsails, a double reefed spanker and the foretopmast staysail. Even under these reduced sail conditions, the ship would still have maintained a remarkable forward speed, although attempts to measure speed with the chip log likely would have been frustrated by the steep seas and the ship's rolling and pitching. Myers might have eventually had to reduce all the sails, leaving only the foremast topsail and a greatly reduced spanker sail on the mizzenmast so as to maintain rudder control and steering.

By nightfall on the fifteenth, any precipitation would probably have changed over to snow. Given the inability to accurately determine the ship's position since the start of the storm, any idea of where the ship was would have been pure guesswork. Myers might have estimated that the ship had traveled perhaps 260 miles since his last reliable navigational position on the morning of the fourteenth. The ship might have arrived where hand lead line soundings of water depth would be possible. In any case, Captain Myers would have had no real idea of the ship's position except what had been surmised by dead reckoning. As such, he probably would have ordered the mate on watch to begin taking soundings every thirty minutes beginning that evening.

Myers most likely knew from experience, the area charts and sailing directions that water depth soundings would be possible starting at a point about sixty nautical miles off the New Jersey coast. At some time before midnight, the leadsman might have reported measuring a sandy bottom at twenty-four fathoms (i.e., 144 feet of depth). Shortly after midnight, the leadsman would likely have reported a depth of eighteen fathoms (108 feet) as the ship continued to sail closer to the coast. The amount of flooding below decks might have also been increasing in spite of the continuous

pumping, which would have shown that the ship was surely going to sink. To Captain Myers and his officers, the decreasing water depths indicated the ship's proximity to the beach but which beach? Should the ship heave to or alter course farther to the south? At what point would the leakage cause the ship to sink before reaching land?

By this time, Captain Myers probably concluded that the *Powhattan* would not reach port before it succumbed to seawater flooding from the hull leakage. If the ship could continue to withstand the storm's waves that weakened its old wooden hull and spars and the gale-force winds that threatened to rip off the ship's sails and rigging, there might be enough time to reach the shore. While Captain Myers might have known of the federal rescue boathouse facilities in the area, he might have considered what the relative risks would be between either foundering far out at sea because of a weakened hull that was leaking beyond its pumping capacity or intentionally allowing the ship to run aground on one of the beaches in New Jersey, taking a chance that rescue by available volunteers using the federally supplied equipment might save at least a portion of the survivors.

By midnight on the fifteenth, the snowfall would likely have changed to near whiteout conditions. As the ship continued to close the coastline, the sounding measurements would have indicated that the seas beneath the ship were becoming shallower and shallower. The crew would have listened closely for the sound of surf, but with the storm winds squealing through the rigging and the noises of the ship groaning under the impact of the seas, it would have been very difficult to hear any surf noises far enough offshore to serve as a warning. During the early morning hours of the sixteenth, the soundings would have indicated that the ship had passed over the five fathom (thirty foot depth) curve, meaning that it was directly off a beach.

At some time shortly after morning twilight on the sixteenth, the crew probably heard a lookout's warning call of surf sounds just ahead of the ship. The likely response would have been to turn the ship hard a port or sharply to the left. This would have brought the ship's stern through the northeast gale so it would have become necessary to brace the yards to starboard. How well the *Powhattan* might have responded will never be known, but such a maneuver would have been a standard response in these circumstances. A turn to port would have reduced the ship's angle of grounding or possibly have avoided running aground at all. The ship might then have been able to haul off to port and gain valuable sea room. But that was not to be.

The ship might have initially grazed the outer sandbar with the deepest portion of the ship's bow, sustaining some hull damage. In any event, it

appears from the only eyewitness report that the *Powhattan* continued in motion while coming in closer to the beach, bumping against the bottom of the outer sandbar as it moved parallel with the beach toward the south-southwest. It is probable that Captain Myers knew that he was on the New Jersey coast, but he didn't know exactly where. When viewed from sea, (especially during periods of poor visibility), all New Jersey barrier beaches look alike from Manasquan southward. The light beams from the lighthouse at Barnegat Inlet, which might otherwise have helped in determining location, would not likely have been visible far enough at sea given the storm conditions and snowfall.[39]

Sunrise occurred at about 5:20 a.m. on Sunday, April 16, 1854, with a high tide at about 9:15 a.m., followed by a low tide at about 3:30 p.m.. The seawater temperature would have been about forty to forty-five degrees Fahrenheit. The usual tidal range (the difference in water depth between the high and low tides) three days after the full moon that had occurred would have been nine inches more than the average range of 4.00 feet. During a storm of gale force, high tides can run 2.00 or more feet above the predicted tides. If beach conditions off Long Beach Island in 1854 were similar to those documented later in 1878, the depth over the outer sandbar was usually about 4.00 feet at low tide. Adding to the tide range of 4.00 feet plus 0.75 feet for the full moon effect, it yields a depth over the outer sandbar of 8.75 feet, plus at least 2.00 feet from the additional height caused by the storm's effects. Thus, at the high tide that occurred at about 9:15 a.m. on April 16, 1854, there might have been upward of eleven feet or more of water covering the outer bar, a significant piece of information toward determining how and where the *Powhattan* went aground.

During the morning on Sunday, April 16, the *Powhattan* slammed onto the hard sand of a sandbar and stuck. For the next hour or so (the actual time being unknown from available records), incoming waves and wind pushed the ship farther against the outer sandbar, causing the ship to drift slowly to the south–southwest, parallel to the shoreline. The action of the waves on the *Powhattan*'s hull as it bounced off the outer sandbar produced a ship's motion that an eyewitness ashore later termed "thumping."

At some time later on the sixteenth, the ship finally stranded and stuck with the bow pointing toward the beach at an angle of about fifteen degrees. The wind later caused the ship to turn so that its stern was headed to the east–southeast. In the afternoon, the ship swung broadside, port side toward the beach and heeled over to starboard, exposing part of its bottom to the shore. The photograph on the next page illustrates a typical ship grounding

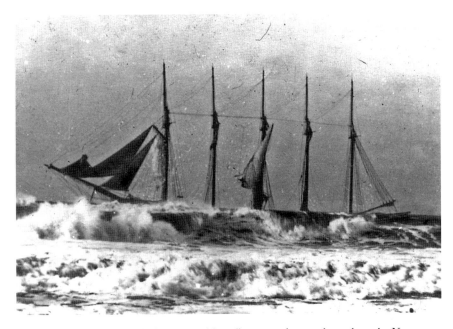

An unidentified five-masted schooner accidentally aground somewhere along the New Jersey coastline during a storm, illustrating the roughness of the storm surf, the vessel's broadside aspect to the waves and the typical distance off of the beach where such vessels would run aground. *Courtesy of the U.S. Coast Guard.*

along the New Jersey coast, with the ship having been forced by wind and seas to turn broadside toward the incoming storm surf. If the ship's foremast had not already collapsed before grounding (and there is some indication that it had failed on the morning of April 16), it is most likely that it collapsed when the ship's hull grounded, with the rigging failing and foremast shrouds popping in a cacophony of miniature explosions. The foremast would then have toppled forward, draping whatever canvas sails had been rigged, plus its forestays, foreyards and cordage all over the forward part of the ship's hull. Later in the day, it was reported that the main- and mizzenmasts tumbled, leaving the wreck totally dismasted.[40]

The final resting place of the *Powhattan* was about 1.5 miles south of Great Swamp on Long Beach Island, New Jersey (near the present town of Sea Isle City). Although an inn named the Mansion of Health (also known as the Mansion House), existed only 1.5 nautical miles, or 1.8 statute miles, north of the place where the *Powhattan* wrecked, there were few persons there at that time. Long Beach Island as a whole was at that time sparsely populated in recently established Ocean County (1850), which itself was also not well inhabited. The nearest government rescue boathouse, Station No. 7, was

located about 3.8 nautical miles, or 4.3 statute miles, to the north of the shipwreck's location, at a place known today as Harvey Cedars.

Thus, on Easter morning, April 16, 1854, the ship *Powhattan* disastrously terminated its voyage and ceased being a ship of hope, instead becoming a ship of horror.

THE WRECK AND THE AFTERMATH

With the stranding of the *Powhattan*, our focus now shifts to Edward Jennings, who was the designated Ocean County commissioner of wrecks for Long Beach Island. Jennings was the person responsible for any rescue or salvage attempts at the scene of this shipwreck, supposedly using equipment available at federal rescue Station No. 7 and engaging the assistance of any nearby volunteers. Jennings happened to be the manager on duty at the Mansion of Health at the time of the *Powhattan*'s stranding, and his family resided in the same building. Among those who could have composed a rescue crew were his family members, namely his sons Edward, Thomas and Henry.

An early 1800s depiction of the Mansion of Health on Long Beach Island, New Jersey, which was close by to the site of the grounding of the *Powhattan*. *Courtesy of Jennifer Bailey Wright.*

Jennings was probably familiar with Station No. 7's equipment, knowing that he needed a sufficient number of volunteers to transport the equipment along the storm surf-swept beach. To gain access to the equipment, however, he and his volunteers needed to contact Samuel Perrine, a Long Beach Island resident who held the key to Station No. 7. It is not known what collaborative relationship, if any, existed between Perrine as the unofficial keeper of Station No. 7 and Jennings as the local wreckmaster. The two men operated competing hotels but surely would have had to maintain some degree of cooperative engagement. Whether Perrine was even on Long Beach Island that day is unknown.

To the south of the *Powhattan*'s wreck scene, at a distance of about six nautical miles, was the next federal rescue boathouse on Long Beach Island, Station No. 8, at a place later called "Bonds." While local resident Thomas Bond was not the original person to whom the boathouse keys were given, by 1854, Bond had become the key holder and unofficial keeper of that station. Bond, like Perrine and Jennings, also ran a nearby hotel. Station Nos. 7 and 8 were about ten miles apart with the land route between them at that time consisting solely of beach and dunes; i.e., there were no roads. Travel along Long Beach Island was either on foot or horse or by means of a boat rowed or sailed along the bayside shoreline of Barnegat and Manahawkin Bays. It is not known if Jennings considered sending to Station No. 8 for rescue equipment and assistance.[41]

While the exact events surrounding any rescue attempts are not known from available records, what is definite is that no one was rescued or survived the *Powhattan* shipwreck, and all of the ship's records were lost. The hull of the ship completely disintegrated in the pounding storm surf, and no portions of the ship's hull, rigging or cargo were salvaged. The catastrophic manner in which the ship suddenly disintegrated under the force of a high wave is indicative of a ship with a compromised hull, caused by extreme wood rot, failed fastenings or broken frames. After the ship disintegrated, sometime after 5:00 p.m. on April 16, anyone who had not yet been washed overboard and still remained on the wreck also perished.

The few people who had gathered on the beach during daylight that morning were probably able to see that there were survivors on board the stranded wreck. Witnesses reported that these onlookers watched helplessly, unable to make any rescue attempts as the survivors fell from the ship into the sea, and they were not able to pull any survivors out of the storm surf.[42]

The cause of death among the survivors would have been drowning, being fatally struck by pieces of the hull and spars tossed about by waves or

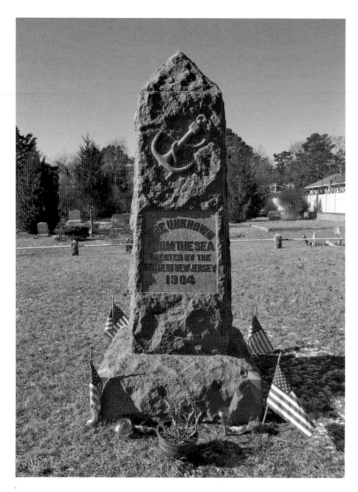

A mass grave marker, erected in 1904 by the State of New Jersey, in the cemetery of the Old Baptist Church in Mantoloking, New Jersey, for the victims of the *Powhattan*. *Photograph taken by T. Dring in 2015.*

from hypothermia. It was reported that bodies were carried by the strong southward along-shore current, with many being washed ashore near Peahala, about three miles south of the wreck on Long Beach Island. Other bodies were carried even farther south, all the way past Absecon Inlet to the present location of Atlantic City. Volunteers on shore recovered about fifty bodies nearer the wreck and placed them in the Mansion of Health under Jennings's supervision. These human remains, along with those recovered at Peahala, were later buried on the mainland.

Isaac and Robert Smith (of Smithville, New Jersey, on the mainland) discovered fifty-four bodies floating in the waterways near Absecon, New Jersey. They retrieved these and, using two boats, took them to Smithville. The bodies were initially placed in Isaac Smith's warehouse, where the women of the community made burial garments and prepared the bodies for burial.

The Smithville men made rough caskets, and the bodies were buried in a long trench in the old Quaker Cemetery on Brigantine Rum Point. About forty other bodies that washed ashore on the beach between Little Egg Inlet/ Brigantine Inlet and Absecon Inlet were also buried at Rum Point.

About 140 of the victims' bodies were initially held in Predmore's barn on Stafford Avenue in Manahawkin, New Jersey. These were later buried in an unmarked grave in Manahawkin's Old Baptist Church Cemetery, and a monument was later erected by the State of New Jersey to memorialize this tragedy.

Captain Myers's brother-in-law traveled from Maryland to Long Beach Island and identified Myers's remains, returning them to Maryland for burial. In all, a total of 234 bodies were recovered, with the bodies of 92 persons (assuming a total passenger and crew size of 326 persons) unaccounted for. It is also possible that some bodies identified as *Powhattan* victims were, in fact, from other fatal shipwrecks.[43]

THE WRECK OF THE *NEW ERA*

In contrast to the *Powhattan*, the available historical record concerning the tragic fate of the packet ship *New Era* is more informative. As with the *Powhattan*, much of the information is derived from the archives of the *New York Times*, which covered the disaster over several editions. A valuable secondary source is a document that was prepared on behalf of the Pennsylvania-German Society and included, in part sixteen of its 1907 publication *Pennsylvania: The German Influence in its Settlement and Development*, a section called "The Wreck of the Ship *New Era*." Much of the Pennsylvania-German Society's account of the *New Era*'s stranding as well as the events leading up to it were derived from the pages of the *New York Times*; however, the society's authors also interviewed survivors of the wreck (the interviews were conducted, however, fifty years after the event) and included their recollections in the publication.[44]

Five months and twelve days after the *Powhattan* wrecked on Long Beach Island, the new American ship *New Era* departed on the final leg of its maiden voyage from Bremen, Germany, to New York with 426 persons on board. On Monday, November 13, 1854, the *New Era*, while caught in a nor'easter, stranded at Deal, New Jersey, about thirty-six nautical miles to the north of where the *Powhattan* met its fate. Unlike the situation with

the *Powhattan*, though, a number of those aboard the *New Era* survived the disaster, including the ship's master, its officers and most of its crew. As such, there were survivors to provide testimony about the ship's voyage and accidental grounding.

The following outlines the particulars of the sailing packet ship *New Era*:

Vessel name: *New Era*
Registry and homeport: American; Bath, Maine
Rig type and hull layout: Fully rigged sailing packet type ship, three masts
Date/place built: Bath, Maine, by Hitchcock & Company
Date launched: April 1854
Measured tonnage: 1328 tons
Vessel master: Thomas J. Henry
Number of ship's boats: Four

Its owners were the ship's builders, Hitchcock & Company, and it was consigned to the firm of Charles C. Duncan & Company of 52 South Street, New York. Unlike the *Powhattan*, the *New Era* was insured as follows:

- $10,000 coverage by the Mutual Insurance Company, of Bath, Maine
- $50,000 coverage, divided among six Boston-area companies
- $25,000 coverage by other Bath-area companies
- $6,000 coverage by an unknown firm located on Wall Street, New York

The dimensions of its hull are not available, but, given the reported gross tonnage, the vessel's registered length was probably around 170 feet, its breadth about 40 feet and its draft about 15 feet. A gross tonnage of 1,328 tons represents the volume of the enclosed hull, less ballast space, which would have been about 132,800 cubic feet. A standard rule of thumb in allowing for hull shape is to deduct between 30 to 33 percent of the product of length, depth and breadth to account for hull shape. The breadth of sailing packet ships approximated 25 percent of their length except where the design was intended to produce greater speed. It is likely that the *New Era*, which was new in 1854, might have been in design more like a faster clipper ship design than the *Powhattan*, where the length-breadth ratio approached six to one. The registered depth is the vertical distance inside the hull between the top of the keel and the bottom of the lowest deck beam that supports the highest watertight deck. Applying the previous estimate of 132,800 cubic feet, 70 percent of 132,800 is 92,960 cubic feet. A ship's length of 150 feet, multiplied times a breadth of 35 feet, times a depth of 18 feet, yields 94,500 cubic

feet. This type of calculation can lead to an estimate of the most probable registered dimensions of *New Era*, as 150 feet in length, 35 feet in breadth and 18 feet in depth. This becomes important when estimating the draft of the *New Era* when it stranded.

THE VOYAGE AND TRAGEDY

The *New Era* boarded 397 passengers at the ports of Bremen, Germany, and London, England, bound for New York. As with the *Powhattan*, most of these were immigrants. Of those passengers, 11 counted as cabin passengers, 12 were passenger cooks and the remaining 374 were steerage passengers. The exact number of passengers varies slightly depending on which historical account is referenced. There were a total of 29 crewmembers.

In addition to its passengers, the vessel had been loaded with six hundred tons of chalk as cargo in London, England, along with twenty thousand cubic feet of other cargo loaded in Bremen. The ship departed Bremen on September 28, 1854, for its voyage to New York. On October 20, 1854, about three weeks into its voyage, the *New Era* encountered heavy seas.

The packet was reportedly hit by one particularly heavy wave that swept everything off the main deck, killing two or three passengers in the process and injuring several others. The extreme seas wracked the ship's hull, causing its seams to open and leak. As a result, Captain Henry kept one or two pumps in continuous operation for the remainder of the voyage.

As the ship reached a point about one hundred miles out from New York, cholera reportedly broke out in the steerage accommodation area, with the result that 46 steerage passengers died. The crew, apparently, did not disclose this tragedy to the remaining passengers, fearing that a panic might result. All of the dead were buried at sea. As a result of the cholera outbreak, by the time the *New Era* made its approach to New York, the number of persons remaining on board had decreased to a total of 377 or 378, depending on the exact number lost during the October 20 storm.

Captain Henry made his last celestial observation on Friday, November 10, 1854, to determine the ship's position. He reported that position as being 41°50' latitude north and 66° longitude west. The ship encountered stormy weather from the Friday through Sunday period leading up to its grounding. By Saturday, November 11, 1854, the *New Era* was encountering heavy rain and a strong breeze from the south. On Saturday night, the wind backed

to the east, diminishing in strength, but later veered to the southeast about midnight and intensified in strength to a strong breeze.

Captain Henry estimated his position on Saturday to be at 40°25' latitude north, and 72°30' longitude west, which would have placed the ship about sixty-eight nautical miles due east of Sandy Hook, New Jersey. Although Henry did not cite the time he used for that position estimate, it can be assumed that it was at either 8:00 a.m. or at noon, following the typical procedure for obtaining the ship's position. For a noon position, at a speed of seven knots (which was the higher of two speeds estimated by Seaman Griffin, one of the surviving crewmen), the ship would then be 9.7 hours from Sandy Hook. At a lesser speed of six knots, it would have been 10.3 hours from Sandy Hook. This would indicate an estimated time of arrival at Sandy Hook of between 9:30 p.m. and 10:20 p.m. on Saturday evening.

While there is no specific testimony from Captain Henry regarding wind conditions, the standard Beaufort Wind Scale for the term strong breeze meant that the conditions would have been at Beaufort Force 6, with winds of twenty-two to twenty-seven knots and seas eight to ten feet high, with large waves accompanied by foam crests and some spray.

With the wind from the south, the ship would have been at risk of running aground along Long Island, which was the lee shore. The *New Era*, sailing westward toward the entrance to New York Harbor, would have been on a port reach, meaning the wind would have been filling the sails from across the ship over its port beam. Captain Henry reported that the *New Era* carried a heavy press of sail to keep it off the Long Island coast, meaning that all the sails had been set and were in use. The concern was of the ship making too much leeway and then being set onto the beach by the southerly wind. With a full set of sails in use along with the reported wind velocity, its speed through the water might have been eight to ten knots. Seaman Griffin recollected that, during the hours leading up to the ship running aground, its speed was about six or seven knots.

Reportedly, fog had reduced visibility at the entrance of New York Harbor and along the New Jersey coast by the morning of November 13, 1854, but there were still high seas and a strong southerly wind. Low tide occurred at about 7:30 a.m. on November 13, with high tide occurring at about 1:30 p.m. The conditions were such that Captain Henry and his crew would not have sufficient visibility to see any landmarks ashore in their approach to New York Harbor and would be facing shallower water depths due to the low tide.

In its approach to New York Harbor, the *New Era* would have passed through that port's pilot grounds where pilot boats were stationed. The

pilot grounds were located not far from Sandy Hook. Captain Henry later admitted that he had not used the services of any of the New York Harbor pilots; his reason being that he had never had an accident piloting the ship himself. Given common pilot practices, the only way that Henry might have elected *not* to take a pilot would have been for him to refuse a pilot's offer of service when hailed by a pilot boat.

Captain Henry might have realized that the ship's westerly course would place him at Sandy Hook during the nighttime hours on Saturday evening, a period of darkness and low visibility. With this realization, he then might have altered the ship to port in order to run close hauled toward the southwest and parallel to the New Jersey coast. After nightfall, with the onset of a light easterly wind, he might have steered even farther to port on a southeasterly direction in order to increase the ship's distance from both the New Jersey and Long Island shores. After midnight, he would likely have tacked the ship, bringing the strong southeast wind across his starboard bow and then heading the ship on an easterly course.

Perhaps hoping to obtain a morning celestial navigational position that he was not previously able to get due to the prevailing cloud cover, Captain Henry might have worn ship to port, bringing the southeasterly wind across his port quarter and placing the ship on a westerly heading. He probably did not have an exact idea of the ship's location and distance from either shoreline, as evidenced by his later testimony; nevertheless, he probably at least maintained a dead reckoning navigational track line of the ship's various headings and estimated speeds. He also was likely to have had the ship change course to the south–southwest to compensate for the ship's set and drift and in order to maintain a safe distance between the ship and the Long Island coastline.

At about 6:00 a.m. on Monday, November 13, 1854, while the *New Era* was still headed west in thick fog toward the New Jersey coastline and seeking the entrance to New York Harbor, the depth of water under the ship's hull decreased to zero as it struck an outer sandbar. It bumped the bottom two or three times and finally was aground. Using whatever effect of the wind and rudder that remained, the ship's crew attempted to turn the bow to port and brace the yards aback in order to use the southeast wind to back the ship off the shoals. This attempted maneuver failed, resulting in the ship swinging broadside to the waves. Finally, at about 6:15 a.m., the ship grounded firmly on the outer sandbar at a distance of about 200 to 250 yards off the beach at Deal, New Jersey (reportedly at the mouth of Deal Pond), and nearly abreast of the federal government's rescue boathouse Station No. 3.[45]

THE WRECK AND THE AFTERMATH

Captain Henry mustered all the *New Era*'s passengers on the main deck. Allegations were later made that he had ordered the hatches closed and battened down, thereby trapping survivors below deck, but these charges were never apparently substantiated. Recognizing the ship's precarious situation, the captain then ordered the ship's four boats prepared for launching.

To establish communication between the ship and shore, Captain Henry launched one boat to carry a guide rope from the ship to the beach. This guide rope could then be followed by the ship's boats in attempting to safely transfer the survivors to shore. The first boat was manned by the chief mate and four or five seamen and reached shore safely. The seamen in the boat, however, accidentally let go of the guide rope (possibly it was too short in length to span the distance between ship and shore), and the intended safety link to shore was lost, although the boat's crew was now ashore.

Captain Henry then ordered two of the other boats launched. A large number of the crew remaining on board the *New Era*, along with two of the cabin passengers, jumped on board these two boats and rowed to shore, deserting the ship and all the remaining survivors. Witnesses later recounted that three of the *New Era*'s boats were drawn up on shore with the disembarked ship's crew and that these crewmembers then stayed on shore and did not return to the ship to disembark any of the other survivors. There is, in fact, no evidence that any of the ship's crew on the beach attempted to re-launch any of these boats in order to return to the wreck to rescue the others.

One ship's boat, the long boat, remained on board. It would have been the largest and most seaworthy of the ship's four. Captain Henry reportedly busied himself with the launching of this remaining boat.

The unofficial keeper of rescue boathouse Station No. 3 in Deal at that time was Abner Allen, who had custody of the keys and whose residence was located nearly opposite the shipwreck. Allen had reportedly received training in the use of the boathouse's mortar and apparatus when the station was first established in 1849 and, while not an official station keeper, was given the responsibility for the keys and collaborating with the local commissioner of wrecks and any agents of the marine insurance underwriters.

Allen arrived on the beach only minutes after the *New Era* struck the sandbar. He immediately spread the alarm, summoning local citizens to assist him. In this regard, Allen was more effective than wreckmaster Jennings was during the wreck of the *Powhattan* because the area around Deal Beach was well settled by the 1850s with year-round residents as compared to barren Long Beach Island.

Two Packets of Hope

Allen managed with the volunteers available to deploy the Francis metallic surfboat from the boathouse out onto the beach, but he couldn't find enough skilled surfmen to man and operate the surfboat, which entailed launching and recovery through the prevailing fog and storm surf. Allen then had the beach apparatus cart pulled out of the boathouse and deployed. Allen realized that he must act without delay. He loaded the mortar and prepared the shotline and then attempted to fire a shot across the wreck. Something, however, went wrong, and the accounts of the attempted rescue indicate that the first three shotline firing attempts failed. Perhaps Allen's aim was poor or perhaps the strong winds from the south carried the shot too far to the north past the wreck. Another possibility was that the shotline parted. In fact, there was always a risk of the shotline parting if the spiral-wound connecting wire between the cannonball and shotline was corroded or frayed (as was reported for Station No. 3 in an inspection after the wreck). Finally, on Allen's fourth attempt, the shotline landed successfully across the *New Era*'s bowsprit, and the ship's crew was able to haul in on the shotline.

The next sequence of events, however, was a serious breach of proper procedure compared to the technique that Allen would have been trained to use. Instead of using the shotline to haul the main hawser rope over to the wreck, the crew of the *New Era* attached the ship's end of the shotline to the ship's one remaining boat, on board which were about eight to ten persons including Captain Henry. Henry later explained that, as he attempted to bail out the sea-swamped ship's longboat, some of the passengers jumped in such that Henry and his crew felt that they had no option but to push off from the ship and proceed to shore because the boat would be at risk of foundering with only untrained passengers aboard. Whether or not Captain Henry intended to escape without regard to the safety of all his passengers is subject to conjecture; nevertheless, the volunteer rescuers on the beach had no alternative but to haul the boat toward shore using the shotline. In the process, the boat capsized in the surf. Captain Henry and at least four of those in the boat with him reached shore safely. This debacle occurred at about 11:00 a.m.

At about 3:00 p.m., Allen again successfully fired a shotline across the wreck that caught in its rigging. By this time, only two or three of the ship's crew still remained on board to retrieve the shotline. They had a difficult time getting to the shotline and failed to retrieve it. They also lost the cannonball shot, which happened to be the last cannonball shot available in Station No. 3's original inventory of ten shot. The number of tries described in the accounts does not equal ten, but it can be assumed that there were other unsuccessful shots that went unrecorded.

The Deadly Shipwrecks of the *Powhattan* and *New Era* on the Jersey Shore

Allen then sent word to the next nearest government rescue boathouse, Station No. 2 at what was later called Monmouth Beach, located six and a half nautical miles to the north. However, by the time the additional supply of cannonball shot had been obtained from Station No. 2 and had reached Deal Beach, darkness had fallen. In the meantime, the surf had increased in height and regularly broke clear over the wreck, sending the remaining shipwreck survivors on board the *New Era* to seek safety in the ship's rigging.

A crowd of about two hundred people eventually gathered on the beach, including a reporter from the *New York Times*. Among the witnesses were the local customs inspector Jacob W. Morris, wreckers, surfmen, citizens and public officials. Several of the wreckers and surfmen—including a Mr. Wilson of Squan, James Green of Long Branch and Henry J. Wardell of Monmouth Beach—had dispatched their own Jersey-type wooden wrecking surfboats with volunteer crews to the scene, but the high surf conditions prevented any of those surfboats from being launched. The gathered crowd observed survivors on board the *New Era* falling from the rigging into the sea or onto the wreck's deck. Bystanders on shore, anxious to help in any way possible, formed human chains into the surf, at their own peril, to rescue any survivors they found afloat.

Earlier that day, the steam-tug *Achilles* lying off Sandy Hook received notification of the wreck from Customs Inspector Morris. Sailing through dense fog and encountering strong southerly winds, the tug proceeded to the scene and arrived at about 3:00 p.m. The tug *Leviathan* also appeared on the scene as well as the tug *Hector* towing a wrecking schooner. Captain John Maxon Brown, who was aboard the schooner, was the agent for the marine insurance underwriters. Unfortunately, there appear to have been no surfboats available on any of the tugs, and the seas at that point were so severe that none of the tugs could make a direct approach to get alongside the wreck without significant risk of damaging their own hulls. Several bystanders volunteered to assist, but Captain Brown dismissed their offers, apparently realizing that they could become victims themselves.

Finally, at about 8:00 p.m., the volunteer rescuers successfully fired another shotline across the wreck, but the remaining survivors by this time were unable to retrieve the shotline or assist in the rescue efforts. Part of the problem might have been that many of the German or Dutch immigrant passengers were unable to speak or comprehend English, which meant that they could not have understood any instructions in English by either the remaining ship's crew members or the volunteer rescuers on shore. A crew member who had remained on board later estimated that there were only

a total of five ship's crew remaining at that point, and reportedly none of them could speak German or Dutch.

Allen kept a fire burning on shore all night. Toward morning on November 14, the gale abated. With daylight, experienced surfmen under the direction of wreckers Brown, Wardell and Green manned and launched their surfboats. They succeeded in rescuing all of the ship's survivors who had lasted through the night. Once ashore, the rescuers took the survivors to Abner Allen's house for shelter. Those that couldn't fit into his house took shelter on the sunny side of the shore or in his barn and outbuildings.[46]

Insurers determined the *New Era* to be a total loss, and the wreck eventually sank. Local citizens continued to recover bodies of dead passengers as they washed up on the beaches. They discovered that many of the deceased passengers had carried money and jewels sewn in their undergarments, a common practice among immigrants. These valuables were collected, accounted for and turned over to the authorities. A large number of the deceased were eventually interred in the cemetery of the old First Methodist Church in West Long Branch, New Jersey.[47]

RECONSTRUCTION OF A DISASTER

INTRODUCTION

Any time a horrific and tragic shipwreck occurs, including those of the *Powhattan* and the *New Era*, there should always be lessons learned by the maritime industry to help prevent future disasters. Critical to this process is a properly conducted investigation into the circumstances and details of each shipwreck to determine what happened and what improvements should be made to prevent future accidents. While the situation today is such that there are a number of international and national agencies capable of conducting such in-depth investigations (the International Maritime Organization, or IMO; the United States National Transportation Safety Board, or NTSB; and national coast guard agencies like the United States Coast Guard), the situation in the nineteenth century and before was such that there were few, if any, agencies or organizations in existence that possessed the authority and resources to conduct this type of marine safety investigation.

As was then customary for American-flagged sailing ships, there was never any governmental inquiry into any causal factors surrounding a shipwreck. It was just assumed that such sailing ship disasters were a risk inherent to the maritime industry and therefore inevitable and beyond the possible reach of any governmental preventive measures. No agency had responsibility for establishing or enforcing maritime safety standards, and

no federal safety regulations existed for merchant vessels propelled by sail. By the 1850s, however, safety standards for ship design, on board life-saving appliances and ship's officer licensure had been established for American-registered steam vessels as a result of a number of horrific explosions and fires that had occurred in various steam-propelled river boats and ships. The reason for this was due, in part, to the fact that the bulk of the passengers on United States steamboats were United States citizens, who were able to pressure Congress to enact the necessary legislation to create these safety regulations. There was not the same degree of concern and pressure on Congress for ship disasters involving foreign citizens, such as the immigrant packet ships.

Although there was little governmental pressure brought to bear on the safety of oceanic sailing ships, that was not the case for ships that were covered by the insurance policies of marine insurance underwriters. The surges in European immigration that provided the impetus for the construction of new passenger packet ships also increased the financing of such vessel construction and the resultant need for insurance coverage. The marine insurers then became the primary means for enforcing marine safety standards in ship design, construction and maintenance. Once marine insurance coverage was no longer needed, though, this oversight was lost, and it would only have been at the discretion of the ship's owner whether or not any safety standards were followed for a ship and only if they were cost-beneficial.

THE MARINE SAFETY INVESTIGATION PROCESS

The lead author served as a United States Coast Guard marine investigating officer during his time on active duty. The bible for conducting marine safety investigations was and continues to be the United States Coast Guard's *Marine Safety Manual.*[48] This reference very clearly describes the key objectives of a properly conducted investigation into any marine accident.

> *An important purpose of marine casualty investigations is to obtain information for the prevention of similar casualties, as far as practicable. It is necessary that the causes of the casualty be determined as precisely as possible in order that detailed factual information will be available for review and statistical studies. It is not sufficient to know only how a casualty occurred; it must also be clear why it happened. Based on this information, appropriate*

corrective measures, regulations, and standards of safety may be developed and instituted, or legislation for marine safety may be recommended, if needed.

Both the *Powhattan* and *New Era* shipwrecks certainly qualify as marine casualties. If the same federal standard that is enforced today existed back in 1854, the investigating officer would have interviewed survivors, amassed documentary evidence, obtained relevant meteorological and hydrographic data and applied good judgment based on the investigator's personal experience as well as expert testimony.

If the United States had utilized qualified and professional mariners to conduct an investigation, such as the officers of the United States Revenue Marine, the investigators would have taken testimony from the ship's crew and passengers and witnesses. The investigation would have attempted to collect precise information regarding:

- The ship's characteristics and registry
- Passengers and cargo carried
- The ship's crew staffing and experience/qualifications
- The ship's safety and rescue equipment carried
- Deaths among crew and/or passengers
- Sources and quality of the ship's provisions and drinking water
- The ship's owners, financing and insurance coverage
- The material condition of the ship at time of wreck
- The navigational methods and equipment available
- Details of the voyage and route taken
- The events immediately prior and leading up to the wreck

If the shipwreck resulted in the deaths of everyone on board, an investigation was more difficult, but eyewitness testimony could provide at least some information to determine the reason why a ship came ashore. In the absence of data on the ship itself, the investigation could at least estimate some parameters based on information supplied by the ship's owners.

RECONSTRUCTING THE LOSS OF THE *POWHATTAN*

It is pretty obvious from the available records that the "how" regarding the *Powhattan*'s shipwreck was that the ship ran aground, and the seas then demolished the ship's hull before any survivors could be safely removed.

Going to the question concerning why the *Powhattan* wrecked, there are several possible reasons—bad navigation; loss of vessel control; sea and wind conditions beyond the capability of the vessel; poor material condition of the vessel's hull, spars and rigging; and rescue attempts that failed to meet the prerequisites of effective rescue doctrine.

Little evidence exists concerning the navigation techniques applied prior to the ship's grounding, whether control of the vessel remained intact up until the grounding or what the ship's material condition was at the time of the wreck. Some evidence exists, however, concerning the sea and wind conditions and the efficacy of the rescue attempt.

The April 20, 1854 *New York Times* reported a storm of gale strength that had hit the coast between Friday, April 14, 1854, and Monday, April 17, 1854.[49] The storm was accompanied by heavy snowfall, unusual for New Jersey in mid-April but not unheard of. In that same article, the *Times* reported a number of shipwrecks that had occurred during that storm, including the *Powhattan*, and that fifty-eight bodies had already washed ashore at Absecon, New Jersey (located south of the shipwreck's location).

On April 21, 1854, the *New York Times* again reported on the shipwreck:[50]

> *The* Powhattan *was owned in Baltimore by William Graham, Esq., one of the heaviest shipping merchants of that city. She was built in 1837, was nearly 600 tons register and valued at about $20,000. Her cargo consisted of French and German goods, and left Havre about the 1ˢᵗ of March, bound to New York.*

The reporter then filed his own report on April 18:[51]

> *I arrived at Long Beach at 8 A.M. today, and found the wreck to be the ship* Powhattan *of Baltimore, Capt. Myers, from Havre to New York. She is a total loss, and every soul that was on board perished. She went on Saturday night, it broke up at 5 P.M. on Sunday. About 75 or 80 packages of passengers' baggage are in charge of Mr. Jennings, wreckmaster. The bodies of 27 passengers and 2 seamen have come ashore; and from the fragments of passengers' luggage, I estimate that there were 250 on board. About 40 feet of the starboard side, amidships, and 30 of the larboard side, aft, are high and dry, 50 feet apart. Not a vestige of anything indicating what her cargo consisted of.*

Edward Jennings was also interviewed. While unknown others supposedly were witnesses to the tragedy, Jennings was the only source

reported to have made a statement about the wreck. The April 22, 1854 edition of the *Times* published Jennings's statement:[52]

On Saturday the wind blew with great violence from the northeast. The sea ran very high all day, and I supposed that there would be many a wreck along the coast from Barnegat to Little Egg Harbor. On Sunday morning I observed a ship of about 900 tons thumping on the bar about 100 yards from shore. I immediately sent those men who were with me to the Government station-house, distant about six miles, for the life car, mortar and other wrecking apparatus. During the day the ship's deck was crowded with passengers and when the surf ran out I could get within 75 yards of the vessel, which I found out to be the ship Powhattan *of Baltimore, Capt. Meyers, on her voyage from Havre to New York. The surf ran mountains high; indeed, I never saw such an area in my life. Several persons now began to be swept overboard.*

Captain Meyers hailed me through his speaking trumpet and asked me for God's sake to try and save any of those who might happen to wash ashore. I told him I had went down the beach to where the bodies came ashore, but found them all dead and it was of no use trying to save them as they were all drowned before they got halfway to the beach. Captain Meyers asked me just before this if any aid would soon reach them. I said I hoped so, as four men had been sent down to the government station for that purpose. Captain Meyers again called out to me to save any of those who might be washed ashore alive. I replied that I would see to it, and went down about 200 yards on the beach where the bodies were being washed on shore. Women and children came on shore first.

The vessel then lay E.S.E. and had shifted from the N.E. Her foremast was gone at this time. I suppose she lost it before she struck on the bar. About 5 o'clock P.M. on Sunday, the ship keeled over to windward from the shore. The seas then, of course, made a clean breach over her and passengers began to be washed off in great numbers. The sea running mountain high, and completely hiding the vessel from my view, I could no longer hold any communication with the captain. I never saw him since.

The main and mizzen soon went by the board, and bodies appeared floating in the surf in great numbers. Some 25 dead bodies, mostly women, came on shore about a mile south of the wreck.

About dark, the sea rose to a great height, and one large wave, fully 100 feet high struck the unfortunate vessel, and in one moment the hull was shattered into fragments which tossed wildly through the surf. The shrieks of the drowning creatures were melancholy indeed, but I could render them

no aid, as the sea ran so high I could not get near the unfortunate people. In a few minutes all disappeared beneath the surface of the water except a few fragments of the wreck.

Never did I see such a sight in my life. Never do I remember witnessing such a dreadful gale or such a high running sea. In many places it made a complete breach over the island, and carried, no doubt, many a poor fellow into the bay behind it.

The men got back the next morning from the Government station-house with a life boat, mortar, and the usual wrecking apparatus, but it was too late. All on board the ill-fated Powhattan *had perished—no one remained to tell the fearful tale. None of the crew or officers of that vessel came ashore, which is a curious fact, but I think they will be found some 10 or 15 miles farther down the beach.*

The luggage and portions of the wreck lay scattered along the beach. I have collected all the valuables I could and have found some money, ($80) in a money belt belonging to some of the passengers. The friends and relatives of the deceased can have all the necessary information regarding the effects of those drowned by inquiring for me at Manahawkin, New Jersey.

The *New York Times* reports of the wreck on April 21 and 22, 1854, had been submitted by persons on the scene of the tragedy. The April 22 article included the above statement made by Edward Jennings and appears to be the only available eyewitness account. Certain other pieces of information have also appeared in print, but their original sources are unknown.

The following chronology has been recreated, incorporating Wreckmaster Jennings's interview with the *New York Times* reporter along with historical information related to the prevailing environmental conditions, sailing and hydrographic information and common ship practices of that time.

1. Jennings probably first saw the *Powhattan* when it was nearly abreast of the Mansion of Health. That first sighting might have been a fleeting one. Jennings's initial discovery of the *Powhattan* might have occurred at about 8:00 a.m. The justification for projecting this time estimate is that the ship eventually stranded about 1.9 statute miles south of the Mansion of Health, most likely during the morning high tide that would have occurred at 9:15 a.m. that morning. A southerly set of one to two knots on the waters seaward of the inner bar would be a reasonable assumption. With the ship drifting at two knots from the time of predicted high tide, 8:00 a.m. seems a reasonably approximate time to establish the first sighting.

The tide then would probably have been sufficiently high to enable the ship, at a deep draft of about eleven feet, to cross over the outer bar to the area seaward of the inner bar and shoreward of the outer bar.

To Jennings's credit, he wasted no time in recognizing that the ship "thumping on the bar" needed immediate assistance. Jennings, however, greatly overestimated the distance between where he first probably saw the *Powhattan* and Station No. 7. Jennings apparently continually observed the ship as it drifted south along the beach.

2. It is apparent that if the surf was as high as Jennings reported, he would not have been able to go out twenty-five yards until low tide, which would have occurred that day at about 3:30 p.m. This means that the passengers had been on deck from about 9:00 a.m., when the ship stranded, until past the time of low tide. People were, by then, being swept overboard by the seas passing across the hull. The average seawater temperature on Long Beach Island in mid-April was about 45 degrees Fahrenheit, or 7.3 degrees Celsius. Hypothermia would have been a major factor in survivability, but even after thirty minutes of immersion, persons brought to shore could have survived.

3. Initially, the starboard side of the ship lay closest to the beach, which might have prompted persons on board to ascend the standing rigging of the main- and mizzenmasts. As the ship pivoted its bow in a clockwise direction, however, the ship's starboard side gradually became the offshore side, receiving the brunt of the waves hitting the ship. The ship undoubtedly took on water, causing two events to take place; first, the ship's freeboard decreased, making the main deck more vulnerable to crossing seas, and then, the people who had sought refuge in the rigging would be afraid to descend and cross the deck to the rigging on the opposite side of the ship.

4. The men Jennings sent for the rescue equipment might have included one or more of his sons and, perhaps, an employee or two from the Mansion of Health. Surely, the hotel was not hosting a large population of guests by that time in the winter compared to the summertime period. It is curious that Jennings did not mention the need for a larger party of men to deploy the rescue apparatus. This begs the question of whether or not Jennings (or the station's keeper, Perrine) had ever conducted any training drills with the apparatus. Also in doubt was whether he was actually familiar with the equipment available to him at Station No. 7. Finally, how would Samuel Perrine fit into this picture, since he was the

possessor of the station house key and a knowledgeable surfman? By longstanding agreement between the people on Long Beach Island and the people at Manahawkin on the mainland, whenever a wreck occurred, the men on the beach signaled word of the wreck across the bay. The bay was the narrowest and shallowest near Harvey Cedars, enabling cross-bay transits when it would otherwise be impossible under storm conditions between the mainland and other locations along Long Beach Island. Jennings might have expected that Perrine and his four men would have sent such a signal. It is not clear exactly what assistance volunteers from Manahawkin ever provided. Wreckmaster Jennings's account indicates that the requested help didn't arrive until the morning of April 17, 1854.

5. If the *Powhattan* wrecked on the outer sandbar, it would have been well within the range of the Manby mortar, enabling the use of the lifecar. Jennings reportedly said that he was able to proceed 25 yards out from the beach toward the ship at low tide and engage in a verbal exchange between himself and Captain Myers. If the ship was stranded on the outer sandbar (about 200 yards from shore), that Jennings and Myers could converse and hear each other would have been remarkable owing to the loud sounds of the wind and surf. If the ship was stranded on the inner bar, however, located about 100 yards from the beach, Jennings's report of a conversation becomes more believable. That would also have meant that the persons on board who were still alive at 3:30 p.m. were only 75 yards (225 feet) away from safety on the beach. Had human chains been attempted, certainly some number of those people entering the surf on the leeward side of the wreck might have survived.

6. Because there was no handcart in Station No. 7's inventory, the only efficient way for the apparatus to have been delivered to the scene would have been to load all the gear into the surfboat and then manhandle the heavy surfboat and its wagon (with the loaded apparatus) along the beach to the wreck scene. At best, this would entail the use of either a team of horses or a large party of men. The surfboat weighed about 1,400 pounds, the boat wagon possibly another 1,000 pounds and the mortar and associated gear at least another 800 pounds. As such, the total weight would have been at least one ton and a half, perhaps more. Even if sufficient pulling and pushing power had been available, however, the beach during such a wintertime storm would have become nearly impassable.

7. Jennings's discussion with Captain Myers had to have taken place in the afternoon hours approaching 3:00 p.m., when low tide would have

occurred. Thus, Jennings's comment about "when the surf ran out" means that the tide had fallen enough so that he could wade about twenty-five yards out from the beach toward the ship that had by then stranded about one hundred yards off the beach. It also indicates that Captain Myers was a compassionate man who was truly interested in the safety of his passengers.

8. As the wind and seas worked the *Powhattan*'s hull, the hull would have been rotated clockwise, pivoting about its bow with the axis of the keel then taking a position of "east southeast" or, more technically, 112.5/295.5° true in direction, which would have appeared to be nearly head-on to the beach. The wreck lay in that position during the exchanges of information between Captain Myers and Wreckmaster Jennings. By low tide, a great portion of the wreck's hull bottom lay on the inner bar's offshore slope. Meanwhile, the hull would have flooded as a result of the damaged sustained in the initial grounding.

 The rising tide and seas would have pushed the hull farther onto the inner sandbar, causing the remnants of the hull to heel to starboard, which was the windward side and the direction from which the nor'easter was blowing. The final position "keeled over to windward" would have placed the *Powhattan*'s keel on an axis of about 135/315° true. This would have been almost two hours into the period of high tide. Having sunk on the seaward slope of the inner sandbar, the wreck's hull might still have had sufficient floatation to lift with the rising tide and rotate further clockwise. Such a position, now broadside and inclined toward the wind and seas, would have caused any persons who were swept overboard to first be washed by the sweeping seas to windward and then pushed to the south and around the wreck's stern by the wind-driven current, eventually to be washed ashore by the surf.

9. With the main- and mizzenmasts gone over the side of the wreck, no standing rigging would have remained to offer refuge to any persons capable of ascending. The foremast would have long since toppled.

10. The sun set at about 6:30 p.m. on April 16, although, with storm conditions prevailing, darkness would have occurred earlier.

11. There is no testimony to indicate that any would-be rescuers attempted to form human chains by wading out into the surf to attempt to retrieve persons off the wreck. Perhaps there were not enough people to do so. We do not know if Jennings tried to encourage any people who gathered on the beach to wade out in the heavy surf to help him retrieve victims. To do so would have been consistent with the common practices that

local resident volunteer rescuers employed eight years earlier during the February 1846 wrecks. Perhaps there were insufficient people willing to volunteer and assist. Nevertheless, they did apparently participate in recovering the bodies washed up on the beach. Jennings stated that he had ranged south along the beach to locate bodies that washed ashore before the wreck disintegrated. Sometime after 5:00 p.m., the persons on shore observed the ship break apart and disintegrate under the actions of the waves. Every person remaining on board—even those who climbed into the rigging—disappeared into the roiling surf, and no one survived.

12. Edward Jennings was later accused of stealing valuables and personal effects from the bodies of the *Powhattan* victims. It was claimed that he was later forced to flee the area to escape investigation and prosecution. Although Jennings might have left the Long Beach Island area as reported after 1857, along with his wife and children, he didn't leave Ocean County. In fact, he seems to have lost nothing in his reputation as a hosteller, having been gainfully employed as one in nearby Dover Township in 1860. Whether he was guilty of the crime for which he was accused is unknown, and only an official investigation could have established whether these accusations were valid.

The absence of other witnesses begs the question of what really happened. Could some rescue attempts have been made, were they made or were they suppressed by the wreckmaster? More grotesquely, was Jennings more interested in recovering cargo and valuables from the wreck than rescuing any survivors? On the other hand, Jennings might have been a bona fide but maligned hero who modestly refused to elaborate upon his contributions in a failed rescue effort. Jennings's primary role was to ensure that whatever rescue attempts could be made were made and, after the wreck, to secure any salvaged goods until the marine insurance underwriter completed their tasks, and to secure any bodies and personal goods. There is no evidence to suggest that Edward Jennings did anything other than that.

Whether Jennings did all he could with respect to organizing a rescue, however, remains debatable. Surely, the rescue was anything but successful. He did send four men to Station No. 7 to deploy the rescue equipment. Someone alerted the Manahawkin crew under Stacy Hazelton on the mainland, who gathered together his rescue boat crew. That they did not arrive until the next morning might be explained by the delays associated with the severe weather conditions, specifically any over-wash of the barrier beach by the high seas along with the rough bay conditions and gale-force winds. Hazelton's men might have crossed the bay and reached Harvey Cedars on Sunday, but the record is not complete.

Edward Jennings might have had no idea about the delay; in fact, it seems as if he was expecting their arrival when he exchanged calls with Captain Myers. Had Jennings sent his four volunteers to Station No. 7 for the rescue equipment, located about three miles north of the Mansion of Health, by about 9:00 a.m., those rescuers should have reached that station by about 10:00 a.m. The distance between Station No. 7 and the wreck scene was about 4.5 statute miles, and over a period of five hours at the rate of 0.9 miles per hour, it does not seem unattainable. Could Jennings have sent a messenger north to Station No. 7 to find out what was happening? He might have done that, but if the circumstances on the beach prevented the use of the government rescue equipment, it might have been to no avail, at least during the time of high tide that occurred at 9:15 a.m. that morning. The beach might have been easier to traverse at low tide than during the morning high tide, which indicates that Jennings might have expected the government gear and the rescue team during the afternoon hours.

By 10:30 a.m., they could have begun deploying the government surfboat. Finding the beach impassable (as it probably was since it would have been high tide), had the four men been properly instructed, they might then have exercised some initiative and launched the surfboat near the Harvey Cedars hotel, which lay close to the Station No. 7. The three-mile passage on the inland bay waters between the Harvey Cedars hotel and the Mansion of Health would have been all downwind. The surfboat, equipped with air tanks, would have been unsinkable. There surely must have been wagons, carts, wheelbarrows or other kinds of wheeled contrivances available at the Mansion of Health in which the mortar, its base, the ordnance, shotline and lifecar might have been transferred from the surfboat to the wreck scene. It seems that such a movement might have been completed by the time of low tide and in time to save a number of persons then still alive on the wreck.

If the Manby mortar had been used before 5:00 p.m., there is every reason to believe that a shotline could have been fired successfully over the wreck, provided the spiral wires attaching the shotline lanyard to the shot ball did not break. A physical connection between the beach and the wreck might, therefore, have been established, and rescue operations with the lifecar could have commenced before the wreck disintegrated at about 7:00 p.m. that evening. The daylight hours between the initial time of Jennings's morning discovery until 5:00 p.m. would have allowed potential rescuers sufficient time to undertake and complete a successful rescue response. If that had happened, some, if not all, of the persons on board surely would have been rescued.

CONCLUSIONS AND PROBABLE
CAUSAL FACTORS

The material condition of the *Powhattan* might be surmised to have been marginal, if only because the ship was nearing the end of the expected lifespan of typical mid-nineteenth-century wooden sailing ships. The age of the ship's wooden hull (approximately seventeen years) was probably a factor in as much as it might have been deteriorated. It is unknown whether it had been rebuilt, sheathed or repaired. Without any evidence as to its state of repair, it would be reasonable to assume that a vessel of its age experienced continuing leakage that would have been exacerbated by the high seas and storm conditions. The rapid destruction of the hull indicates that the ship's structural integrity had probably been diminished by seventeen years of wear and tear on its fastenings along with the normal deterioration of its wooden hull structure. The same age factor might have affected the strength of the vessel's spars and standing rigging. Thus, if the foremast collapsed prior to grounding, that failure might have been attributable to material failure resulting from the ship's deteriorated strength.

The report that two rather large sections of the hull washed ashore the next morning certainly begs the question of the intact adequacy of the ship's frame structure and the soundness of its fastenings. Were the frames broken or rotted to the extent that wave action could cause sections of hull to rip off and float ashore in recognizable portions? While the condition of the *Powhattan*'s hull might be questioned, the absence of testimony or physical evaluation makes it impossible to determine that the cause of the catastrophe and whether the approximate three hundred deaths that occurred following the stranding were directly attributable to material failure.

Presuming that the vessel remained maneuverable and that its crew was capable of taking soundings at such time as when the *Powhattan* crossed the ten fathom curve, Captain Myers would have had sufficient sea room (about six nautical miles) to wear ship and head safely to the south. This also presumes that Captain Myers possessed the local coastal charts and was versed in warnings about the local depth soundings contained in published sailing directions. It will never be known what was in James Myers's mind when he approached the New Jersey shoreline during this particularly nasty nor'easter. Whether his actions or lack of action served to condemn the ship and its occupants can only lead to speculation. The oft-given excuse that, had there been adequate lighthouses, this accident would not have happened fails to recognize that visibility in thick weather, especially snow, precludes the effectiveness of any lighted aids to navigation. There seem to be three reasonable causal factors for

the stranding. One, Myers's navigation was faulty, and failing to ascertain the depth of water as his ship crossed the ten-fathom curve, he neglected to alter course to the south, bringing the wind across his ship's port quarter, thereby increasing the distance to land. This resulted in the ship grounding not once but repeatedly, eventually crossing over the outer sandbar and stranding on the seaward side of the inner sandbar. Two, the damage sustained to the ship's foremast and standing rigging prevented any effective maneuvering to avoid going aground. The ship, therefore, was blown ashore and there was not one thing that could have been done to avoid grounding. Finally, Captain Myers might have intentionally grounded the aged and leaking vessel in the hope that some of the passengers might reach the beach alive.

RECONSTRUCTING THE LOSS OF THE NEW ERA

In contrast to the *Powhattan* shipwreck, there were a few contemporary published accounts of testimony given by the *New Era*'s master, Captain Henry, as well as by some crew members. Like the accounts of the *Powhattan* disaster, most of the contemporary accounts related to the *New Era* shipwreck were published in the *New York Times*. Following the ship's stranding, the newspaper dispatched reporters to the scene and conducted interviews. The initial report published on November 15, 1854, contained few specifics.[53] A far more detailed report followed a few days later. Captain Henry, master of the *New Era*, made a statement to the *Times* reporter that was published in the November 18, 1854 edition.[54] Captain Henry's statement concerning the events on board the *New Era* leading up to the grounding was also included in the Pennsylvania German Society's report of this tragedy.[55]

An artist's rendition of the wreck of the *New Era* depicts a fully rigged ship, stranded, head to the south and broadside to the beach. Sails—including the courses, topsails, topgallants and royals—were still set, as were the spanker, foremast and foretopmast stay sails and the inner jib. A ship's boat is depicted being lowered from the starboard quarter. The ship's yards are braced to port as they might have been if they had been backed following grounding, as reported by Captain Henry.

Captain Henry reported that the wind was blowing heavily from the southeast. The sails that had been set at 3:00 a.m. were the topsails on the fore-, main- and mizzenmast, but they were close reefed, meaning that the amount of sail area exposed to the wind had been reduced to the minimum

amount possible by securing each sail using its reef points. The ship had also set the triangular staysails leading between the jib and the foretopmast, between the main topmast and the base of the foremast, along with its spanker sail and the spencer sail. Captain Henry had apparently furled all the other sails that earlier had constituted his full press of sail, meaning that he had furled the courses, the top gallants, the royals, the jibs and whatever other staysails the ship carried.

A somewhat contrasting statement by *New Era* crew member Seaman Griffin noted the following key points:[56] that the ship had started leaking about a week prior to the grounding, requiring constant pumping; that severe weather was experienced for a full three days leading up to the grounding, yet most of the sails were still used rather than being taken in for stormy weather; that soundings taken prior to grounding clearly indicated that the ship was heading into shallow water near shore; and that many of the immigrant passengers drowned below decks and never had the chance to get overboard to shore.

If sounding measurements of the water depth had been ordered at 5:30 a.m., either the mate on watch or Captain Henry should have been concerned enough to increase the frequency with which soundings were taken, despite Henry's statement that he had ordered soundings hourly. In any case, the *New Era* plowed ahead at six or seven knots. Mariners were warned in the sailing directions for the New Jersey coast that shoal water depths inside of the ten-fathom water depth level might be rapidly encountered for any vessel sailing on a westerly heading. Under conditions of low visibility and cloud cover that might preclude any celestial observations to determine a ship's position, it was important that repeated soundings of water depth be taken as the ship progressed westward. If a ship was attempting to approach the entrance to New York Harbor, identifying any water areas shallower than those marked by the ten-fathom curve would become critical to the vessel's safety. In order to heed these warnings, the only recourse for a shipmaster was to have a leadsman stationed forward in the ship to heave the ship's lead line to take water depth measurement soundings, with these soundings to be taken frequently enough so that the vessel's speed of advance would not negligently place it in danger during the intervals between sounding measurements.[57]

At 5:30 a.m. on November 13, the leadsman on the *New Era* reported between thirteen to fifteen fathoms of water depth. According to the nautical chart for the approaches to New York Harbor, the charted ten-fathom curve parallels the New Jersey coastline near Deal at an average distance of about 3.5 nautical miles off of the beach. The master of a vessel, therefore, headed

on a westerly heading could approach within 3.5 nautical miles of the beach at Deal and still be confident that he would still have a safe depth of water of at least ten fathoms (sixty feet) for the ship to sail through.

Using a hand lead to take soundings every hour, a vessel making seven knots will travel seven nautical miles in a sixty-minute period between soundings or three and a half nautical miles in sixty minutes. If a shipmaster ordered the sounding interval to be reduced to once every half hour, a vessel just passing over the ten fathom curve line offshore of Deal at the time of such a sounding would—just thirty minutes later, at the time the next sounding was due—find itself aground on the beach. In view of this, a prudent navigator approaching New Jersey's ten-fathom curve would want to decrease the interval between soundings to less than thirty minutes, perhaps having them only ten minutes apart.

Given the prevailing weather and visibility conditions on November 13 and not knowing the precise position of the *New Era*, Captain Henry inadvertently rammed his ship aground at Deal Beach, very close to the government rescue boathouse station at Deal. Theoretically, the shipwreck should have been discovered without much delay, and volunteer rescuers and salvagers would then assemble and use the provided rescue equipment to attempt a rescue of survivors.

There were some concerns that Captain Henry was guilty of barratry (the act of deliberately wrecking a ship for insurance money collection purposes). In support of this theory, it was claimed that Henry might have intentionally picked a suitable time and place to run the ship aground. If Henry's intention was to come ashore near a government rescue boathouse station, Deal was a good choice since it was located in one of the most populated coastal areas of any among the eight stations in existence by 1854. Hitting the outer sandbar at an hour and a half before low tide would also ensure that the vessel went aground and sustained enough damage from the surf to stay stranded. The ship would come to rest on the offshore slope of the outer sandbar where storm seas would eventually pound the vessel to pieces, inhibiting any attempts to refloat the ship. The vessel's master and his crew would, however, have the best opportunity to escape, and perhaps, some of the passengers would survive.

Notwithstanding any conspiracy theory, the site of the *New Era*'s stranding offered the best hope of a successful rescue, especially using the new government equipment available at Station No. 3, particularly given that the distance from the beach to the wreck was well within the range capability of the Manby mortar and lifecar. There were no reports of Deal Beach

being overwashed by waves, meaning that rescue efforts by volunteers using the beach apparatus should not have been impeded, even if the surf was too high to safely use the government surfboat. The storm that beset the *New Era* was a sou'easter not a winter nor'easter, and the typically warmer seawater temperatures of mid-November should have reduced the risk of hypothermia for survivors, unlike the situation associated with wintertime storms having colder water temperatures.

One advantage associated with the *New Era*'s grounding at Deal that did not exist with the *Powhattan*'s grounding at Long Beach Island was the road infrastructure available in the area around Deal Beach. While these roads were certainly not the paved roads of present day, they were of decent construction for that time and paralleled the beach about one mile inland, between the Shrewsbury River and Shark River Inlet, and below the inlet down to the Manasquan River. From these primary north–south routes were secondary roads that ran eastward at numerous points, providing access to farms as well as to fishing encampments on the beach. This road network also facilitated the movement by volunteers of federal rescue boathouse equipment and surfboats on wagons from the station sites up and down the coast so they could be deployed to the beach nearest a wreck. The proximity of farms also created the possibility that horses would be available for use in hauling any rescue equipment.

It was also easier gathering a rescue force of experienced, competent volunteer surfmen (including those who were typically employed by the state wreckmasters in that region) along the beaches near Deal than it was on isolated Long Beach Island. When surf and weather conditions permitted, local salvors could muster several competent surfboat crews. The proximity of a wreck to the New York area further enabled the dispatch from New York Harbor of any available steam-powered tugs to the scene.

As was related in the previous chapter, the rescue efforts supervised by Abner Allen using the Manby mortar failed because multiple shotlines fired out to the wreck failed and the rigging to enable the use of the lifecar was never set up properly. It would not be until the following day, when local wreckmasters and experienced surfmen were able to launch one or more surfboats from the beach, that any effective rescue efforts were made.

On November 12, 1853, a year before the *New Era* shipwreck, Israel I. Merritt, a special inspector employed by the Life-Saving and Benevolent Association of New York to visit and inspect the rescue boathouse stations, provided a report of his inspection visit to the New Jersey–area rescue boathouses to Walter R. Jones, Esq., then president of the association.

The Deadly Shipwrecks of the *Powhattan* and *New Era* on the Jersey Shore

In part of his letter, Merritt reported that the surfboats were in need of maintenance and that many of the mortar shot spiral wires were rusted and in poor condition for use.[58] As such, there is evidence that the spiral wires were a potential source of trouble for rescuers attempting to use the apparatus, particularly if the equipment was not receiving proper attention and care.

Captain Ottinger submitted a report (believed to have been in 1869) to N. Broughton Devereaux, then head of the United States Revenue Marine Bureau, in which he summarized:

> *At that terrible disaster the wreck of the ship "New Era" by which nearly three hundred human beings were drowned—it is said several spiral wires broke and the shot also were expended—I put ten shot at each of the first stations that were established, if other shot have been furnished and not carefully turned smooth so as to fit the bore of the mortar almost airtight much of the force of the powder was lost and the flight of shot would be wild.[59]*

A total of 170 *New Era* crew and passengers survived, due in large part to the local Deal citizens' provision of shelter, food and dry clothing. They also helped the survivors obtain transportation to New York or other destinations. There was apparently no remuneration provided to these citizen volunteers by the ship's owners for their donated kindnesses.

The actual numbers of *New Era* shipwreck survivors and deceased, however, is subject to speculation. Available evidence suggests that 28 of the 29 men in the crew survived. Of the original 397 passengers, 40 died of cholera and 2 or 3 were swept overboard earlier in the voyage, leaving about 355 passengers alive on board the ship at the time of her stranding. The agent for the marine insurance underwriters, Captain Brown, reported that 140 of the passengers and all but 1 of the ship's crew members survived, which would mean 28 crew members and 112 passengers surviving, and a death toll for passengers of 243 (although the death toll had been estimated in other sources as 222 passengers).

A reader of the *New York Times*, in a letter to the editor dated November 22, 1854, decried the fact that no punitive action had been initiated against the ship's owners, crew or the would-be rescuers on the beach. While there might have been an investigation of a sort, there is no published account of one having been conducted, suggesting that any such investigation conducted by the marine insurance underwriters were likely to have been kept private.[60]

CONCLUSIONS AND PROBABLE CAUSAL FACTORS

Based on the available archival records and contemporary accounts, the following are likely to be the true circumstance and causes associated with the loss of the *New Era*:

1. The approximate cause of the casualty was that Captain Henry, while approaching the entrance to New York Harbor, misjudged the position of the *New Era*. In the process, steering westerly on a port tack and under a heavy press of sail, he sailed his vessel headlong onto the New Jersey coast at Deal Beach. The *New Era* had been on a port reach when it grounded with the wind coming from nearly or slightly abaft the port beam. When Captain Henry braced the yards aback to port in an attempt to back off the shoal, the southerly wind drove the ship broadside to the beach, starboard side to the shore, with the ship's bow facing to the south. The artist's depiction of the event supports this conclusion.

2. The *New Era* first grounded on the outer sandbar and was stranded about two hundred yards off the beach near Deal, New Jersey. With a wind on the port beam and under full sail under a Beaufort Force 5, the *New Era* probably had been making a speed of eight to ten knots over the ground. Therefore, between 5:30 a.m. (when the last sounding of depth was made) and 6:00 a.m., the ship would have traveled between four to five nautical miles. This elapsed time of thirty minutes was sufficient to allow the vessel to pass over the ten-fathom curve and impact the outer sandbar.

 Despite Captain Henry's concern about staying off the Long Island coast, he should also have been concerned about the depths of water off the New Jersey coast. He failed to give particular attention to the impending changes in water depth as his ship approached the coast and properly consider the ship's course and speed when taking soundings and the imminent presence of the charted ten-fathom curve. A reported depth sounding of between twelve and fifteen fathoms at 5:30 a.m. would have been consistent with the ship's approach to the beach at Deal. Had soundings been taken every fifteen minutes, however, the presence of the ten-fathom curve would have been detected sooner, and Captain Henry then would have known that he was not approaching the Long Island coast where such soundings would have been inconsistent. He would have had enough sea room to effect a turn to starboard and wear offshore to deeper water.

The Deadly Shipwrecks of the *Powhattan* and *New Era* on the Jersey Shore

In view of the reported conditions of low visibility and the absence of any means for determining the ship's position other than from depth soundings, it must be concluded that a significant contributing cause of the stranding was Captain Henry's failure to order soundings more frequently than just hourly. Considering the recommendations in the period sailing directions publications concerning the dangers of the ten-fathom curve off the coast of New Jersey, a sounding interval of fifteen minutes or less would have been more prudent. It must be concluded, therefore, that Captain Henry's negligence rested on his failure to take proper soundings and failure to follow published safety recommendations, as would any other prudent mariner of his status and experience. Had Captain Henry taken a New York bar pilot on board when the services were likely to have been offered, he would have obtained the experience of a skilled, knowledgeable mariner who would have been exceptionally familiar with the hydrography of the New York Harbor approaches.

3. At the time of the stranding, the prevailing sea conditions allowed the *New Era*'s boats to reach shore safely. Therefore, it must be concluded that surfboats manned by competent surfmen might have been able to be successfully launched from the beach and, if the volunteers had done so, could have contributed to the successful rescue of most of the survivors on board the wreck. The federal rescue boathouse system failed in this instance, however, due to the apparent lack of competent volunteer surfmen to man the rescue surfboat. It is also possible that the later-reported poor condition of the metallic surfboat at Station No. 3 was a factor in Abner Allen's decision to forgo use of the surfboat. When rescues using surfboats occurred later on the morning of November 14, there was no mention that the government surfboat had been used.

4. The distance to the wreck lay well within the maximum range of the government-supplied Manby mortar, as evidenced by the several reported successful shots falling across the ship. Equipment failure probably occurred, though, most likely relating to failures of the spiral wires with the mortar shot. Because it took at least four tries to send the first shot across the wreck and subsequent attempts (though at least two subsequent shots fell across the wreck) depleted the inventory of shot at the station, the circumstances suggest that there had been inadequate maintenance of the rescue boathouse's equipment, in addition to an absence of training and a lack of exercising and firing

the mortar. It is also not especially surprising that neither the local life-saving benevolent society nor the secretary of the treasury admitted that the spiral wire problem had been reported to them before the disaster. This failure can also be attributed to the absence of paid keepers and drilled surfmen.

5. Captain Henry failed to exercise a proper level of discipline among his crew. The crew certainly displayed a lack of discipline by deserting their posts and abandoning the passengers to the perils of shipwreck. Had the crew properly performed their duties on board and in the first boat that Captain Henry sent ashore to rig a rescue line, and if they had remained at their posts on board the ship and been trained to understand the method by which the beach apparatus should be rigged, most of the deaths following the stranding would have been prevented.

6. In view of the fact that the ship's hull remained intact until the following morning, it must be concluded that the number of deaths would have been significantly higher had the ship had not been materially sound.

7. The loss of life among the passengers indicates poor leadership by Captain Henry in that he allowed passengers to be exposed to the forces of sweeping seas across the ship's deck. The earlier passenger deaths from cholera (which today is recognized as being directly attributable to consuming contaminated water or food) indicates lax food and water quality standards allowed by Captain Henry on board his ship for passengers, especially since no crew members died of that disease. As such, the ship callously failed to provide a safe environment for its passengers in many aspects, and this attitude reflects poorly on the vessel master and his officers.

8
AFTERMATH

It's always a challenge to differentiate between the cause of an accident and the result of the accident. Even though the *Powhattan* stranded on a sandbar, the large loss of life among the passengers and crew was not because of the stranding itself but instead the result of a number of factors associated with the ship's grounding: a catastrophic material failure of the *Powhattan*'s hull structure; an error in navigation by the ship's master or officers; the inability of the vessel to withstand the storm conditions of wind and sea; loss of control of the ship's movement by the captain; the possible deliberate act by the shipmaster to beach the ship rather than sinking at sea in order to save as many on board as possible; the failure of the volunteer-manned rescue boathouse station system in terms of poor leadership, inadequate location, poorly maintained rescue equipment and the failure to effectively utilize the rescue equipment in a timely manner.

The federal boathouse system's iron-hulled Francis surfboats, the purchase of which had expended a sizeable portion of the $10,000 federal funding allocation, had been summoned for use at both the *Powhattan* and *New Era* shipwrecks. They failed, however, to be properly employed, whether a result of neglect or from a lack of qualified volunteers, although wreckmaster-owned surfboats were successfully employed at the *New Era* wreck on the day after the grounding. Use of the beach apparatus, while successful in getting a shotline to the wrecked *New Era*, was a failure in that the lifecar was never employed at either the *Powhattan* or the *New Era* shipwrecks.

AFTERMATH

Local surfmen, marine insurance agents, wreckmasters and United States Revenue Marine officers all had at least some degree of confidence that the volunteer-manned federal rescue boathouse system could succeed if a sufficient number of skilled volunteers could be available at the scene of a shipwreck and if the available boathouse station equipment was properly utilized in time to attempt a rescue. While that was a reasonable assumption for well-populated coastal areas such as Deal Beach, it surely was not the case for sparsely populated Long Beach Island in the early to mid-1800s, particularly during the winter months when severe storms were typically experienced. In the case of the *New Era* shipwreck, which went aground in the immediate vicinity of a rescue boathouse and in an area that had a well-established year-round population, even such an optimal situation for a rescue can still result in a disaster when responders and ship's crew members fail to demonstrate proper judgment and actions.

While a well-developed federal response doctrine did not exist in 1854, common sense surely did. The repeated warnings and urgings of supervising United States Revenue Marine officers, along with the protests of unpaid rescue boathouse keepers, demanding proper training and material support for the federal boathouses and equipment following their establishment in 1849 and the early 1850s were, unfortunately, ignored by a very cost-conscious Congress. Their complaints, though, clearly demonstrated the serious concerns they had for properly maintained equipment, the necessary skilled manpower to use the equipment and the overall effectiveness of the system.

Documentary evidence regarding the material condition of the rescue equipment stored in Station No. 7, located at Harvey Cedars on Long Beach Island around the time of the *Powhattan* shipwreck, indicates that there were problems. On October 7, 1854, Samuel C. Dunham, acting as a special inspector for the secretary of the treasury, visited this station and submitted the following important negative observations:[61]

> -*One surf or life boat* [sic] *in bad order rusting out*
> -*One boat wagon, wanting new bolsters, chuck and sword*
> -*One life car* [sic]*, with India float fenders, out of order*
> -*Ten spiral wires, in bad order*

Dunham also inspected Station No. 3, which had been used in the *New Era* shipwreck response. Similar equipment deficiencies were also observed:

-One surf or life boat [sic] *(new boat ordered) always out of order, of same
make as that in Station house No. 1.*

-One boat wagon, requires new bolsters, chucks and sword.

-One life car [sic], *with India rubber float fenders out of order.*

-One bundle match rope; wasted and in bad condition.

-Ten spiral wires, in bad order.

The most critical items of rescue equipment (the metallic surfboat and the metallic lifecar) were reported to be in poor material condition at both stations and another important item, the spiral wire connectors for the Manby mortar shot and shotlines, were in bad condition. From this inspection report, therefore, it can be reasonably concluded that, even if the government metallic surfboat and beach apparatus had arrived in time to be used at the scene of the *Powhattan's* wreck, there probably would have been severe equipment failures that, by themselves, would have resulted in a failed rescue attempt. That Abner Allen and his volunteers also experienced difficulties in their response to the *New Era* shipwreck might also be due to these equipment problems.

The *Powhattan* shipwreck occurred in the desolate area that Long Beach Island was back in the 1850s, whereas the *New Era* shipwreck occurred in the Deal Beach area, which was, by that time, a moderately well-populated community. The comparative competence and qualifications of the responders in each of these shipwrecks is also of note. Wreckmaster Jennings of the *Powhattan* shipwreck managed a business concern (the Mansion of Health) that was a commercial rival to those associated with the keepers of the two government rescue boathouse stations located to the north and south of his establishment and the scene of the shipwreck. It makes for interesting speculation to consider what relationship Jennings had with these keepers and what provisions were in place for the use by Jennings and any of his volunteers of the government rescue equipment. Despite the criticisms of Jennings in the aftermath of the *Powhattan* shipwreck, he was later given an appointment as the keeper of the new government rescue boathouse station erected at the *Powhattan* wreck site. There were no complaints of incompetence against keeper Abner Allen at the wreck of the *New Era*, and Allen continued to serve as the keeper of Station No. 3 for some time after the disaster.

United States Secretary of the Treasury Guthrie sent a post-disaster commentary letter to Senator Hamlin, who had inquired about these tragic shipwrecks, and it would seem that a careful assessment had been made

of the extent to which the federal rescue boathouse system and the local wreckmaster (in this case, Jennings) had a negative impact on the outcome of the shipwreck:[62]

> *The ship* Powhattan *a short time since went on shore some six or seven miles from a station, and in consequence of a storm prevailing at the time, the apparatus did not reach the spot until it was too late. The result was that 300 persons perished, who might have been saved if the apparatus had been at hand. This distressing loss of life, and the opinions of the most intelligent persons conversant with wrecks upon these coasts, have satisfied me that the stations ought to be doubled in number, so as to be but five miles apart, instead of ten, and I am equally satisfied that instead of being left to the voluntary care and incidental attention of the associations mentioned or of individuals, the business should be put in the hands of proper persons, accountable to the Department.*

In a letter written around 1869 by Captain Douglas Ottinger of the United States Revenue Marine (the officer to which was given the assignment for the establishment of the federal rescue boathouse system along the New Jersey and Long Island coasts) to N. Broughton Devereux, then head of the United States Revenue Marine Bureau, Ottinger stated:[63]

> *At the wreck of the ship* Powhattan *there was also much loss of life mainly from the lack of effectual assistance.*

He also provided recommendations on equipment that should be included at the rescue boathouses to address some deficiencies and shortcomings.

The oversight role by the federal government (especially by the United States Treasury Department, which was specified in Congressional legislation as the responsible federal agency) of the rescue boathouse stations was extremely limited and was essentially dependent on whatever attention the United States Revenue Marine and private benevolent associations could bring to bear on the system. There was no method of accountability between the appointed keeper of each boathouse station and the federal government nor was there any process for regular inspections of stations and equipment. Because the enacting Congressional legislation never included a mandate for either volunteer training or maintenance of the rescue equipment and station buildings, over time, the buildings and equipment gradually deteriorated, with no assurance that any of the equipment, even if available, could be properly employed in a rescue attempt.

THE DEADLY SHIPWRECKS OF THE *POWHATTAN* AND *NEW ERA* ON THE JERSEY SHORE

A major limitation was the relatively small amount of funding the government was willing to invest in the system, even at nineteenth-century levels of federal spending. The initial $10,000 sum cited in the 1848 Congressional legislation only covered the costs associated with the establishment of a total of eight stations along a sixty-mile stretch of New Jersey coastline. Revenue Marine Captain Ottinger, who oversaw the expenditure of this appropriation, sought the advice and participation of knowledgeable locals to help create a system that would be the best affordable given that amount of funding, and it would seem that he did the best he could. Ottinger placed the eight original stations on exposed beach sites where they might do the most good, although these sites were, on average, about ten miles apart, thereby limiting the ability of responding volunteers to gain access to the rescue equipment of the next station up or down the coast from the primary station (as was the case at the wreck of the *Powhattan*). By 1854, however, the equipment supplied in 1849 by the federal government had clearly deteriorated since it had not been properly maintained.

Using volunteers to attempt rescues using government-supplied rescue equipment made sense, but only if these people were competent enough or could be trained to properly use the equipment. It is noteworthy to consider the long, successful histories of the Royal National Lifeboat Institution of Great Britain, Scotland and Ireland (still very much in effective operation today) and of the Massachusetts Humane Society. The critical feature of these two programs is the employment of *trained* volunteer rescuers, not simply any person available at the scene. Risking one's life to save another is heroic; however, in the 1850s, the potential risk was much greater for losing one's own life in a rescue attempt given the lack of training and well-maintained equipment. Many volunteer rescuers perished in the 1840s and '50s in the aftermath of their heroic exploits, and in those days, before life insurance and family care, if a head of a household lost his or her life, there was no assistance available to the rescuer's next of kin except other family resources or charity.

Captain Ottinger and the other Revenue Marine officers tasked with establishing the federal rescue boathouses tried to assign in as careful a manner as possible the keys and responsibility for each boathouse to the most reliable and competent individual they could find at each site. Some of these keepers exercised initiative, obvious from the early successful rescues using this equipment, and it can only be assumed that in these cases, the keeper had secured the cooperation of all local resources, including wreckmasters, marine insurance underwriter agents and experienced boatmen and surfmen.

It is also evident, however, that this level of initiative and competence did not extend to the keepers of all of the federal stations.

In the immediate aftermath of the *Powhattan* shipwreck disaster, the only significant change in the federal system that was recommended and adopted by Congressional Act on August 14, 1854, was the establishment of additional rescue boathouse stations at sites that were located in between those existing in 1854, in an attempt to reduce the between-station interval to about five miles or less. The hope was that establishing more rescue stations would rectify the problem of having sites spaced too far apart to be mutually supporting and to account for the difficulties in transporting the rescue equipment over long distances of uninhabited beaches with no roads and where storm seas might wash over the beachfront routes to the wreck scene. As a result, one of these new stations was built in 1856 at the site of the *Powhattan* wreck.

On October 7, 1854, Samuel C. Dunham submitted a report recommending locations for new life-saving stations as authorized by the act of August 14, 1854.[64] In compiling this recommendation, Dunham ensured that one of the new stations would be located at the scene where the *Powhattan* shipwreck had taken place only six months earlier. Initially, Dunham identified the new station as "New Station H." It was later re-designated "Station No. 15." It was located 1.50 miles south of the site of the Mansion of Health. The location of this new station was also selected to be mutually supportive of the original Station No. 7, which was about 4.25 statute miles/3.70 nautical miles away.

This still did not address the limitations inherent in a coastal rescue system manned by unpaid, untrained volunteers. As was described earlier, the *New Era* shipwreck occurred almost immediately opposite rescue boathouse Station No. 3, and there had been no issues with the availability of potential volunteers because of the local year-round beach population in Deal. It was not until additional Congressional legislation was passed on December 14, 1854, that some positive changes were made that provided for the employment of paid station keepers plus one district superintendent each for the New Jersey and Long Island coastal areas. It was hoped that this change would rectify the problems associated with the deterioration of unattended rescue equipment at the station. It did not, however, address the problems associated with the system's reliance on untrained volunteers to respond to a shipwreck.

It also seems that the Treasury Department itself was guilty of mismanagement of the federal rescue boathouse system. The department never seemed to grasp the importance and significance of the new rescue

stations that had been placed in its charge by Congress. Successive political appointees to the department repeatedly failed to act on the recommendations of the officers of the United States Revenue Marine, which had cited shortcomings of the system, recommended the training of keepers and selected volunteers by Revenue Marine officers and reported equipment problems that had been identified from station inspections (such as the Manby mortar shot spiral wire deterioration problems). Even in those instances when a private organization like a benevolent association or a board of marine insurance underwriters provided some supervision of the stations in their respective areas, there were problems. Stations were allowed to deteriorate, with these organizations apparently limiting their involvement to merely forwarding repair bills to the Treasury Department for reimbursement.

Another tragic aspect to the *Powhattan* and *New Era* disasters was the lack of any federal laws or regulations for American-registered sailing vessels that required certain basic safety features or on-board equipment, despite the fact that such laws had already existed for American-registered vessels propelled by steam engines. Had the *Powhattan* and *New Era* been propelled by steam engines instead of sails, they would have been required by law to have been inspected by government inspectors and certificated as being safe, be operated by persons holding mariner licenses and carry specific types of life-saving equipment.[65]

Again, it took major sailing ship disasters like the *Powhattan* and *New Era* shipwrecks to force positive changes. Congress eventually became concerned enough for the safety of immigrants on passenger ships to pass legislation entitled the Passenger Act of August 2, 1882, which represented the first attempt by the federal government to protect passengers on American-registered sailing ships. Even this, however, was limited in that sailing vessels under 700 gross tons were exempt. These vessels would not be subject to the same safety inspection laws until the later enactment by Congress of 30 Statute 756, on December 21, 1898. Interestingly, the *Powhattan*, at 599 gross tons would not have been required to be inspected even in 1898. Any deficiencies in its hull or equipment would not have been detected by a government inspection even forty-four years later.

Even with improvements in station placement and coverage, the employment of paid station keepers and district superintendents and the implementation of marine safety regulations for sailing vessels, serious deficiencies in the federal rescue boathouse system persisted. These problems were only made worse by the effects of the Civil War. Following

the end of the war, what was left of the federal system was in a serious state of disorganization and dilapidation. Moreover, it was the occurrence of additional horrific shipwrecks with significant loss of life during the winter of 1870–71 that finally resulted in the ultimate solution: Congress's creation of the United States Life-Saving Service as part of the United States Treasury Department on April 20, 1871. The Life-Saving Service had a new system of appropriately located, constructed and equipped stations manned during the most dangerous fall and winter storm seasons (later changed to year-round) by crews of paid, professionally trained surfmen supervised by paid, professional station keepers and district superintendents, with United States Revenue Marine commissioned officer oversight and technical assistance.

For Sumner I. Kimball, the new general superintendent of the United States Life-Saving Service, one of the first and most important tasks was an accurate assessment of the condition of the old federal network of rescue boathouses and equipment. For this task, Kimball selected one of the United States Revenue Marine's best officers, Captain John Faunce, who was extremely professional and thorough (and ruthless) in his investigations, observations and reports. The final report of his inspection visit to every one of the existing rescue boathouse stations (all of which were located in New Jersey and on Long Island), which included an assessment of each station's keeper and the regional superintendents, was both revealing and damning of the disgracefully poor state to which the original federal system had degraded by 1871.[66] It also provided a very clear road map to the necessary reforms and improvements that would be critical to reinvent the system and produce a new organization that would have state-of-the-art facilities and equipment along with truly proficient personnel.

From these ashes, the new system was created. From 1871 to 1872, Congress authorized the construction of twenty-nine new stations consisting of the primary station house (which usually included the boatroom on the ground floor and the crew's dormitory on the second floor) plus any required outbuildings (such as a cookhouse building and outhouse). These new station buildings were not just storage facilities for rescue equipment but were also living quarters for the station keeper and surfman crew (which typically numbered six to eight men) and served as a place of shelter for shipwreck survivors. Along with the new station buildings, the latest and best rescue equipment available was procured for each station. Along with the material improvements, standard procedures were adopted for the employment of the rescue boats and beach apparatus and weekly periods of instruction and drill in the proper

use of all equipment were required. Also included was a process of regular inspections of each station by the district superintendents, with the assistance of assigned officers of the United States Revenue Marine.

In terms of the rescue boats to be employed, it included the provision of at least one wooden-hulled pulling surfboat (initially of the Jersey type design, similar but larger in design and construction to the Sea Bright Skiff that many New Jersey–area beach lifeguards use today). For stations located at a harbor or on a protected body of water where a marine launchway could be constructed, a slightly larger wooden-hulled, self-righting and self-bailing pulling lifeboat was provided (very similar in design and construction to the wooden-hulled pulling lifeboat types then in use by the Royal National Lifeboat Institution).

In terms of the beach apparatus to be employed, it was the development and adoption (in 1875) of the Lyle gun, a very simple but effective, lightweight transportable gun capable of firing a projectile with attached shotline a maximum range of six hundred yards off the beach. The Lyle gun was a significant improvement over the original Manby mortar and shotline. The firing of the shotline with a Lyle gun was then followed by the rigging of a much-improved beach apparatus that featured the use of the lightweight breeches buoy rather than the heavy and bulky lifecar.

For the first time, the area of coverage for this system was extended beyond just the coastlines of New Jersey and Long Island to also include New England, the mid-Atlantic states (the area around the Outer Banks of North Carolina), the Great Lakes and select locations on the Gulf of Mexico and along the Pacific Coast. This additional coverage paid almost immediate dividends in terms of successful rescues and saved lives (over the period of June 1872 to June 1873, a total of 234 shipwreck survivors were rescued from a total of thirty-two shipwrecks) using the new equipment and procedures. Over the remaining years of the nineteenth century, this network was further expanded to add additional stations where needed (by June 1900, there were a total of 269 fully manned stations in operation across the United States), and the means were established for the development, testing and adoption of improved items of rescue equipment, including better rescue boat designs, improved beach apparatus–related items and articles of uniform and working attire for the crews. Also included was the preparation and publishing of an annual report to Congress and the public, recapping the key events of the previous year, critically important rescues, lessons learned and new developments in equipment and technology.

AFTERMATH

Although it took tragedy and loss of life to force positive changes, these changes were eventually made, resulting in a responsible and effective federal government agency without peer among the rescue organizations of the nineteenth century, trained and equipped to perform rescues of shipwreck survivors under even the worst of conditions.

THAT THEY SHALL NOT HAVE DIED IN VAIN

It is a common saying among United States Coast Guard personnel that all of the safety-related rules and regulations that exist today, whether for the Coast Guard itself or for the maritime industry in general, are "written in blood." In other words, these safety requirements were not created for hypothetical reasons or situations but as the result of tragic accidents, which might have been prevented if additional safety measures had been taken. The history of and aftermath from the *Powhattan* and *New Era* shipwrecks is no different in this regard. Tragically, it took the deaths of hundreds of passengers and crew members from the wrecks of these two ships to compel the United States to reevaluate the original 1848 federal rescue boathouse system and to improve the measures taken to provide a reliable and effective means of rescue for those shipwrecked on the coastlines of the United States.

The need for continual safety improvements in ship construction, maintenance and life-saving equipment did not stop with the *Powhattan* and *New Era* wrecks. Even a cursory review of maritime history will show that there have been many tragic shipwrecks and marine accidents since those days in the 1850s, with the root causes of these typically being the result of neglect or lack of attention to detail on some aspect of marine transportation safety. A few well-known examples include:

- The sinking in the northeast Atlantic Ocean of the British steam-propelled ocean liner *Titanic* in 1912 after accidentally striking an iceberg, with the loss of 1,517 passengers and crew. It resulted in reforms to ship watertight compartmentation construction as well as

in the provision of adequate numbers of lifeboats for every person on board.

- The burning of the American motor vessel *Morro Castle* in 1934 in plain sight of the New Jersey coastline, with most of the ship's passengers having been left on the ship by the escaping ship's crew members, with 137 passengers and crew members lost. It resulted in reforms in ship fire prevention/protection features and construction, as well as in shipboard safety procedures for passengers and crew.

- In 2012, the accidental grounding and sinking of the Italian cruise liner *Costa Concordia* in the Mediterranean Sea with the loss of thirty-two passengers, the result of careless navigational procedures and a lack of assistance by crew members for passengers trying to escape the sinking ship.

The reader will note that none of these ships were sailing vessels, that all of these accidents occurred in the twentieth century or later in what were more modern conditions of maritime transportation and that all of these ships were subject to some form of official marine safety inspection, certification and crew member licensing prior to their tragic voyages. All of these ships were also considered in their day to be state-of-the-art in terms of their safety features and crew proficiency. Yet in each accident, the causes and resultant losses of life were later deemed to have been entirely preventable had more precautions been taken.

Although the United States has, in the years since the *Powhattan* and *New Era* disasters, gradually evolved and improved its own national marine safety laws and regulations, it really took the *Titanic* disaster to instigate a truly international effort at improving maritime safety. The initial attempt at this, the 1914 Safety of Life at Sea (SOLAS) Convention, was never put into effect because of the outbreak of World War I. Subsequent SOLAS conventions created and implemented by the new International Maritime Organization (IMO) in the years 1929, 1948, 1960 and 1974 have been effective in establishing a global system of maritime safety requirements and standards applicable to all shipping regardless of nationality. Definite improvements have been achieved in the requirements for safe vessel construction and maintenance standards, required on board life-saving devices and lifeboats for all passengers and crew and minimal standards of proficiency to which ship crew members must by trained and licensed, such that there should never be a repeat of a shipwreck disaster and loss of life on the scale represented by the *Powhattan* and *New Era*.

THE DEADLY SHIPWRECKS OF THE *POWHATTAN* AND *NEW ERA* ON THE JERSEY SHORE

Significant improvements have also been achieved in maritime search and rescue capabilities, not just for the Coast Guard but for many other maritime rescue agencies and organizations across the globe. With the advent of satellite navigation and communications capabilities, long-range distress message transmission and receipt has now become possible, with very precise determinations of a vessel's location to aid rescuers in getting to the scene as quickly as possible. The use of helicopters and high-speed, shore-based motor lifeboats helps to significantly reduce rescue response time. With the development of mass evacuation and rescue procedures, rescue crews are now better equipped to deal with situations requiring the rescue and evacuation of large numbers of survivors from vessels like cruise liners.

The combination of better marine safety rules and regulations, along with improved rescue methods and equipment, has helped to reduce the rates of shipwreck and loss of life. Maritime transportation, however, whether on the open ocean or on a local lake, has been and will continue to be a potentially hazardous business and will always require the application of common sense and prudent judgment by mariners, not just strict laws and rules, to prevent future catastrophes. The critical aspect to this, however, is that none of the persons who have lost their lives in this endeavor should have died in vain, that the lessons learned from tragedy are always taken to heart and improvements to maritime rules should be immediately made to prevent a future tragedy. It is in this vein that the authors maintain that the victims of the *Powhattan* and *New Era* shipwrecks and their deaths helped to serve a higher purpose.

Appendix A
Glossary

aft: Toward the rear portion of a vessel.

bilge: The flat part of a vessel's bottom on each side of the keel, on which the vessel would rest if aground. The bilge extends out to where the hull frames turn upward, an area also termed the "turn of the bilge."

block: Nautical term for a pulley.

boom: A long pole or spar used to extend the bottom of a sail.

bow: The front end of a vessel.

chart: A highly detailed, map-like presentation of landmasses, bodies of water and depths thereof, shoal areas, channels and aids to navigation; includes latitude and longitude scales along each edge to allow the mariner a means of measuring the position of the vessel.

chronometer: A specialized, highly accurate marine clock, usually set to the time at the Prime Meridian in Greenwich, England (at 0°0'), for the purposes of making celestial observations using a sextant.

course or heading: The direction a vessel is being sailed or steered with reference to either a magnetic compass (which indicates direction in degrees of arc referenced to the North Magnetic Pole) or (today) a gyrocompass (which indicates direction in degrees of arc referenced to the True North Pole).

draft: The vertical distance from the water's surface down to the bottom of a vessel.

floor: The lengthwise planks that are secured to a vessel's frames at the lowest level inside the hull.

forward: Toward the front portion of a vessel.

frames: The ribs of a vessel, consisting of curved timbers secured to the keel and extending upward to the gunwale.

freeboard: The vertical height of the deck or gunwale of a vessel above the water's surface.

Fresnel lens: An optical device, invented by the nineteenth-century French physicist Augustin Fresnel, using mounted ground glass prisms to concentrate and project the light beam of a lighthouse, providing a very focused and concentrated light beam with greater visible range. The Fresnel lens replaced an older and much less effective system of mirror reflectors mounted in a lighthouse for light beam projection.

gaff: A spar used to extend up and out the upper edge of a sail.

gunwale: The topmost edge of the side of a vessel's hull.

halliard (or halyard): A line or rope used to hoist and lower sails, booms or yards.

helm: The equipment used to steer a vessel, usually employing either a tiller (which is directly attached to the top of the rudder) or a steering wheel (which is remotely connected to the rudder by means of cables, chains or by electrical/hydraulic steering engine/motor controls).

keel: The principal timber of a vessel, extending along the bottom from the front of the vessel to the back of the vessel. The keel supports the entire framing of the vessel.

knot: A unit of vessel speed, with one knot being equal to one nautical mile per hour.

latitude: The angular distance in degrees and minutes of arc north (above) of or south (below) of the equator, to a maximum of 90° at the North and South Poles.

lead line: A large lead weight with attached rope used to measure the water depth around a vessel. The rope is marked at intervals by bits of cloth or leather to indicate the depth in fathoms, with one fathom being equal to six feet in depth.

leadsman: The sailor using the lead line to measure the water depths adjacent to a vessel.

lee, or leeward: The downwind side, opposite to the windward side. A so-called lee shore nearby to a sailing vessel was the most dangerous situation for safe navigation as the wind would have a tendency to push the vessel onto the shore.

lifeboat: Any boat designed for the purposes of saving life. Lifeboats could be carried by and launched from a ship or could be shore-based.

In design, shore-based lifeboats were usually larger than surfboats and more seaworthy.

lifecar: An egg-shaped rescue capsule constructed of sheets of corrugated iron, which (depending on the design) could hold from four to six persons lying down inside. The lifecar would be sent out from the shore to a shipwreck using a system of ropes and pulleys, and shipwreck survivors would climb into the lifecar, close the hatch and be pulled back to shore by the volunteer rescue crew on the beach.

log (or chip log): A line of rope graduated in distance, with a drogue attached, that is used to determine a vessel's speed through the water in nautical miles per hour.

longitude: The angular distance in degrees and minutes of arc to the east or west of the Prime Meridian in Greenwich, England (at 0°0'), to a maximum of 180° in either an easterly or westerly direction.

lunar distance: A celestial navigation technique using observations of the moon to determine longitude, which did not require precise measurements of the exact time of observation. This method was commonly used prior to the availability of ship chronometers.

mast: The vertical, round-shaped pole on which sails can be rigged on a vessel.

nor'easter: A severe wintertime coastal storm that could occur along the Eastern Seaboard of the United States, wherein the storm winds would appear to be coming from a northeasterly direction, usually at near-hurricane velocities.

port: The left side of a vessel when standing on board and looking forward toward the bow.

reef or reefing: The act of reducing or shortening the sails of a vessel to protect the sails and the vessel against damage in storm condition winds.

rudder: A flat board or set of boards hung on a vessel's sternpost (by means of metal fittings termed "gudgeons" and "pintles"), used for steering the vessel.

sextant: A handheld navigation instrument used to measure the angle in degrees and fractions of a degree in arc between the visible ocean horizon and a celestial object such as the sun, moon, planets or stars. With knowledge of the precise time at the moment of the observation or measurement, such angular measurements could be mathematically converted (using a nautical almanac and a table of spherical trigonometric solutions) to a celestial line of position. An older, less accurate version of this type of instrument was called an octant.

sheer: The rise of the longitudinal lines of a vessel from the horizontal, as seen in looking along the vessel's side.

sheet: Line or rope attached to a sail used to hold the sail in position.

shrouds: Lines or ropes stretched from the masthead to a vessel's side rails on each side of the vessel, supporting the sailing rig masts.

soundings: Measurements taken of the water depth using a lead line.

starboard: The right side of a vessel when standing on board and looking forward toward the bow.

stem: The upturned portion of the keel at a vessel's bow to which the hull planks are secured.

stern: The rear end of a vessel.

sternpost: The primary structural part of the stern of a vessel that is connected to the vessel's keel on which the rudder is usually mounted. The sternpost is connected to the vessel's keel.

strakes: Continuous lines of fore-and-aft hull planking, with each line of planks termed a "strake."

surfboat: A boat specifically designed for use in and launching/recovery through beach surf. Most boats of this type were wooden and could be propelled by oars, sails or (later, with the adoption of marine-type engines) motors. In design, surfboats could be single-ended (sharp-shaped bow plus squared-off stern) or double-ended (sharp-shaped bow and stern).

windward: The upwind side, being the opposite of the leeward side.

wrecker: An individual who responds to a shipwreck for the purposes of salvaging cargo or portions of the ship itself. Some wreckers acted on their own behalf while other wreckers were in the employ of a state government or a marine insurance company for these purposes. Such wreckers would also try to rescue survivors if weather and sea conditions were not too dangerous. The person in charge of a group of wreckers was usually referred to as a wreckmaster.

yard: The round-shaped pole or spar hung from a mast on which a sail can be attached.

IMPORTANT HULL AND SAIL PLAN FEATURES OF A SAILING SHIP

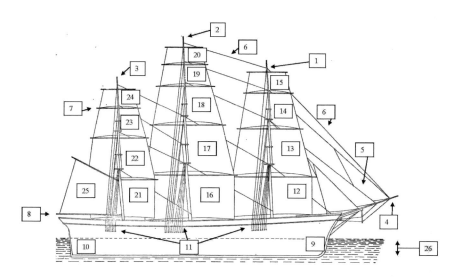

Sail and rigging arrangement for three-masted ship-rigged sailing vessel. *Courtesy of the authors.*

1. foremast
2. mainmast
3. mizzenmast
4. bowsprit and jib boom
5. jib sail and stay sails
6. stay
7. yard
8. boom
9. bow
10. stern
11. shrouds, backstays, and ratlines
12. foresail
13. fore topsail
14. fore topgallant sail
15. fore royal sail
16. mainsail
17. main topsail
18. main topgallant sail
19. main royal sail
20. main skysail
21. mizzen sail or cross-jack sail
22. mizzen topsail
23. mizzen topgallant sail
24. mizzen royal sail
25. spanker sail
26. draft of ship

Appendix B
Federal Rescue Boathouse Stations of 1849–50

The only known period photograph of a federal government rescue boathouse station (this one being No. 4, located at Long Branch, New Jersey). The view is looking at the rear of the boathouse (the main doors are located at the far end), showing the smaller cedar hull wooden pulling surfboat on its wagon, the Manby mortar with shot and the Francis metallic lifecar. The ocean is located to the right background of the photograph. *Courtesy of the Monmouth Historical Society.*

STATION LISTING FOR NEW JERSEY

NAME	YEAR BUILT	STATION NUMBER/DESIGNATION		
		1849	1855	1872**
Sandy Hook	1855	—	1 (old A)	1
Spermaceti Cove	1849	1*	2	2
Seabright	1872	—	—	3
Monmouth Beach	1849	2*	3	4
Long Branch	1855	—	4 (old B)	5
Deal	1849	3*	5	6
Shark River	1872	—	—	7
Wreck Pond/Spring Lake	1849	4*	6	8
Squan Beach	1855	—	7 (old C)	9
Bay Head	1855	—	8 (old D)	10
Mantoloking	1872	—	—	11
Chadwicks	1849	5*	9 (old E)	12
Toms River	1855	—	10	13
Island Beach	1849	6*	11	14
Cedar Creek	1872	—	—	15
Forked River	1855	—	12 (old F)	16
Barnegat	1855	—	13 (old G)	17

Name	Year Built	Station Number/Designation		
		1849	1855	1872**
Loveladies	1872	—	—	18
Harvey Cedars	1849	7*	14	19
Ship Bottom	1854	—	15 (old H)	20
Long Beach	1872	—	—	21
Bonds	1849	8*	16	22
Tuckers Island/Little Egg	1854	—	17 (old I)	23
Little Beach	1872	—	—	24
Brigantine	1849	9	18	25
South Brigantine	1872	—	—	26
Atlantic City	1849	10	19	27
Absecon	1872	—	—	28
Great Egg	1854	—	20 (old J)	29
Beazley's/Ocean City	1849	11	21	30
Pecks Beach	1872	—	—	31
Corson Inlet	1854	—	22 (old K)	32
Sea Isle City	1872	—	—	33
Townsend Inlet	1849	12	23	34

Appendix B

Name	Year Built	Station Number/Designation		
		1849	1855	1872**
Tathams	1854	—	24 (old L)	35
Hereford Inlet	1849	13	25	36
Holly Beach	1872	—	—	37
Turtle Gut	1854	—	26 (old M)	38
Cold Spring	1854	—	27 (old N)	39
Cape May/ Bay Shore***	1849	14	28	40

*One of eight initial constructions during the campaign of 1848–49.

**The U.S. Life-Saving Service was created in 1871, and new stations of larger size and capacity were constructed to replace the original 1849–55 rescue boathouse stations. These 1871–72 buildings were the first station facilities intended to be staffed by professional crews plus a keeper.

***Later supplemented in 1876 with the establishment of a new station at Cape May Point (using the station building from the U.S. Life-Saving Service exhibit at the 1876 Centennial Exposition in Philadelphia); Station Cape May Point was assigned No. 40, and original Bay Shore station site was assigned No. 41.

Appendix B

Typical Station Equipment List

Item	Number Supplied
26-foot Francis metallic (corrugated galvanized iron) pulling surfboat	1
16-foot oars	14
Surfboat wagon with 5in. tread iron wheels	1
Francis metallic (corrugated galvanized iron) lifecar	1
Manby mortar on bed	1
24-pound iron mortar shot with fastening wires	10 shot
Tin box of signal rockets and blue lights	1
Globe lanterns	2
India rubber buckets	2
Boat hooks with line	2
Grapnel or boat anchor with line	1
4½-inch manila hawser	1 720-foot length
2½-inch manila line	2 720-foot lengths
Flax shotline	3 900-foot lengths
Spiral wire (for mortar shot)	12 wires
Coiling frame and box	1
Brass priming wire	1
Shot hooks	2

Appendix B

Item	Number Supplied
Copper powder magazine	1
Gunpowder	4 pounds
Quickmatch tin box	1
Match rope	1 coil
Match staff	1
Land Anchor	1
Bull's-eye, strap and hook	1
Reef tackle with double and single block (pulleys)	1
Shovel	2
Hand saw	1
Nail hammer	1
Hand axe	1
Nail gimlet	1
Spike	1
Nails	1 pound
Marlinspike	1
Flax twine	1 1-pound ball
Spun yarn	1 3-pound ball
Match safe	1

Item	Number Supplied
Matches	3 boxes
Oil betty/lamp filler	1
Lamp wick	1 ball
Lamp oil	1 gallon
Paint oil (boiled linseed oil)	2 gallons
Spirits of turpentine	½ gallon
Paint brushes	2
White lead	1 23-pound keg
Black lead	1 23-pound keg
Sponge (natural)	1
India rubber cloth tarp	9 yards
Oakum	4 pounds
Box stove	1
Zinc	1 piece
Cord wood	1 cord

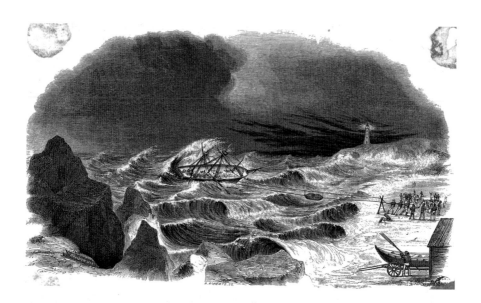

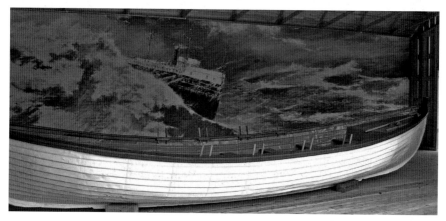

Top: Artist's concept drawing of the rescue response to the *Ayrshire* shipwreck of January 1850, showing the apparatus rigged between the beach and the ship for the use of the lifecar. The Francis metallic surfboat is shown on its wagon by the boathouse. This drawing, however, erroneously depicts the local geographic features and the proximity of the boathouse and Barnegat Lighthouse to the site of the shipwreck. *From William C. Bryant's* Francis' Metallic Life-Boat Company.

Bottom: One of only two known surviving examples of the twenty-seven-foot-long, double-ended Francis metallic pulling surfboat, this one belonging to the Saugatuck-Douglass Historical Society in Michigan. *Courtesy of Saugatuck-Douglass Historical Society.*

Opposite: The first rescue boathouse (No. 1) constructed by the federal government pursuant to the act of August 14, 1848, which was located at Spermaceti Cove, New Jersey, about midway along the Sandy Hook peninsula, circa 1930s. Relocated in the early 1950s, this building still survives as a display at the Navesink Twin Lights Historical Site, in nearby Highlands, New Jersey. *Courtesy of the U.S. Coast Guard.*

FIRST-LIFE-SAVEING
STATION
SPERMACETI-COVE

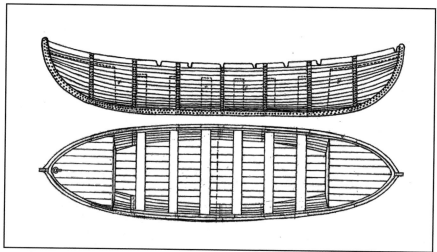

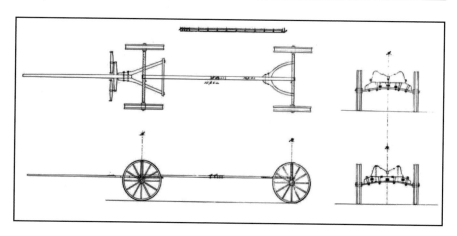

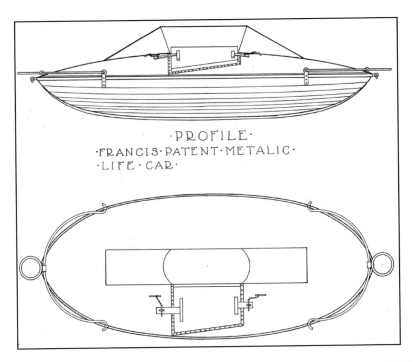

·PROFILE·
·FRANCIS·PATENT·METALIC·
·LIFE·CAR·

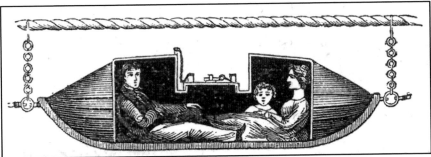

Above: An early version the Francis corrugated iron lifecar, showing front and rear rings from which the lifecar was suspended from its riding hawser and the small hatch into which survivors had to enter and lie down flat inside the car. Total survivor capacity was theoretically up to six persons, depending on body size. *Courtesy of the National Park Service.*

Opposite, top: A profile drawing of the Manby mortar, showing the mortar shot to the left, with a slot for attachment of the spiral wire and the messenger shotline. *Courtesy of the National Park Service.*

Opposite, middle: A profile plan of the twenty-seven-foot-long, double-ended version of the Francis metallic pulling surfboat. *Courtesy of the U.S. Patent Office.*

Opposite, bottom: A profile drawing of a surfboat wagon, this model being the initial type used by the later U.S. Life-Saving Service but very similar in form and function to the type supplied to the rescue boathouses in the 1840s and '50s. *Courtesy of the National Archives and Records Administration.*

Top: Architectural plans for the first eight rescue boathouses established by the Newell Act of August 14, 1848. *Courtesy of the National Park Service.*

Bottom: A photograph taken in the 1890s of the original 1849-built Spermaceti Cove rescue boathouse, showing the degree to which the structure had deteriorated since the time of its completion in 1849. *Courtesy of the U.S. Coast Guard.*

NOTES

CHAPTER 2

1. American Colonization Society, *Annual Report*, 47.
2. Hall, *Report of the Ship-Building Industry*, 66–72.
3. Lubbock, *Western Ocean Packets*, 99–104.
4. Ibid., 94–99.
5. Ibid., 3–10.
6. Maddocks, *Atlantic Crossing*, 142–68.

CHAPTER 3

7. Hall, *Report of the Ship-Building Industry*, 66–72; Knight, *Modern Seamanship*, 15–32.
8. *Congressional Globe* 25, Steamboat Act of 1838.
9. *Congressional Globe* 32, Steamboat Act of 1852; Mitchell, *Premium on Progress*.
10. *Congressional Globe* 25, Steamboat Act of 1838.
11. *Congressional Globe* 32, Steamboat Act of 1852; Putnam, *Lighthouses and Lightships*.
12. Marshall, "Frequently Close."

13. Bowditch, *American Practical Navigator*, 1–55.
14. Knight, *Modern Seamanship*, 136.
15. Klawonn, *Cradle of the Corps*, 176–8.
16. Edwards, *Improvements of New York*, 54–7; Marshall, "Frequently Close."
17. Hardin, *Northwest ¾ West*, xv–xxvii.

CHAPTER 4

18. State of New Jersey, *Report of the Commissioners*.
19. Howe, *Humane Society*, 12.
20. State of New Jersey, "Acts of the General Assembly," 519–21.

CHAPTER 5

21. *Congressional Globe* 30, Newell Act, excerpt from the lighthouse bill, August 9, 1848.
22. NARA RG 26, secretary of the treasury, correspondence, August 22, 1848.
23. NARA RG 26, Captain Ottinger, USRM, to secretary of the treasury W.M. Meredith, May 21, 1849.
24. By the U.S. Life-Saving Service–era in the late 1870s, the lifecar was typically replaced by use of the breeches buoy apparatus that, although allowing only one to two persons to be rescued at a time, was much lighter in weight and easier to rig and use than the lifecar.
25. Wilkinson and Dring, *American Coastal*.
26. NARA RG 26, letter book P, lighthouse letters, Treasury Department files, secretary of the treasury, August 1, 1851.
27. Ibid., January 21, 1853.
28. Ibid., October 7, 1854.
29. State of New Jersey, "Wrecks," 1,255–60.

CHAPTER 6

30. Lubbock, *Western Ocean Packets*, 99–105; Maddocks, *Atlantic Crossing*, 142–68.
31. Immigrant Ship Transcribers Guild, "*Powhatan*."
32. Hall, *Report of the Ship-Building Industry*, 66–72.
33. Immigrant Ship Transcribers Guild, "*Powhatan*."
34. *New York Times*, April 17, 1854.
35. Daniels, *Eagle Seamanship*.
36. Immigrant Ship Transcribers Guild, "*Powhatan*." Notwithstanding the spelling on the government report, we should assume that this was the same ship. The different spelling of the ship's name is consistent with such anomalies in other records, and the ship's gross tonnage matches that listed elsewhere for the *Powhattan*. We must also note that the master was cited as William Myers, although it is not clear whether this was the same man or perhaps a relative of James Myers.
37. Defense Mapping Agency Hydrographic/Topographic Center, "Distance Between Ports."
38. Bowditch, *American Practical Navigator*, "Beaufort Wind Scale."
39. At this point in 1854, Barnegat Light was still the original short 40-foot tower and did not yet have a Fresnel lens, which it received (albeit only a Fourth Order lens) later in 1854. Its replacement 170-foot tower was completed in 1857 with the most powerful First Order Fresnel lens.
40. State of New Jersey, "Shipwrecks."
41. NARA RG 26, listings of Life-Saving Station keepers for the Fourth District.
42. *New York Times*, April 17–21, 1854.
43. USGENWEB, "Information for Old Manahawkin."
44. Saschse, "Wreck of the Ship."
45. State of New Jersey, "Shipwrecks."
46. Saschse, "Wreck of the Ship."
47. Palmer, "1854 Ship *New Era*."

CHAPTER 7

48. U.S. Coast Guard, *Commandant Instruction Manual*.
49. *New York Times*, April 20, 1854.
50. Ibid., April 21, 1854.
51. Ibid., April 18, 1854.

52. Ibid., April 22, 1854.

53. Ibid., November 15, 1854.

54. Ibid., November 18, 1854.

55. Saschse, "Wreck of the Ship."

56. Ibid.

57. Blachford, *Sailing Directions*, 35.

58. NARA RG 26, lighthouse letters, Treasury Department files, Israel Merritt to Walter Jones, Esq., on inspection of life-saving stations, November 12, 1853.

59. Ibid., Treasury Department files, Captain Douglas Ottinger to N.B. Devereux, Esq., 1869.

60. Bruzelius, "*New Era.*"

CHAPTER 8

61. NARA RG 26, letter book P, lighthouse letters, Treasury Department files, Samuel Dunham to the secretary of the treasury, October 7, 1854.

62. Ibid., lighthouse letters, Treasury Department files, Secretary of the treasury to Honorable H. Hamlin, report of summary of life saving legislation, May 24, 1854.

63. Ibid., Treasury Department files, Captain Douglas Ottinger to N.B. Devereux, Esq., 1869.

64. Ibid., letter book P, lighthouse letters, Treasury Department files, Samuel Dunham to the secretary of the treasury, October 7, 1854.

65. *Congressional Globe* 21, "Steamboat Act of 1852"; *Congressional Globe* 36, "Passenger Act of August 2, 1882."

66. NARA RG 26, lighthouse letters, Treasury Department files, John Faunce, report of inspection, August 1871.

BIBLIOGRAPHY

PRIMARY SOURCE DOCUMENTS AND REFERENCES

National Archives and Records Administration (NARA). Record Group 26. Records of the U.S. Life-Saving Service, U.S. Lighthouse Establishment/ Service and U.S. Coast Guard.

Records of State of New Jersey. Book AAA of Commissions. Archives and History Bureau, New Jersey State Library, Trenton, NJ.

———. Book 15 of Deeds, folio 3146. In Freehold, County of Monmouth, NJ. Archives and History Bureau, New Jersey State Library, Trenton, NJ.

———. Speech of the Honorable William F. Brown of Ocean County to the New Jersey House of Assembly. Archives and History Bureau, New Jersey State Library, Trenton, NJ, March 13, 1856.

State of New Jersey. "Acts of the General Assembly of the State of New Jersey, Commissioners of Wrecks." Laws of New Jersey. 1799, 519–21.

———. "An Act Concerning Wrecks." Laws of New Jersey. 1806, 662–8.

———. General Assembly. "Shipwrecks." 1856.

———. *Report of the Commissioners to Investigate the Charges Concerning the Wrecks on the Monmouth Coast.* Trenton, NJ: Sherman and Harron, 1846.

———. Revised Statutes. "Internal Police." 1845–46, 622–9.

———. Revised Statutes. "Wrecks." 1877, 1255–60.

GOVERNMENT REPORTS, PUBLICATIONS AND ARCHIVAL MATERIALS

Bowditch, Nathaniel. *American Practical Navigator Publication Number 9.* Washington, D.C.: Defense Mapping Agency Hydrographic/Topographic Center Publication, 1977.

Defense Mapping Agency Hydrographic/Topographic Center. *Publication No. 151*, "Distance Between Ports." Washington, D.C.: Defense Mapping Agency Hydrographic/Topographic Center, 2015.

Hall, Henry. *Report of the Ship-Building Industry of the United States.* U.S. Department of the Interior. Washington, D.C.: Government Printing Office, 1884.

Klawonn, Marion J. *Cradle of the Corps: A History of the New York District, U.S. Army Corps of Engineers, 1775–1975.* New York: U.S. Army Corps of Engineers, 1977.

Shoemaker, Charles F. *The Evolution of the Life-Saving System of the United States from 1837 to June 30, 1892: An Outline of the Part Taken in its Development by the United States Revenue Marine.* Washington, D.C.: U.S. Coast Guard Historian's Office archives, n.d.

U.S. Census Reports. Washington, D.C.: Government Printing Office, 1850, 1860 and 1870.

U.S. Coast Guard. *Commandant Instruction Manual 16000:10A-Marine Safety Manual.* Vol. 5. Investigations and Enforcement, April 2008.

U.S. Coast Survey. Nautical Charts Nos. 22 and 123. National Oceanographic and Atmospheric Administration, Office of Coast Survey, Nautical Charts and Publications, Historical Maps and Charts. www.nauticalcharts.noaa.gov.

U.S. Congress. *Congressional Globe* 17, 20, 21, 22, 23, 25, 30, 32 and 36.

———. House of Representatives. Miscellaneous document 2, no. 20, vol. 2. from *Report of the Board on Behalf of United States Executive Departments at the International Exhibition Held at Philadelphia, Pennsylvania, 1876.* 47th Cong., 2nd sess., 1884.

———. House of Representatives. Committee on Interstate and Foreign Commerce. *Hearings May 1 and 8, 1914.* 63rd Cong., 2nd sess., on S. 2337, 1914.

U.S. National Ocean Service. Nautical Chart No. 12300, "Approaches to New York, Nantucket Bank to Five Fathom Shoals." 2015.

U.S. Treasury Department. *Annual Reports of the Secretary of Treasury.* Washington, D.C.: Government Printing Office, 1848–75.

———. *Annual Reports of the U.S. Life-Saving Service.* Washington, D.C.: Government Printing Office, 1876–1914.

————. Letter from secretary dated January 24, 1872. From *Report of Captain John Faunce, U.S. Revenue Marine*, Executive Document No. 22. 1–31. (Full report dated August 9, 1871 on the condition of all pre-U.S. Life-Saving Service rescue boathouses and equipment along the coasts of New Jersey and Long Island.)

Books

Bennett, Robert F. *The Coast Guardsman's Manual*. 7th ed. Annapolis, MD: U.S. Naval Institute, 1983.

————. *Life-Saving Along the Coast*. Toms River, NJ: Ocean County Historical Society, 2002.

————. *Sandpounders*. Washington, D.C.: Government Printing Office, 1998.

————. *Surfboats, Rockets and Carronades*. Washington, D.C.: Government Printing Office, 1976.

Blachford, Robert. *Sailing Directions for the Coast and Harbors of North America*. London, UK: Navigation Warehouse No. 114, 1811.

Brown, William F. *Speech on Joint Resolution to Congress in Relation to the New Jersey Coast on March 15, 1856*. Belvidere, NJ: Hemenover and Moore, 1856.

Bryant, William C. *Francis' Metallic Life-Boat Company*. New York: n.p., 1852.

Clothier, Ernest A., and W. Hilton Lowe. *State Pilotage in America*. Washington, D.C.: American Pilots' Association, 1979.

Cornell, Felix M., and Allan C. Hoffman. *American Merchant Seaman's Manual*. Cambridge, MD: Cornell Maritime, 1964.

Cunningham, John T. *The New Jersey Shore*. New Brunswick, NJ: Rutgers University Press, 1958.

Daniels, Edwin H., Jr. *Eagle Seamanship*. 3rd ed. Annapolis, MD: Naval Institute Press, 1990.

Edwards, Joseph. *Improvements of New York Harbor, 1885 to 1891*. New York: Wynkoop and Hallenbeck, 1893.

Forbes, Robert B. *Life-Boats, Projectiles and Other Means for Saving Life*. Boston, MA: William Parsons Lunt, 1872.

Guthorn, Peter J. *The Sea Bright Skiff and Other Jersey Shore Boats*. New Brunswick, NJ: Rutgers University Press, 1971.

Hardin, Mel, ed. *Northwest ¾ West: The Experiences of a Sandy Hook Pilot, 1908–1945; Captain Edward C. Winters, Jr.* Mystic, CT: United New Jersey Sandy Hook Pilots' Benevolent Association, 2004.

BIBLIOGRAPHY

Howe, M.A. DeWolfe. *The Humane Society of the Commonwealth of Massachusetts: An Historical Review, 1785–1916.* Cambridge, MA: Riverside Press, 1918.

Howland, S.A. *Steamboat Disasters and Railroad Accidents in the United States: To which is Appended Accounts of Recent Shipwrecks, Fires at Sea, Thrilling Incidents, Etc.* 2nd ed. Worcester, MA: Dorr, Howland and Company, 1840.

Humane Society of the Commonwealth of Massachusetts. *History of the Humane Society of the Commonwealth of Massachusetts.* Boston, MA: T.R. Marvin and Son, 1876.

Knight, Austin M. *Modern Seamanship.* 8th ed. New York: D. Van Nostrand Company, 1921.

Kraft, Bayard Randolph. *Under Barnegat's Beam, New York.* N.p.: Privately printed by Marion C. Kraft, 1960.

Krotee, Walter, and Richard Krotee. *Shipwrecks off the New Jersey Coast.* Philadelphia, PA: Privately published by Walter and Richard Krotee, 1966.

Lloyds of London. *Register of Shipping.* London, UK: Lloyds of London, 1934.

Lubbock, Basil. *The Western Ocean Packets.* Glasgow, Scotland: James Brown and Son, 1925.

Maddocks, Melvin. *The Atlantic Crossing.* Alexandria, VA: Time-Life Books, 1981.

Methot, Jean. *Up and Down the Beach.* Navesink, NJ: Whip Publishers, 1988.

Miller, Pauline S. *Ocean County, Four Centuries in the Making.* N.p.: Privately printed by Pauline S. Miller.

———. *Three Centuries on Island Beach.* N.p.: privately printed by Pauline S. Miller.

Norris, Martin J. *The Law of Salvage.* Mount Kisco, NY: Baker, Voorhis and Company, 1958.

Putnam, George R. *Lighthouses and Lightships of the United States.* Boston: Houghton Mifflin Company, 1917.

Rattray, Jeanette E. *Perils of the Port of New York.* New York: Dodd Mead and Company, 1973.

———. *Ship Ashore.* New York: Coward-McCann, 1955.

Salter, Edwin. *A History of Monmouth and Ocean Counties.* Bayonne, NJ: E. Gardner and Son, 1890.

Saschse, Julius Friedrich. "The Wreck of the Ship *New Era* Upon the New Jersey Coast, November 13, 1854." from *Pennsylvania: The German Influence on Its Settlement and Development, Part XVI.* N.p.: Pennsylvania-German Society, 1905.

Shanks, Ralph, and Wick York. *The U.S. Life-Saving Service: Heroes, Rescues and Architecture of the Early Coast Guard.* Petaluma, CA: Castano Books, 1996.

Smith, Darrell Hevenor, and Fred Wilbur Powell. *The Coast Guard: Its History, Activities and Organization.* Washington, D.C.: Brookings Institution, 1929.

Stick, David. *The Graveyard of the Atlantic*. Chapel Hill: University of North Carolina Press, 1952.

Tide Tables 2008: East Coast of North and South America. Camden, ME: International Marine/McGraw-Hill, 2008.

Wilkinson, William, and Timothy R. Dring. *American Coastal Rescue Craft*. Gainesville: University Press of Florida, 2009.

Woolman, H.C., T.F. Rose and T.T. Price. *Historical and Biographical Atlas of the New Jersey Coast*. Philadelphia: Woolman and Rose, 1878.

ARTICLES

Bennett, Robert F. "A Case of Calculated Mischief." *Naval Institute Proceedings* (March 1976).

———. "The Life-Savers: For Those in Peril on the Sea." *Naval Institute Proceedings* (March 1976).

———. "The Lifesaving Service at Sandy Hook Station, 1854–1915." Historical Monograph Program. Washington, D.C.: U.S. Coast Guard Public Affairs Division, 1976.

Monthly Nautical Magazine and Quarterly Review. "Appalling Shipwreck of the New Era." 1855.

New York Herald. "Life Among the Surfmen." October 12, 1882.

New York Times. Interview with Edward Jennings. April 22, 1854.

———. Report regarding severe storms and the wreck of the *New Era*. November 15, 1854.

———. Report regarding severe storms and the wreck of the *New Era*. November 18, 1854.

———. Report regarding severe storms and the wreck of the *Powhattan*. April 17–21, 1854.

Royal National Lifeboat Institution. "Francis's Corrugated Iron Boats." *Lifeboat* 1 (October 1856): 195–8.

———. "The New York Life-Saving Benevolent Association." *Lifeboat* 1 (January 1856): 111–3.

Washington (D.C.) Star. "Shot With a History: Wreck of the Ayrshire." March 11, 1898.

"Wreck of the Ayrshire." *Via the Port of New York*. Port Authority of New York–New Jersey. April 1963.

BIBLIOGRAPHY

OTHER PUBLISHED MATERIAL

American Colonization Society. *Annual Report*. 1857.

Board of Underwriters of New York. *Suggestions to Masters of Vessels and List of Agents etc., for Vessels and Cargoes in Distress*. New York: Board of Underwriters of New York, 1882.

Cox, S.S. *Life: Its Perils and Salvation*. Washington, D.C.: R.O. Polkinhorn, 1878.

Life-Saving Benevolent Association of New York. *A Copy of the Charter: Premiums, Awards, List of Managers, Donors and a Portion of its Correspondence*. New York: Life-Saving Benevolent Association of New York, 1857.

Manasquan Chamber of Commerce. *Manasquan, New Jersey*. Lewiston, ME: Geiger Bros., 1962.

Marshall, Amy K. "Frequently Close to the Point of Peril: A History of Buoys and Tenders in U.S. Coastal Waters, 1789–1939." Master of arts' thesis, East Carolina University, February 1998 (accessed via the U.S. Coast Guard Historian's Office, Washington, D.C.).

Mitchell, C. Bradford. *A Premium on Progress: An Outline History of the American Marine Insurance Market, 1820–1970*. New York: Newcomen Society in North America, 1970.

Ocean County Principals' Council. *Tides of Time in Ocean County*. N.p., 1940.

Sawyer, E. Phillip. Papers relating to the schooner *David H. Tolck*. Submitted by Peter Sawyer.

INTERNET SOURCES

Ancestry. "German Immigrant Surnames." http://lists.rootsweb.ancestry.com/index/intl/deu/german-surnames.html.

Bruzelius, Lars. "*New Era*." Maritime History Virtual Archive. http://www.bruzelius.info/Nautica/Nautica.html.

Immigrant Ship Transcribers Guild, September 1853. "*Powhatan*." http://www.immigrantships.net.

New Jersey Historical Museum. Mansion of Health. www.njhm.com/mansionsofhealth.htm.

Palmer, Michael. "1854 Ship New Era Wreck on New Jersey Coast." E-mail message to author.

USGENWEB. "Information for Old Manahawkin Baptist Cemetery for Burial of *Powhattan* Victims." http://files.usgwarchives.org/nj/ocean/cemetery.

INDEX

INDEX

INDEX

ABOUT THE AUTHORS

C APTAIN ROBERT FRANK BENNETT, USCG retired, was born and raised
on the Jersey shore in Sea Girt, New Jersey, and is a descendant of
three heroes of the United States Life-Saving Service. Bob graduated from
the United States Coast Guard Academy in 1958 and began his career
in the United States Coast Guard with his final duty station as captain of
the port in Charleston, South Carolina. His many awards included two
USCG Commendation medals. While in Savannah, then-Commander
Bennett served as recorder on the Marine Board of Investigation into the
collision of the merchant vessel *African Neptune* with the Sydney Lanier
Bridge in Brunswick, Georgia, in November 1972. His vast experience as
a marine investigator gives a perspective to the wrecks of the *Powhattan*
and *New Era* that has not been available before now.

He received his masters in education degree from the Citadel and joined
the staff of the Charleston Pilots Association while continuing his maritime
consulting services. He drafted several rules and regulations for the State of
South Carolina on maritime pilotage promoting maritime safety in the port
industry of South Carolina, and he authored the *USCG Approved Apprentice
Training Course* for pilots. He was a member of the South Carolina Maritime
Security Commission and the South Carolina Commissioners of Pilotage until
his passing on September 7, 2011. In 2005, he received the South Carolina
Distinguished Service Medal for his tremendous work in maritime safety.

Captain Bennett was considered a leading expert on the United States Life-
Saving Service. A passion for its history began during a tour in Washington,

ABOUT THE AUTHORS

D.C., where he spent hours in the National Archives researching the history he longed to share. He authored two books, *Sandpounders*, published in 1999, and *Surfboats, Rockets and Carronades*, published in 1976. He revised the *Coast Guardsman's Manual, Seventh Edition* as well as wrote countless articles on the USCG and the history of the service he loved.

Bob was also a dearly loved husband and father. He was married to Barbara Bennett for nearly fifty-one years and resided in Charleston, South Carolina, until his passing. He had two daughters, Lorri Bennett and Susan Leigh Bennett.

SUSAN LEIGH BENNETT, Captain Robert Bennett's daughter, received her bachelor of science in biological sciences/science teaching from Clemson University and her masters plus thirty in speech and language pathology from the University of South Carolina. She is the proud daughter of a coast guardsman and a descendant of three heroes of the former United States Life-Saving Service who were stationed along the New Jersey coastline. She resides in the Lowcountry of South Carolina with her mother, Barbara Bennett, and sister, Lorri. Susan shared her father's passion for the story of the *Powhattan* and *New Era* shipwrecks and spent countless hours discussing this book and the telling of this important story with Captain Bennett before he died. In the finalization of this book manuscript and submission for publication, a promise made to him is now a promise fulfilled.

COMMANDER TIMOTHY R. DRING retired from the United States Naval Reserve after twenty-seven years of active and reserve duty service on board destroyers and frigates, as well as reserve duty in a number of assignments including composite navy/coast guard coastal warfare/harbor defense units on the United States East Coast and an Atlantic Fleet carrier battle-group staff augmentation unit. He is the coauthor, with William D. Wilkinson, of a book published in 2009 by the University Press of Florida, *American Coastal Rescue Craft*, on the technical design history of all the coastal rescue lifeboats and surfboats ever used by the United States Coast Guard and its predecessor service, the United States Life-Saving Service. This book won the best history book award from the Foundation for Coast Guard History in 2010.

Commander Dring is on the board of directors of the United States Life-Saving Service Heritage Association (the historical society for the United States Life-Saving Service and its mission continuation in today's United States Coast Guard) and on the board of trustees for the

Twin Lights Historical Society (the historical preservation group for the former Navesink Twin Lighthouses in Highlands, New Jersey). He is a regular author-contributor to the heritage association's quarterly journal *Wreck & Rescue* on the topic of coastal rescue craft. In 2010, he was given the United States Coast Guard's Meritorious Public Service Award for his years of volunteer assistance to the coast guard in researching, preserving and teaching the history of rescue craft and their use by the United States Coast Guard and United States Life-Saving Service.

Commander Dring, in civilian life, is a pharmaceutical scientist, currently with Johnson&Johnson. He is married to the former Leslie Burkle, has two children and resides in New Jersey.

Visit us at
www.historypress.net
...
This title is also available as an e-book